AMERICAN LANDSCAPE PAINTING

AN INTERPRETATION
BY
WOLFGANG BORN

GREENWOOD PRESS, PUBLISHERS
WESTPORT, CONNECTICUT

TO

THE MEMORY OF MY MOTHER

CONTENTS

	PAGE
ACKNOWLEDGMENTS	vi
LIST OF ILLUSTRATIONS	vii
METHOD AND PURPOSE	1
I. THE EUROPEAN HERITAGE	3
II. SENTIMENT OF NATURE	24
III. THE PANORAMIC STYLE	75
IV. WITH FRESH EYES	118
V. PAINTERS OF TONE AND LIGHT	149
VI. TOWARD A TECHNOCRATIC LANDSCAPE	196
IN CONCLUSION	214
NOTES	217
INDEX	223

ACKNOWLEDGMENTS

IT is a pleasure to acknowledge the generous assistance I have received in preparing this volume. Space does not permit the list to include everyone with whom I corresponded and who contributed to my work with information and pictures, but I should like to mention especially: my wife Mary, who edited the manuscript; Mr. Frederick A. Sweet and Miss Alice Winchester, who read the manuscript and gave valuable suggestions; Mr. Heinrich Schwarz, who allowed me to draw from his unpublished notes and advised me about the European part of my study; Miss Marie Alexander, Mr. Albert C. Barnes, Mr. John I. H. Baur, Mrs. Ralph Catterall, Miss Elizabeth Clare, Miss Bartlett Cowdrey, Mr. James Thomas Flexner, Mr. Henry Sayles Frances, Mr. Alfred V. Frankenstein, Mr. Norman Hirschl, Mr. Thomas T. Hoopes, Mr. Edward S. King, Miss Antoinette Kraushaar, Mr. James W. Lane, Mr. C. W. Lyon, Mr. J. Alden Mason, Mrs. Betty Mont, Mrs. Clyde Porter, Miss Helen Porter, Mr. Perry T. Rathbone, Mr. Edgar Preston Richardson, Mrs. John Shapley, Miss Theodora Stover, Mr. R. P. Tolman, Miss Ninfa Valvo, Mr. Robert C. Vose, Miss Ruth Walling, and Mr. Herman W. Williams.

The Frick Art Reference Library and the Art Room of the New York Public Library put their unique research facilities at my disposal, and I owe gratitude to the Hill Memorial Library of Louisiana State University and to all the museums and art galleries I contacted during the preparation of this work.

The photographs Figs. 16, 22, 69, 74 were graciously loaned to me by the magazine *Antiques,* and Figs. 8, 13, 101, 140 by the *Magazine of Art.*

The owners of the pictures included here for purposes of illustration are named in the captions of the pictures. Without their kind permission to use these illustrations, this volume would have been impossible. I wish to express my thanks to all of them.

ILLUSTRATIONS

All measurements are given in inches.

Frontispiece: CHARLES SHEELER, *The Artist Looks at Nature,* oil, 21 x 18, sgd. 1943, courtesy of the Art Institute of Chicago, Society for Contemporary American Art Collection.

I. THE EUROPEAN HERITAGE

Fig. 1. Cornelius Massys (?) or another follower of Patinir, *Imaginary Landscape with the Arrival at Bethlehem,* oil, 26½ x 36⅞, c. 1550, courtesy of the Metropolitan Museum of Art, New York City 5

Fig. 2. Pieter Brueghel the Elder, *Winter Landscape,* oil, 40 x 63¾, sgd., 1555, courtesy of the Kunsthistorisches Museum, Vienna 6

Fig. 3. Jacob van Ruisdael, *Forest Scene,* oil, 41½ x 51½, sgd. c. 1660–65, courtesy of the National Gallery of Art, Washington, D.C., Widener Collection 8

Fig. 4. Nicolas Poussin, *St. John on Patmos,* oil, 40 x 52¼, c. 1660, courtesy of the Art Institute of Chicago, Chicago, Ill. 9

Fig. 5. John Constable, *Wivenhoe Park,* oil, 22 x 39¾, 1816, courtesy of the National Gallery of Art, Washington, D.C., Widener Collection 13

Fig. 6. William Turner, *The Junction of the Thames and the Medway,* oil, 42¾ x 56½, probably 1505–08, courtesy of the National Gallery of Art, Washington, D.C., Widener Collection 14

Fig. 7. Théodore Rousseau, *Edge of the Wood,* oil, 31⁷⁄₁₆ x 48¹⁄₁₆, sgd. c. 1850, courtesy of the Metropolitan Museum of Art, New York City 15

Fig. 8. Jean-Baptiste Camille Corot, *The Bridge of Narni,* oil, 26¾ x 37¼, bears the stamp of the "Vente Corot," courtesy of the National Gallery of Canada, Ottawa 16

Fig. 9. Caspar David Friedrich, *A Monastic Cemetery in Snow,* oil, 47⅗ x 64⅕, 1819, National Gallery, Berlin. Photograph courtesy of Mrs. Helen Appleton-Read 17

Fig. 10. Ferdinand Georg Waldmüller, *The Hochkelter Seen from Wimbish Valley,* oil, measurements unobtainable, 1837, Gallery of Prince Lichtenstein, Vienna. Photograph courtesy of Mr. Heinrich Schwarz 18

Fig. 11. Gustav Courbet, *The Source of the Loire,* oil, 21½ x 25¼, sgd., c. 1850–60, courtesy of Wildenstein & Co., Inc., New York City 20

Fig. 12. Claude Monet, *Banks of the Seine, Vetheuil,* oil, 29 x 39⅝, sgd., 1880, courtesy of the National Gallery of Art, Washington, D.C., Chester Dale Collection (loan) 21

Fig. 13. Paul Cézanne, *Montagne Ste. Victoire,* oil, 28½ x 36, 1897, courtesy of Bignou Gallery, New York City 22

Fig. 14. Henri Rousseau, *Borders of the Oise River,* oil, 18 x 22, sgd., probably 1905, courtesy of the Smith College Museum of Art, Northampton, Mass. 23

II. SENTIMENT OF NATURE

Fig. 15. Ralph Earl, *Portrait of Colonel William N. Taylor,* oil, 38 x 48¾, sgd., 1790, courtesy of the Albright Art Gallery, Buffalo, N.Y. 25

Fig. 16. Unknown painter, *Southeast Prospect of the City of New York,* oil, 38 x 72½, c. 1756, courtesy of the New York Historical Society, New York City 27

Fig. 17. Thomas Birch, *The City of Philadelphia from the Treaty Elm,* oil, 27⅜ x 39, c. 1800, courtesy of the Historical Society of Pennsylvania, Philadelphia, Pa. 28

Fig. 18. Thomas Birch, *Shipwreck,* oil, 27⅜ x 39, sgd., 1829, courtesy of the Brooklyn Museum, Brooklyn, N.Y. 29

Fig. 19. Washington Allston, *Elijah Fed by the Ravens,* oil, 48¾ x 72½, sgd., 1818, courtesy of the Museum of Fine Arts, Boston, Mass. 33

Fig. 20. Washington Allston, *Moonlit Landscape,* oil, 24 x 35, c. 1819, courtesy of the Museum of Fine Arts, Boston, Mass. 34

Fig. 21. Samuel Finley Breese Morse, *Allegorical Landscape,* oil, 22½ x 36¼, 1836, courtesy of the New York Historical Society, New York City 35

Fig. 22. Samuel Finley Breese Morse, *View from Apple Hill, Cooperstown, N.Y.,* oil, 22⅜ x 29½, 1828-29, courtesy of Mr. Stephen C. Clark, New York City 37

Fig. 23. William G. Wall, *View near Fishkill, N.Y.,* water color, 14 x 21⅛, c. 1820, courtesy of the New York Historical Society, New York City 39

Fig. 24. Thomas Doughty, *The Raft,* oil, 14 x 17, sgd., 1830, courtesy of the Museum of Art, Providence, R.I. 41

Fig. 25. Asher Brown Durand, *Sunday Morning,* oil, 25¼ x 36¼, 1839, courtesy of the New York Historical Society, New York City 43

Fig. 26. Asher Brown Durand, *Kindred Spirits,* oil, 36 x 46, 1849, courtesy of the New York Public Library, New York City 44

Fig. 27. Unknown artist (formerly attributed to Durand), *Mohawk Valley,* oil, 35⅜ x 49⅜, c. 1850, courtesy of the New York Historical Association, Cooperstown, N.Y. 45

Fig. 28. Thomas Cole, *Landscape with Tree Trunks,* oil, 26⅜ x 32¼, c. 1835, courtesy of the Museum of Art, Providence, R.I. 47

Fig. 29. Thomas Cole, *The Maid of the Mist,* oil, 50 x 38, sgd., 1833, courtesy of Mrs. L. T. Gager, Washington, D.C. 48

Fig. 30. Thomas Cole, *Mountain Landscape with Waterfall,* oil, 51 x 39, sgd., 1847, courtesy of the Museum of Art, Providence, R.I. 49

Fig. 31. Robert Havell, *View of the Hudson River from Horton's Road near Croton,* oil, 29 x 40, c. 1840-50, courtesy of the Minneapolis Institute of Arts, Minneapolis, Minn. 51

Fig. 32. Henry Inman, *Picnic in the Catskills,* oil, 17 x 14, sgd., c. 1840, courtesy of the Brooklyn Museum, Brooklyn, N.Y. 52

Fig. 33. James M. Hart, *Picnic on the Hudson,* oil, 35⅝ x 56, sgd., 1854, courtesy of the Brooklyn Museum, Brooklyn, N.Y. 54

Fig. 34. Régis François Gignoux, *Winter Sports,* oil, 24½ x 34, sgd., c. 1860, courtesy of Robert C. Vose Galleries, Boston, Mass. 55

Fig. 35. Alfred J. Miller, *Green River, Oregon,* water color, 9 x 12¼, 1837, courtesy of the Walters Gallery, Baltimore, Md. 57

Fig. 36. George H. Durrie, *Wood for Winter,* oil, 36 x 54, sgd., courtesy of the New York Historical Society, New York City 58

Fig. 37. Jasper F. Cropsey, *View of the Kaaterskill House,* oil, 29 x 44, sgd., 1855, courtesy of the Minneapolis Institute of Arts, Minneapolis, Minn. 60

Fig. 38. Jasper F. Cropsey, *Niagara Falls,* oil, 36⅝ x 25¾, sgd., 1860, courtesy of the Brooklyn Museum, Brooklyn, N.Y. 61

Fig. 39. Jasper F. Cropsey, *Youle's Shot Tower—East River Shore,* New York City, oil, 24 x 20, sgd., 1845, courtesy of the New York Historical Society, New York City 62

Fig. 40. John Frederick Kensett, *Newport Harbor, Rhode Island,* oil, 14 x 21¼, c. 1865, courtesy of Mr. and Mrs. Edward Kesler, Philadelphia, Pa. 63

Fig. 41. David Johnson, *Old Mill, West Milford, New Jersey,* oil, 16⅛ x 22¼, sgd., 1850, courtesy of the Brooklyn Museum, Brooklyn, N.Y. 64

Fig. 42. Jerome Thompson, *Harvest in Vermont,* oil, 30 x 50, sgd., 1859, courtesy of Mr. Ernest Rosenfeld, New York City 66

Fig. 43. George Caleb Bingham, *Missouri*

Landscape, oil, 38 x 48, c. 1850, courtesy of the City Art Museum, St. Louis, Mo. 67

Fig. 44. William Sidney Mount, *Long Island Farm Houses,* oil, 21⅞ x 29⅞, sgd., c. 1855, courtesy of the Metropolitan Museum of Art, New York City 68

Fig. 45. Albert Bierstadt, *Couple Driving,* oil, 13½ x 19½, sgd., c. 1860–70, courtesy of M. Knoedler & Co., New York City 70

Fig. 46. Thomas Hill, *Fishing Party in the Mountains,* oil, 24 x 20, sgd., c. 1880, courtesy of the M. H. de Young Memorial Museum, San Francisco, Cal. 71

Fig. 47. Martin J. Heade, *Storm over Narragansett Bay,* oil, 32 x 54, sgd., 1868, courtesy of Mr. Ernest Rosenfeld, New York City 72

Fig. 48. Martin J. Heade, *Tropical Landscape,* oil, 8 x 10, sgd., 1868, courtesy of the Newhouse Galleries, New York City 73

Fig. 49. Joseph Rusling Meeker, *The Land of Evangeline,* oil, 33 x 46, sgd., 1874, courtesy of the City Art Museum, St. Louis, Mo. 74

III. THE PANORAMIC STYLE

Fig. 50. John Trumbull, *View of the Falls of Niagara Taken from the Road Two Miles below Chippawa,* oil, 29 x 168½, c. 1808, courtesy of the New York Historical Society, New York City 76

Fig. 51. John Trumbull, *View of the Falls of Niagara Taken from under the Table Rock,* oil, 29 x 168½, c. 1808, courtesy of the New York Historical Society, New York City 77

Figs. 52a and b. Henry Lewis (attributed to), *St. Louis after the Great Fire,* water color, 5½ x 31, 1849, courtesy of Mr. Monroe C. Lewis, St. Louis, Mo. 76–77

Fig. 53. John Vanderlyn, *Panoramic View of the Palace and Gardens of Versailles* (section showing the *Basin of Latona*), oil, 58 x 106, 1815, courtesy of the Senate House Museum, Kingston, N.Y. 79

Fig. 54. Thomas Cole, *Destruction* (No. 4 of the series *The Course of Empire*), oil, 39¼ x 63½, sgd., 1836, courtesy of the New York Historical Society, New York City 82

Fig. 55. Robert Burford, *Pandemonium from Milton's Paradise Lost,* print, picture space each: 15⅛ x 3¾, 1829, courtesy of the Metropolitan Museum of Art, New York City 83

Fig. 56. Thomas Cole, *Oxbow,* oil, 51½ x 76, sgd., 1836, courtesy of the Metropolitan Museum of Art, New York City 84

Fig. 57. Unknown painter (formerly attributed to Thomas Cole), *Oxbow,* oil, 16 x 21¼, c. 1830–35, courtesy of the Cleveland Museum of Art, Cleveland, Ohio 85

Fig. 58. Frances Palmer (Bond), *Across the Continent, Westward the Course of Empire Takes Its Way,* colored lithograph, folio, sgd., 1869, courtesy of the Old Print Shop, New York City 87

Fig. 59. John J. Egan, *Terraced Mound in a Snow Storm at Sunset* (section of a panorama), oil, H. 96, c. 1850, courtesy of the University Museum, Philadelphia, Pa. 92

Fig. 60. John J. Egan, *Distant View of the Rocky Mountains* (section of a panorama), oil, H. 96, c. 1850, courtesy of the University Museum, Philadelphia, Pa. 93

Fig. 61. John J. Egan, *Colossal Bust at Low Water Mark, Used as Metre by the Aborigines* (section of a panorama), oil, H. 96, c. 1850, courtesy of the University Museum, Philadelphia, Pa. 94

Fig. 62. John J. Egan, *Lake Concordia and Aboriginal Tumuli* (section of a panorama), oil, H. 96, c. 1850, courtesy of the University Museum, Philadelphia, Pa. 95

Fig. 63. Charles Wimar, *Indians Approaching Fort Benton,* 24 x 48, oil, sgd., 1859, courtesy of Washington University, St. Louis, Mo. (exhibited at The City Art Museum, St. Louis) 98

Fig. 64. Thomas Doughty, *On the Banks of the Susquehanna,* oil, 27½ x 39½, sgd., c. 1830–40, courtesy of a private collector 99

Fig. 65. John Ferguson Weir, *View of the Highlands from West Point,* oil, 19 x 33, sgd., 1862, courtesy of the New York Historical Society, New York City 101

Fig. 66. David Johnson, *Mount Marcy*, oil, 21½ x 34½, sgd., c. 1850–60, courtesy of Mr. and Mrs. Edward Kesler, Philadelphia, Pa. 102

Fig. 67. George Loring Brown, *View of Norwalk Island*, oil, 21½ x 43, sgd., 1864, courtesy of the Addison Gallery of American Art, Phillips Academy, Andover, Mass. 104

Fig. 68. Martin J. Heade, *On the St. Sebastian River, Florida*, oil, 17 x 36, sgd., c. 1885, courtesy of the Harry Shaw Newman Gallery, New York City 105

Fig. 69. Albert Bierstadt, *Bombardment of Fort Sumter*, oil, 26½ x 68½, c. 1865, sgd., courtesy of the Union League of Philadelphia, Pa. 107

Fig. 70. Albert Bierstadt, *Mount Whitney*, oil, 79½ x 117, sgd., 1879, courtesy of the Minneapolis Institute of Arts, Minneapolis, Minn. 108

Fig. 71. Thomas Hill, *El Capitan, Yosemite Valley near Mirror Lake*, oil, 35½ x 53½, sgd., c. 1898, courtesy of Robert C. Vose Galleries, Boston, Mass. 110

Fig. 72. Thomas Moran, *The Chasm of the Colorado*, oil, 83¼ x 144, sgd., 1873–74, courtesy of the Capitol, Washington, D.C. 111

Fig. 73. Thomas Moran, *Cliffs of the Upper Colorado River, Wyoming Territory*, 15½ x 23½, oil, sgd., 1882, courtesy of the National Collection of Fine Arts, Washington, D.C. 112

Fig. 74. Frederick Edwin Church, *Chimborazo*, oil, 48 x 84, sgd., courtesy of Mr. William Church Osborn, New York City 114

Fig. 75. Frederick Edwin Church, *Cotopaxi, Ecuador*, oil, 45 x 85, sgd., 1862, with the kind permission of the owner, Mr. John J. Astor, courtesy of M. Knoedler & Co., New York City 115

Fig. 76. Conrad Wise Chapman, *The Valley of Mexico* (section of a four-part panorama), oil, 14½ x 18¾, 1865, courtesy of the Valentine Museum, Richmond, Va. 116

IV. WITH FRESH EYES

Fig. 77. Unknown painter, *Hudson River Landscape with Sailboats*, oil, 20⅛ x 26, c. 1840, courtesy of the Museum of Art, Providence, R.I. 121

Fig. 78. Thomas Chambers, *"Under Cliff,"* Seat of General George P. Morris, near Cold Spring, Hudson Valley, oil, 20½ x 29¾, c. 1840, courtesy of the Museum of Art, Providence, R.I. 123

Fig. 79. W. Ranford Keefe, *Tree of Foreboding*, oil, 22 x 28, sgd., c. 1860–80, courtesy of the Harry Stone Gallery, New York City 124

Fig. 80. Unknown painter, *Mountain Landscape*, pastel, 14½ x 12½, c. 1865, courtesy of the Museum of Modern Art, New York City 125

Fig. 81. Unknown painter, *"The Washington"—First Double Decker on the Mississippi*, oil, 20¼ x 28½, c. 1820, courtesy of the Harry Stone Gallery, New York City 127

Fig. 82. Susan Merrett, *Fourth of July Picnic*, water color, measurements unobtainable, sgd., 1845, courtesy of Mrs. Henry G. Vaughan, Boston, Mass. 128

Fig. 83. Joseph H. Hidley, *View of Poestenkill*, oil, 18½ x 24⅛, sgd., 1862, courtesy of the New York State Historical Association, Cooperstown, N.Y. 129

Fig. 84. J. Peters, Sr., *The Good Intent*, oil, 60 x 36, sgd., c. 1840, courtesy of the Downtown Gallery, New York City 130

Fig. 85. Unknown painter, *Winter Scene*, water color, 15½ x 21, c. 1840, courtesy of the Henry Shaw Newman Gallery, New York City 132

Fig. 86. Francis Guy, *Brooklyn in 1816–17*, oil, 41¼ x 43⅛, sgd., courtesy of the Brooklyn Museum, Brooklyn, N.Y. 133

Fig. 87. Unknown painter, *Chouteau's Pond, St. Louis*, oil, 26 x 30, courtesy of the Missouri Historical Society, St. Louis, Mo. 134

Fig. 88. Unknown painter after William Henry Bartlett, *View of the Schuylkill Waterworks*, Philadelphia, oil, 24 x 32, c. 1840, courtesy of the Detroit Institute of Arts, Detroit, Mich. 136

Fig. 89. Unknown painter, *View of Barnstable*, oil, 36 x 48, signature illegible, 1857, courtesy of the Addison Gallery of

American Art, Phillips Academy, Andover, Mass. 137

Fig. 90. George Harvey, *Amongst the Allegheny Mountains*, water color, 8⅜ x 13⅝, 1828–38, courtesy of the Brooklyn Museum, Brooklyn, N.Y. 138

Fig. 91. Seth Eastman, *View of Fort Snelling*, oil, 27 x 34, probably 1841–48, courtesy of the Minneapolis Institute of Arts, Minneapolis, Minn. 140

Fig. 92. Albertis D. O. Browere, *The Falls of San Joaquin, California*, oil, 25 x 30⅛, c. 1856, courtesy of the Art Institute of Chicago, Chicago, Ill. 141

Fig. 93. Albertis D. O. Browere, *Stockton, 1856*, oil, 37 x 70¼, sgd., courtesy of the M. H. de Young Memorial Museum, San Francisco, Cal. 142

Fig. 94. Albertis D. O. Browere, *Catskills*, oil, 34 x 44, sgd. 1849, courtesy of the Brooklyn Museum, Brooklyn, N.Y. 143

Fig. 95. Joseph Lee, *Alameda Shore*, oil, 27½ x 48½, sgd., c. 1880, courtesy of the M. H. de Young Memorial Museum, San Francisco, Cal. 145

Fig. 96. Joseph Lee, *Oak Knoll, Napa*, oil, 47½ x 72, sgd., c. 1880, courtesy of the M. H. de Young Memorial Museum, San Francisco, Cal. 146

Fig. 97. Joseph Pickett, *Lehigh Canal, Sunset, New Hope, Pa.*, oil, 23¼ x 34, sgd., c. 1890, courtesy of the Galerie St. Etienne, New York City 147

Fig. 98. Anna Mary Robertson (Grandma Moses), *McDonell Farm*, tempera, 24 x 30, sgd., 1943, courtesy of the Phillips Memorial Gallery, Washington, D.C. 148

V. PAINTERS OF TONE AND LIGHT

Fig. 99. Charles Herbert Moore, *Down the Hudson to West Point*, oil, 20¼ x 30¼, c. 1860–65, courtesy of the Vassar College Art Gallery, Poughkeepsie, N.Y. 151

Fig. 100. Charles Herbert Moore, *The Old Bridge*, oil, 11 x 16, sgd., 1868, courtesy of Mrs. Juliana Force, New York City 152

Fig. 101. John La Farge, *Paradise Valley, Newport*, oil, 32½ x 42, 1868, courtesy of Mr. Francis B. Lothrop, Boston, Mass. 155

Fig. 102. James McNeill Whistler, *The Thames in Ice*, oil, 22 x 30, sgd., 1860, courtesy of the Freer Gallery of Art, Washington, D.C. 157

Fig. 103. George Innes, *The Lackawanna Valley*, oil, 33⅞ x 50⅜, sgd., 1854, courtesy of the National Gallery of Art, Washington, D.C. 158

Fig. 104. George Innes, *Delaware Water Gap*, oil, 22 x 30, sgd., 1861, courtesy of the Metropolitan Museum of Art, New York City 160

Fig. 105. George Innes, *The Roman Campagna*, oil, 43 x 26, sgd., 1873, courtesy of the City Art Museum of St. Louis, Mo. 161

Fig. 106. Winslow Homer, *The Woodchopper*, oil, 10⅞ x 16, c. 1890, courtesy of Wildenstein & Co., Inc., New York City 163

Fig. 107. Winslow Homer, *A Fisherman's Day*, water color, 12½ x 19¼, sgd., 1889, courtesy of the Freer Gallery of Art, Washington, D.C. 164

Fig. 108. Winslow Homer, *On the Lee Shore*, oil, 39 x 39, sgd., 1900, courtesy of the Museum of Art, Providence, R.I. 165

Fig. 109. John Singer Sargent, *In the Luxembourg Gardens*, oil, 25½ x 36, sgd., 1879, courtesy of the Johnson Collection, Philadelphia, Pa. 166

Fig. 110. Homer D. Martin, *Preston Ponds, Adirondacks*, oil, 15 x 25, c. 1870, courtesy of the Minneapolis Institute of Arts, Minneapolis, Minn. 168

Fig. 111. Alexander H. Wyant, *Forest Stream, a Study from Nature*, oil, 12½ x 15½, sgd., c. 1870, courtesy of the Minneapolis Institute of Art, Minneapolis, Minn. 169

Fig. 112. Henry Ward Ranger, *Connecticut Woods*, oil, 28 x 36, sgd., 1898, courtesy of the National Collection of Fine Arts, Washington, D.C. 170

Fig. 113. Henry Ward Ranger, *High Bridge*, oil, 40¼ x 49⅞, sgd., 1903, courtesy of the Metropolitan Museum of Art, New York City 171

Fig. 114. Albert Pinkham Ryder, *Fishermen's Huts*, oil, 12 x 14, sgd., c. 1880–1900, courtesy of the Phillips Memorial Gallery, Washington, D.C. 173

Fig. 115. Ralph Albert Blakelock, *Moonlight Landscape*, oil, 5¾ x 9¾, sgd., c. 1880–90, courtesy of the Phillips Memorial Gallery, Washington, D.C. 174

Fig. 116. Worthington Whittredge, *A Boating Party in Central Park*, oil, 6½ x 10, sgd., c. 1865, courtesy of Mr. Paul Lane, New York City 176

Fig. 117. Worthington Whittredge, *The House on the Sea*, oil, 14¼ x 25¼, sgd., c. 1870, courtesy of the Los Angeles County Museum, Los Angeles, Cal. 177

Fig. 118. Frank Duveneck, *Old Town Brook, Polling, Bavaria*, oil, 31 x 49, sgd., c. 1878, courtesy of the Cincinnati Art Museum, Cincinnati, Ohio 178

Fig. 119. Theodore Robinson, *Val d'Arconville*, oil, 22 x 18, sgd., c. 1888, courtesy of the Art Institute of Chicago, Chicago, Ill. 180

Fig. 120. Childe Hassam, *Sunny Blue Sea*, oil, 33¾ x 35½, sgd., 1913, courtesy of the National Collection of Fine Arts, Washington, D.C. 181

Fig. 121. John Alden Weir, *Willimantic Thread Mill*, oil, 30 x 40, sgd., 1897, courtesy of the Brooklyn Museum, Brooklyn, N.Y. 182

Fig. 122. John H. Twachtman, *Landscape*, oil, 34 x 45, c. 1878–79, courtesy of the Whitney Museum of American Art, New York City 183

Fig. 123. John H. Twachtman, *Blue Brook Water Fall*, oil, 25 x 30, c. 1895, sgd., courtesy of the Cincinnati Art Museum, Cincinnati, Ohio 185

Fig. 124. William Glackens, *Mahone Bay*, oil, 26 x 32, sgd., 1911, courtesy of the Hall Collection, University of Nebraska Art Galleries, Lincoln, Neb. 186

Fig. 125. Ernest Lawson, *Spring Night, Harlem River*, oil, 25 x 30, sgd., 1913, courtesy of the Phillips Memorial Gallery, Washington, D.C. 187

Fig. 126. Willard Leroy Metcalf, *October Morning—Deerfield, Mass.*, oil, 26 x 29, sgd., 1917, courtesy of the Freer Gallery of Art, Washington, D.C. 188

Fig. 127. George F. Bellows, *The White Horse*, oil, 34¼ x 43, sgd., 1922, courtesy of the Worcester Art Museum, Worcester, Mass. 190

Fig. 128. William H. Holmes, *By the Sea*, oil, 22 x 30, sgd., 1900, courtesy of Mr. Glenn T. Martin, Washington, D.C. 191

Fig. 129. William H. Holmes, *A Maryland Landscape*, oil, 22 x 30, sgd., c. 1900, courtesy of Mr. Glenn T. Martin, Washington, D.C. 192

Fig. 130. Arthur Clifton Goodwin, *Landscape with Brook*, oil, 20 x 24, sgd., c. 1927, courtesy of Wildenstein & Co., Inc., New York City 194

Fig. 131. Arthur Clifton Goodwin, *High Bridge, New York*, oil, 25 x 30, sgd., c. 1927, courtesy of Wildenstein & Co., Inc., New York City 195

VI. TOWARD A TECHNOCRATIC LANDSCAPE

Fig. 132. Arthur B. Davies, *Along the Erie Canal*, oil, 18 x 40, sgd., 1890, courtesy of the Phillips Memorial Gallery, Washington, D.C. 197

Fig. 133. Arthur B. Davies, *Spring Time of Delight*, oil, 18 x 40, sgd., 1906, courtesy of the Phillips Memorial Gallery, Washington, D.C. 198

Fig. 134. Maurice Prendergast, *Gloucester*, oil, 18 x 32, sgd., 1913, courtesy of the Barnes Foundation, Merion, Pa. 200

Fig. 135. John Marin, *Island, Small Point, Maine*, water color on paper, 15¾ x 19, sgd., courtesy of the Albert E. Gallatin Collection, Philadelphia Museum of Art, Philadelphia, Pa. 201

Fig. 136. Marsden Hartley, *Smelt Brook Falls*, oil, 28 x 22, 1937, courtesy of the City Art Museum, St. Louis, Mo. 203

Fig. 137. Louis M. Eilshemius, *Bridge for Fishing*, oil, 18 x 35, sgd., c. 1905, courtesy of the Phillips Memorial Gallery, Washington, D.C. 205

Fig. 138. Charles Demuth, *Red Chimneys*, water color, 9¾ x 13¾, sgd., 1918, courtesy of the Phillips Memorial Gallery, Washington, D.C. 208

Fig. 139. Preston Dickinson, *Harlem River*, pastel with India ink, 14⅝ x 21⅛, c. 1925, courtesy of the Whitney

Museum of American Art, New York
City 209

Fig. 140. Preston Dickinson, *Quebec*, pastel, 20 x 28, sgd., 1926, courtesy of the Cincinnati Art Museum, Cincinnati, Ohio 210

Fig. 141. Charles Sheeler, *Connecticut Farm Buildings*, oil, 15¾ x 21½, sgd., 1941, courtesy of the Newark Museum, Newark, N.J. 212

Fig. 142. Charles Sheeler, *Classic Landscape*, oil, 24 x 31, sgd., 1931, courtesy of Mrs. Edsel B. Ford, Grosse Isle, Mich. 213

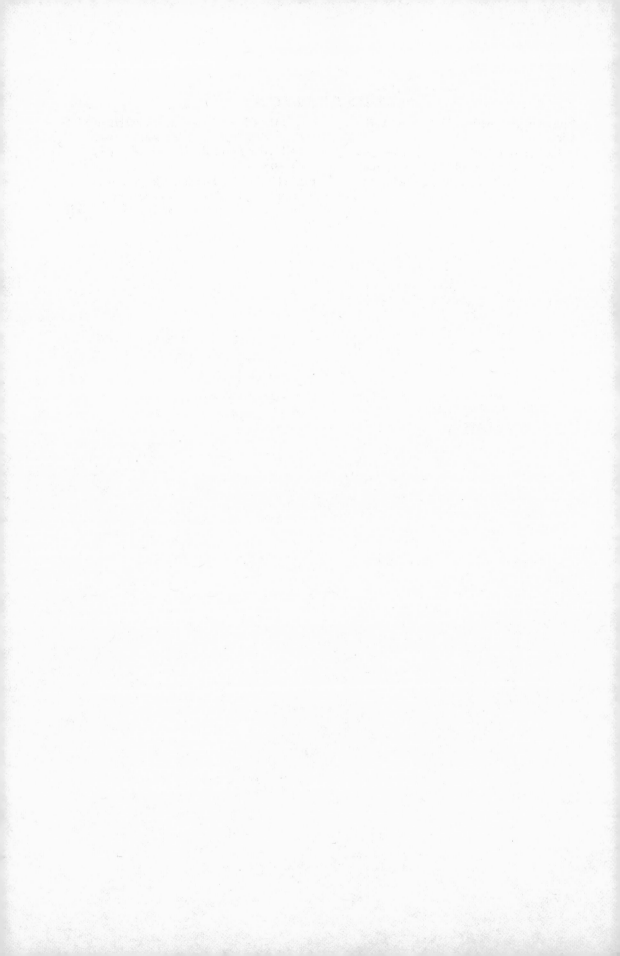

METHOD AND PURPOSE

SINCE America reached independence it has produced a wealth of landscape painting that by bulk alone, if for no other reason, would claim our attention. This attention, moreover, is well justified because no artistic production can be sustained on such a large scale without a genuine creative energy as its driving power.

The interest in our earlier landscape painters has grown steadily. Numerous forgotten painters have been rediscovered, and a whole stratum of art—the work of the primitives—has been collected and appreciated for the first time in the last twenty years. For these reasons it appears timely to discuss the material as far as it is now available, and to interpret it historically. This book will serve such a purpose without attempting to be complete. I have tried rather to select significant examples of the trends determining the evolution. Since these trends derive from European sources, the history of European landscape painting is outlined at the beginning of the book. This outline is presented with an eye to the subsequent development in America.

Few periods in the entire history of art have shown an unbroken evolution. More often than not, outside influences defer the development of a civilization and social factors prevent it from achieving the degree of homogeneity prerequisite to a uniform style. In a heterogeneous society the stylistic evolution is subdivided into different strata overlapping each other. In such cases a "strati-graphic" method of study ought to complement the study of the stylistic development. The latter study is concerned with the sequence of styles, while the stratigraphic method unearths the undercurrents that once were and sometime might become again the leading strata of a period. If this method promises valuable results in older and comparatively well-integrated civilizations, how much more is it qualified to shed light on the history of art in America; for America is heterogeneous in its very origin.

The fact that my approach to the problem is historical imposes a limitation in its scope. I excluded from the discussion those contributions of the recent past that are too close to us to be evaluated objectively. They are the province of the critic rather than of the historian. Although not all landscape painters are listed, American landscape painting is discussed here in its entire development. Since this is done for the first time, the contributions of individual artists frequently appear in a new light. Disregarding inevitable variations in judgment, the artistic merit or deficiency of a work of art of the past can be ascertained. It is the task of the art historian to re-evaluate periods of art hitherto not treated comprehensively. When a balance is drawn after the process of revision is accomplished, it appears overwhelmingly favorable to the American landscape. The gain of newly discovered values far outweighs the losses incurred through the partial eclipse of a few established painters.

Since the art form of the landscape is not strictly separated from the town-scape, from the seascape, and from genre painting, I have not restricted the pictures here discussed and reproduced to an inflexible definition.

As long as figures, buildings, and ships are subsidiary to the vital effect of a landscape, taken in its broadest sense, the picture has been considered suitable for the present book. I have also included paintings in which the artist has consciously employed architectural elements to replace elements of nature in order to capture visually a new man-made aspect of the earth.

Landscapes painted by American artists outside of the United States are included only when necessary for the understanding of the development of art in America, because as a geographic unit America determines the character of American landscape painting. With negligible exceptions, all landscapes painted by Americans in Europe belong more to the history of European than of American landscape painting, for very rarely has an American artist projected an American concept into a European motif.

This book addresses itself to a circle of readers wider than that of those professionally interested in the history of art, without relinquishing the claim to documentation. In order to avoid distraction all notes are assembled at the back of the book. Biographical data are limited to a minimum since this book is a history of ideas rather than a biographical account of a school of painters. Information about the owners, the sizes, and media of the pictures is given in a list of illustrations.

AMERICAN LANDSCAPE PAINTING

CHAPTER ONE

THE EUROPEAN HERITAGE

LANDSCAPE painting as an independent art form is a late comer among the art forms of the West.[1] The middle ages were far too concerned with the world beyond to pay much attention to the terrestrial world. The medieval artist made use of conventional abbreviations for nature handed to him by previous generations and sanctified by age—symbolic motifs, many of which can be traced back to non-Christian civilizations of the Near East. Gradually this symbolism gave way to observation of nature—a development in art that was paralleled in philosophy by the endeavor of St. Thomas Aquinas and his school to reconcile religious revelation with rational thinking. When Giotto in 1305, decorating the walls of the Arena Chapel in Padua, replaced the golden background of Byzantine art with a blue sky, he made the decisive step toward the creation of landscape painting. But it took more than a hundred years before Masaccio, in the Brancacci Chapel of Santa Maria Novella in Florence, painted the first convincing landscape space around his figures. Perspective—this significant achievement of early scientific thinking—had to be developed before landscape painting as the West knows it was possible; and it is no accident that this development took place chiefly in Florence, the center of humanism, as an integral part of the great movement that heralded modern art: the Renaissance. Renaissance art, however, did not immediately create pictures in which nature was reproduced for its own sake. The center of interest, unchallenged by any other subject, was man himself. For this reason nature was relegated to the role of a background for man and his activities. At the best it served to symbolize personality traits, as in Leonardo's *Mona Lisa* where the spell of the sitter is suggested by haunting mountain scenery with meandering rivers and paths.

At about the same time that Leonardo gave the landscape a new significance in his figure paintings, young Albrecht Dürer, coming from the North, painted water-color studies of Alpine landscapes which were possibly the first landscapes painted for their own sake. The masters of the "Danube Style" who were active in the Alpine regions of southern Germany and Austria produced a few pure landscape etchings in the sixteenth century and some paintings in which the landscape evidently was more important than the figures.

In the meantime another artistic development took place in the Low Countries and Burgundy which ultimately led to landscape painting more or less independently of the German and Italian approach: the evolution of calendar il-

lustration. From the medieval concept of the "Labors of the Months" grew a cycle of pictures representing traditional customs and activities. During the fifteenth century the landscape in these illustrations gradually became as important as, or even more important than the activities which make up the main theme of the pictures, such as sawing and harvesting, milking and hunting.

During this period a similar development took place in religious painting; Joachim Patinir (c. 1485–1524) painted elaborate landscapes around the Baptism of Christ and other Biblical themes. In Patinir's art the religious motif is so subordinated to the landscape that Dürer called him a landscape painter without qualification. Only Patinir's school, however, seems to have produced landscapes for their own sake.[2] The style of Patinir's landscapes is reminiscent of the landscape backgrounds of Leonardo da Vinci: one looks down on a wide-extending area with winding rivers and roads, rocks and castles (Fig. 1).

The Elder Pieter Brueghel (1525?–69) developed from calendar illustrations his magnificent paintings of the seasons in which the main theme is the interpretation of nature. For Brueghel, man does not mean the "measure of all things" as for the artists of the Italian Renaissance. His world is not finite. Mountains, woods, and rivers lead the eye to the horizon which is high up in the picture as in Patinir's paintings, and we feel that behind the horizon stretch endless mountains, forests, and rivers (Fig. 2).

The artists of the next generation singled out segments of Brueghel's immense world because of their pictorial values, and made of them pictures in their own right. Thus the landscape in the modern sense of the word originated. Pieter Brueghel's son Jan, called Velvet Brueghel (1568–1625), and Gillis von Coninxloo (1544–1607) were the most important figures in this development. Coninxloo's pictures showing the interiors of woods form the preliminary stage of a development that eventually was to lead to the romantic landscape. But this was as yet two hundred years away. Coninxloo, a Protestant, left the Flemish provinces of the Low Countries then under Spanish Catholic rule, in 1585 and settled in the German city of Frankenthal in the Rhineland, where he remained for ten years. His teachings were transmitted to Italy through Adam Elsheimer (1578–1610), a German, who resided in Rome and painted miniature-like landscapes in which a few figures are woven. These figures, however, do not play a more important role than to justify the preoccupation of the artist with nature in a society not yet accustomed to pure landscape.

The Flemish-born Paulus Brill, who practiced landscape painting in Rome, and his fellow countryman, Roeland Savery, who did the same in his homeland as well as in Germany, popularized landscape painting around 1600. During the 1630's when the new style of the Baroque had matured, Rubens raised landscape painting to a monumental art form imbued with the spirit of drama, thus fusing Italian grandeur with his native Flemish tradition.

Geographically almost a neighbor, but spiritually separated from Rubens as though by an abyss, Rembrandt, the Dutchman, projected into nature his deepest emotions. The etching with the three trees and, among his paintings, *The Windmill*, are "fragments of a great confession," chapters of an unwritten autobiography subtly veiled in the images of

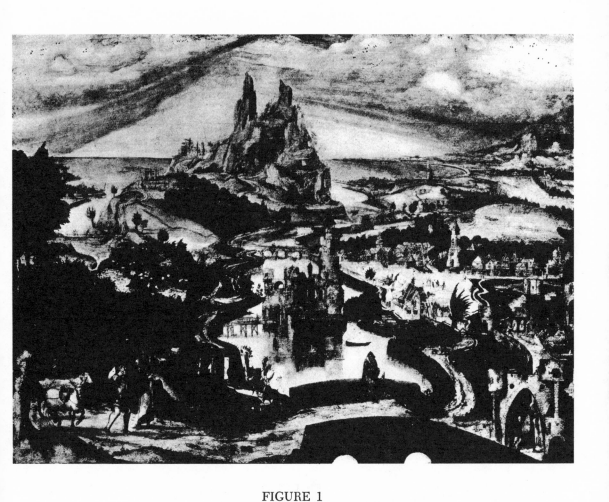

FIGURE 1
Cornelius Massys (?) or another follower of Patinir
Imaginary Landscape with the Arrival at Bethlehem
Metropolitan Museum of Art, New York City

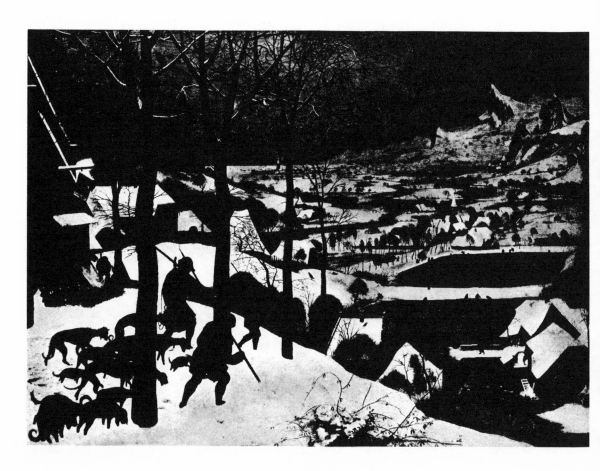

FIGURE 2
PIETER BRUEGHEL THE ELDER
Winter Landscape
Kunsthistorisches Museum, Vienna

an approaching storm and of a bleak nightfall. With Hercules Seghers, Jan van Goyen, and Rembrandt the "landscape of mood" was created as a new development of the Coninxloo-Elsheimer tradition around 1630. It reached its apogee in the hands of Jacob van Ruisdael (c. 1629–82) whose torrents, swamps, and graveyards are fraught with emotion (Fig. 3). The landscape of mood, this momentous contribution of the old Dutch masters, has many facets. The windswept plains under a cloudy sky in which Philip de Koninck contrived to express a feeling half serene, half sad; the peaceful groves and watermills among which Meindert Hobbema invites us to stroll leisurely; and the tranquil rivers of Albert Cuyp on which barges float calmly in the sunset while cattle graze on the shore form recurrent types. The restrained art of Jan Vermeer (1632–75) stood apart from the main current. His preoccupation with light problems corresponds to the development of optics by Dutch scientists of Vermeer's time and anticipates essential traits of impressionism.

The deep-rooted humanism of the Mediterranean world, it is true, still hesitated to accept the new gospel of landscape for the landscape's sake. Venice had approximated the landscape in the "poesies" of Giorgione and the bucolic scenes of the Bassanos in the sixteenth century, and the Bolognese master Guercino, who was born in the late sixteenth century, drew landscapes with impetuous pen strokes; but the first Italian landscape painter in the strict sense of the word was Salvator Rosa (1615–73). Brigands, hunters, and sailors, evidently inspired by Caravaggio who had opened the eyes of artists to the charms of low life, roam through a landscape depicting forests and crags, harbors guarded by crumbling towers, and bridges spanning restless mountain streams. Salvator's art was very popular during the seventeenth and eighteenth centuries, thanks to its Baroque bravura, which was then something new and exciting.

In contrast to the Italian-born Salvator Rosa, the artist guests who flocked to Rome from the north in ever-increasing numbers did not look for dens of robbers as motifs but for classic reminiscences. A nostalgic love for the Italian scene drew them over the Alps. Roman ruins became their favorite theme. Nicolas Poussin (1594–1665), the French master who settled in Rome, developed the "heroic landscape" as a background for his mythological and religious compositions—a type of landscape in which nature is interpreted as if it were monumental architecture (Fig. 4). Dark masses of trees form a kind of frame in the foreground, the so-called *repoussoir* that "pushes back" the rest of the picture. Middle and background are clearly distinguished as in the theater, and classic buildings as well as figures in classic garb are distributed in planes parallel to the picture plane so as to approximate the effect of a relief.

Gaspard Dughet (1613–75), whom his contemporaries called Poussin after the family name of his great brother-in-law Nicolas, applied the latter's teachings to the pure landscape. He was overshadowed by another Frenchman of genius, Claude Lorrain (1600–82), who like Poussin had moved to Rome and there created a more serene and intimate type of Italian landscape with ruins, that has been termed somewhat vaguely "ideal landscape." Claude favored columnal porches of temples as repoussoirs and the sea as background. The sun, boldly placed in the center of the sky, is reflected in the surface of slightly rippled water. A golden light fills the picture space. There

FIGURE 3

Jacob van Ruisdael

Forest Scene

National Gallery of Art, Washington, D.C., Widener Collection

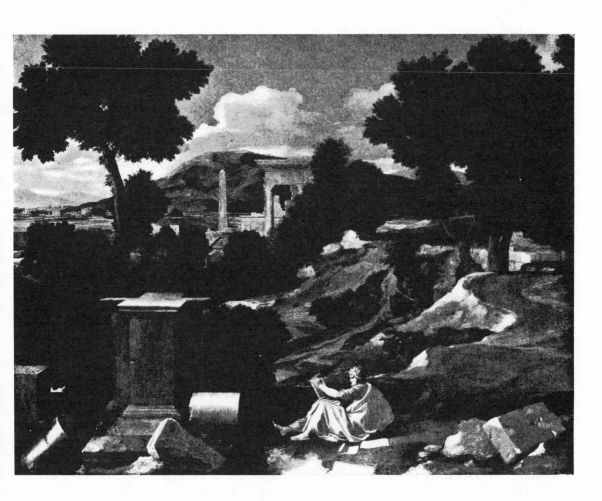

FIGURE 4
NICOLAS POUSSIN
St. John on Patmos
Art Institute of Chicago, Chicago, Ill.

is a magic spell in Claude's work that has survived all changes of taste.

Among the English landscape painters of the eighteenth century Richard Wilson (1714–82) carried on the tradition of Claude Lorrain in the quest of the "picturesque" that played so important a role in the aesthetics of the period.[3] Gainsborough, in the landscapes he liked to paint much more than the portraits which brought him fame, followed the lead of Ruisdael, and thus represented the northern tradition. But he too strove for the ideal of the "picturesque" as conceived by the literati. It was the time when the "grand tour" became an essential element in the education of the upper classes, and British nobility began to collect Italian and French paintings.

Addicts to the cult of the "picturesque" sported the so-called Claude glass on their travels, a plano-convex mirror of about four inches diameter, on a black foil, mounted like a pocketbook.[4] In this contraption a landscape appeared reduced somewhat in size, as in the view finder of a modern camera. Its tone was lowered as in a painting, and it also approximated the effect of a painting because it was seen in a frame.

During the reign of the "picturesque taste," ambitious squires began to remodel their country seats and to lay out what have since been called "English gardens" in contradistinction to the Italian or formal garden. The landscape designers who conceived of this innovation endeavored to create the "picturesque" effect of the then favored types of landscape painting by planned irregularity and artificial ruins.

With this influence on gardening, the Baroque tradition of landscape painting had reached a point in which it was no longer creative in its own right, but had

become popular enough to affect border regions, a process which can be observed with a certain regularity in the history of civilization when a movement grows old. The late years of the eighteenth century saw not only the triumphant march of the English garden through Europe but also another application of Baroque landscape painting: namely the panorama.[5] The Scottish painter Robert Barker took a patent for this invention in 1787 under the name of panorama. The word contains the Greek roots *pan,* all, and *horama,* sight. Hence panorama means an over-all view. Now the Baroque spectator had no desire to have an over-all view; this curiosity was reserved to the era of enlightenment which produced the *Grande Encyclopédie Française.*

Art in its traditional form had no answer for the desire to see an over-all view, a desire successfully met by Barker's invention. Robert Barker, after a trial show in Edinburgh, displayed his first panorama to the London public in the Haymarket in 1789. Barker's panorama and its later imitations, known also under the name of cycloramas, were circular buildings with a platform in the center. A kind of huge umbrella shielded the platform from the light that came from above and was concentrated on the wall. Between the platform and the painting was a gap. The visitor on the platform had a view in his make-believe world as unobstructed as the aeronaut from the gondola of the balloon. It is worth remembering that only four years before Barker invented the panorama the first passenger flight of the *Montgolfière,* a balloon filled with hot air, had taken place in Paris. It is tempting to link the invention of the panorama historically to the invention of the balloon, although this cannot be proved, for according to

tradition the idea was got from observations of light effects. The German theater painter A. Breysig published a theory of the panorama in 1798 in his treatise *Über die Basrelief-Perspektive* evidently based on his experience in stage decoration. Seen as a link in the history of art, the panorama was derived from two sources, landscape and theater painting. The illusionist technique of the Baroque was placed in the service of a thirst for factual information typical of the era of rationalism.

Barker's first panoramas were bird's-eye views of cities. Battle scenes and other historical events followed. The panorama in the Haymarket that was only 25 feet in diameter was superseded in 1793 by another in Leicester Square that had a diameter of 90 feet. The shell of this panorama still survives, but since the 1860's it has housed a Catholic church. Robert Barker's son Henry, a young painter trained at the Academy, did most of the artistic work on this. Barker's panorama was taken over later on by the painter Robert Burford.

At this point in the story America stepped in, in the person of the painter-inventor Robert Fulton (1765–1815), who adopted the idea, had it patented in France and erected a panorama on the south side of the Boulevard Montmartre in 1799.[6] The panorama became a popular sort of entertainment. Napoleon planned a series of battle panoramas on the Champs Elysées to popularize his victories, but his downfall prevented the execution of the plan. England and Germany erected panoramas in the first half of the nineteenth century, and other countries followed. The Franco-Prussian War of 1870 gave a fresh stimulus to the battle panorama. It introduced a new development: the space between the center of the building and the circular wall was covered with realistic stage properties: bushes, trees, rocks, and occasionally even with figures. These props and figures merged into the painted background and produced an effect that deceived the eye about the fact that it did not see the real thing. It was a triumph of illusionism. However, the panorama became obsolete when the moving picture, which was even more illusionistic, was introduced as visual entertainment.

At the time of the invention of the panorama the peep show, a gadget developed as early as the Renaissance, had a new vogue. Its primitive form, a box with a magnifying glass opposite a picture, was soon improved. A slanting mirror was placed between the lens and the picture; figures and miniature props were set in parallel tiers between the picture and the mirror—an arrangement which produced a *trompe l'oeil* effect the same as that achieved by painters bent on "deceiving the eye" in their quest for fidelity. Philip Loutherbourg, an Alsatian-born stage designer, invented a landscape show box in London about 1782 which he called Eidophusicon, combining the Greek words *eidos*, the eye, and *physis*, nature.[7] Its foreground was painted cork, its background consisted of transparent backdrops of glass which allowed changing light effects. Loutherbourg displayed views of famous cities and imaginary scenes such as *Pandemonium* from *Paradise Lost*.

At about the same time as the Eidophusicon and the circular panorama, another entertainment of a similar character was developed that eventually competed with the latter: the moving panorama. Its model probably was a contrivance popular in Venice and known as a *tableau mouvant*. It was a strip of paper

on which a procession of figures in land-scapes was painted. The strip passed before the eyes of the spectator when wound from one cylinder to another. The development from the tableau mouvant [8] to the moving panorama seems to have taken place in the theater where moving scenery became the vogue after 1800. In 1831 an improved form of the moving panorama was displayed by the architect C. F. Langhans and the painter-poet August Kopisch in Berlin under the name of the pleorama.[9] This gave the spectator the impression of seeing the shores of a river from a boat gliding on the water. In reality, of course, the spectator was at rest while a strip of painted canvas passed before his eyes. In a certain sense the landscape scroll of the Chinese, as far back as the middle ages, anticipated the idea of the moving panorama. Winding the scroll from one wooden roller to an-other, the spectator follows the course of a river in a continuous representation.

The panorama employed brilliant technicians among the painters and oc-casionally even great artists such as the German architect Friedrich Schinkel [10] and the English water-color painter Thomas Girtin. But if a true artist worked on a panorama it was under the pressure of economic circumstances. The pano-rama did not influence landscape paint-ing in Europe to any tangible extent.

The landscape with ruins lived on in the work of Hubert Robert (1733–1808) whose decorative compositions veiled in a bluish haze conjure up memories of Italian villas. In Francesco Guardi's (1712–93) Venetian *veduti* the pictur-esque prevailed for the last time. Before him, Canaletto (1697–1768) had turned already toward objectivity—depicting the same motifs with ruler-drawn straight lines, clear and sober.

During the reign of classicism, with its cult of clarity, the "picturesque" was rel-egated to a latent undercurrent. Not until romanticism asserted itself did landscape painting resume the spirit of the picturesque. In England John Con-stable (1776–1837) and William Turner (1775–1851) each in his own way boldly interpreted nature as a color phenome-non (Figs. 5 and 6). In France Théodore Rousseau, Camille Corot, and the other members of the Barbizon school devel-oped the *paysage intime* with its subtle gradations of glowing tones (Figs. 7 and 8). Both the English and the French masters of the romantic landscape were, above all, painters. Their technique was that of the free and suggestive brush stroke. In Germany a romantic resur-gence of folklore and medievalism took place almost simultaneously with the culmination of classicism in literature and architecture—a complex situation which produced the gothicized land-scape of Caspar David Friedrich (1774–1840) (Fig. 9), the nature symbolism of Philipp Otto Runge (1777–1818), and Joseph Anton Koch's (1768–1834) min-iature version of the heroic landscape. The period of German culture between the Napoleonic wars and the Revolution of 1848, called Biedermeier after the title of an obscure book of sentimental poetry in vogue in the 1840's, produced numer-ous landscapes in which emotion ruled supreme. Although they were painted with a sober attention to detail, romanti-cism survived as a poetical overtone in the Alpine landscapes of the Austrian Fer-dinand Georg Waldmüller who lived from 1793 to 1865 (Fig. 10). After Ger-man romanticism had passed its peak its doctrines were popularized by the emi-nently successful Art Academy of Düs-seldorf around 1850.

FIGURE 5

JOHN CONSTABLE

Wivenhoe Park

National Gallery of Art, Washington, D.C., Widener Collection

FIGURE 6
WILLIAM TURNER
The Junction of the Thames and the Medway
National Gallery of Art, Washington, D.C., Widener Collection

FIGURE 7
THÉODORE ROUSSEAU
Edge of the Wood
Metropolitan Museum of Art, New York City

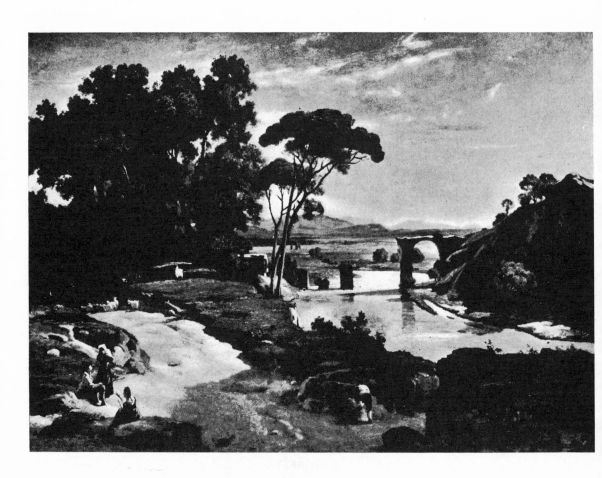

FIGURE 8

JEAN-BAPTISTE CAMILLE COROT

The Bridge of Narni

National Gallery of Canada, Ottawa

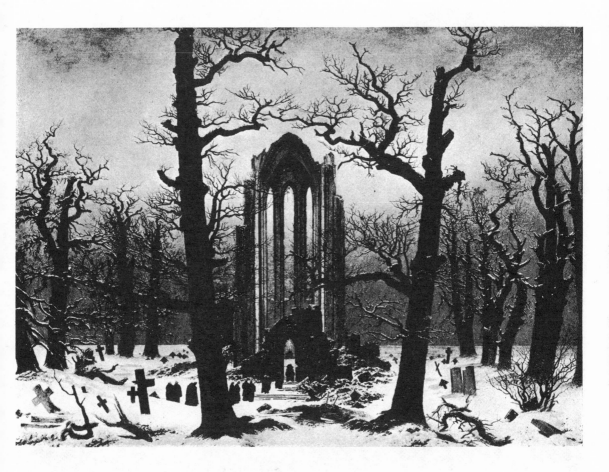

FIGURE 9
CASPAR DAVID FRIEDRICH
A Monastic Cemetery in Snow
National Gallery, Berlin

FIGURE 10

FERDINAND GEORG WALDMÜLLER

The Hochkelter Seen from Wimbish Valley

Gallery of Prince Lichtenstein, Vienna

The center of gravity in the development of landscape painting in Europe, however, was Paris. Here Gustave Courbet (1819–77), the intrepid pioneer of naturalism, set the stage for a revision of all traditional values, broadening the approach of the masters of Barbizon until a new form of landscape painting emerged: unsentimental, firm, and direct (Fig. 11). The tonal scale of the Barbizon masters, however, was not abandoned—only enriched. It was not until Edouard Manet (1833–83) and his circle, stimulated by the optical research of Chevreul, set out to paint nature in plein-air, that the spell of the brown color scale was broken. Pure color replaced warm tonality. Blue shadows appeared. In brief, impressionism was born. This happened in Paris during the 'sixties. The new doctrine passed through the usual stages of hostility, triumph, and popularization. In the 'eighties it began to spend its creative energies, and gradually Claude Monet (1840–1926), the banner bearer of pure impressionism, lost himself in an empty fireworks of color—a fate that previously had befallen his romantic predecessor and model, Turner, the English master of the phantasmagoric seascape (Fig. 12).

The urge for a new picture architecture could not fail to develop. Van Gogh (1853–90) answered it by superimposing a subjective linear and color system on the visible world; Gauguin (1848–1903) by reducing nature to a decorative pattern with symbolic connotations, the elements of which he adopted from primitive civilizations. George Seurat (1859–91) looked in vain for salvation in the pseudoscientific technique of pointillism. It was Cézanne (1839–1906) who first succeeded in converting the confusing diversity of the visual world into a stable structure of formalized color elements without sacrificing the organic character of nature (Fig. 13).

Cézanne's vast heritage could not be mastered by one person alone. It was split among the fauves who under the leadership of Matisse went to the extreme in suppressing space for the sake of color, and under the cubists, Picasso and Braque, who made color subservient to an abstract interpretation of space.

In the meantime central and northern Europe experienced a revival of their creative energies in painting. Edvard Munch in Norway developed from Van Gogh and Gauguin the style of subjective distortion which culminated in the fiery landscapes of the Austrian Oskar Kokoschka, while Germany's painters of the *Brücke* circle arrived at a harsher and more austere but not much less evocative language—expressionism. Another group of Germans turned to a "magic" interpretation of reality, which under the slogan "new objectivity" approached the heightened realism of the style of trompe l'oeil. Together with the similar Italian movement of *valori plastici*, this soon flowed into the stream of surrealism: an attempt to capture the symbol-charged dream world of the unconscious—a trend that by its very nature transformed landscape into imaginary scenery.

Other unconscious energies were released in the work of the "Douanier," Henri Rousseau (1844–1910), the greatest of the "naïve" artists in France (Fig. 14). His ingenuous style, once it was recognized as authentic, opened the eyes of the modern world to works of untrained artists and gifted amateurs in which the nonrealistic art of the middle ages survived as modern primitive painting.

FIGURE 11

GUSTAVE COURBET

The Source of the Loire

Wildenstein & Co., Inc., New York City

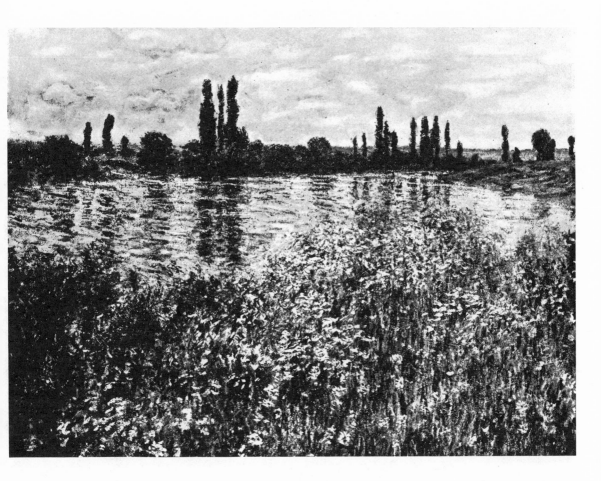

FIGURE 12

CLAUDE MONET

Banks of the Seine, Vetheuil

National Gallery of Art, Washington, D.C., Chester Dale Collection (loan)

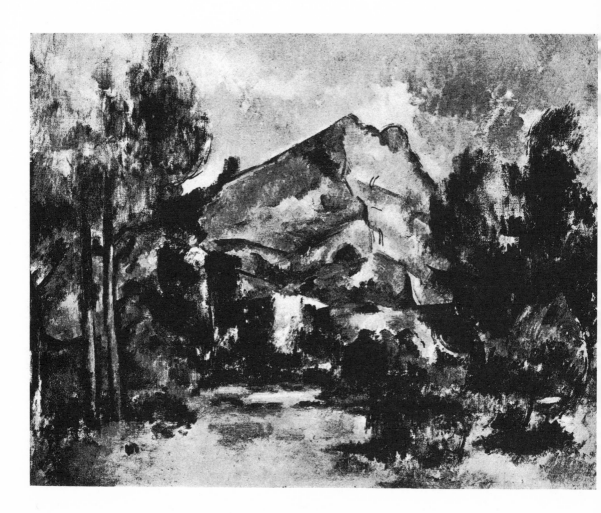

FIGURE 13
PAUL CÉZANNE
Montagne Ste. Victoire
Bignou Gallery, New York City

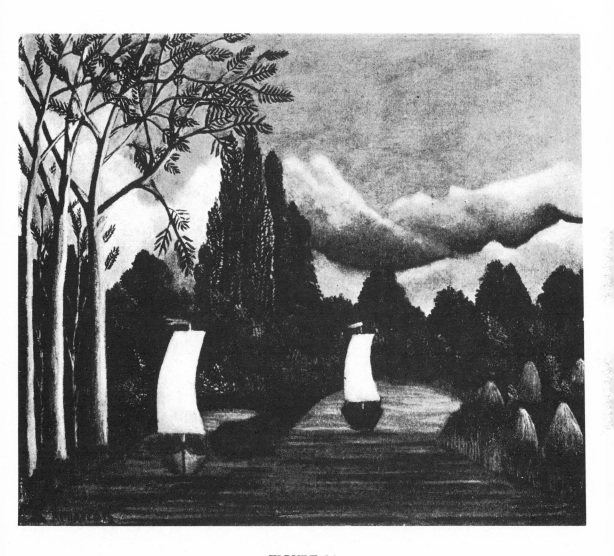

FIGURE 14
HENRI ROUSSEAU
Borders of the Oise River
Smith College Museum of Art, Northampton, Mass.

CHAPTER TWO

SENTIMENT OF NATURE

MEN who wrest a livelihood from the soil do not look at nature with the contemplative detachment indispensable for its aesthetic enjoyment. For this reason landscape painting did not develop in America until her people had mastered the virginal and tough continent. When the Americans felt secure in their country they became interested in its appearance. It is true, this interest did not immediately express itself in pure painting; it was strongly tinged at first with the demand for what we would call today documentation—a quality which American art lost slowly, and scarcely has relinquished entirely. It would be unfair to condemn this tendency, for it is the logical result of the fact that the Americans lived in a new world. They were justified in being curious about it, and this curiosity, in fact, is part and parcel of the artistic attitude of America, just as tradition is important in the artistic attitude of the old world, where the scene is familiar to people for untold generations.

When America was ready to succeed to the inheritance of European landscape painting, romanticism was in the ascendance in Europe. The first professional English landscape painters who settled in America,[1] men of limited capacities, practiced a version of the picturesque then in vogue in the old country: a last diluted infusion of the old Italianate "grand style." There is a painting by an American, Ralph Earl[2] (1751–1801), that illustrates this fact most convincingly (Fig. 15). This is not a landscape in the strict sense of the word but a portrait with a landscape seen through a window. Earl, incidentally, painted a few pure landscapes as early as 1800, but they are hesitating steps in a new direction that was not his line. He was a born portrait painter for all his austerity and naïveté. Colonel Taylor, the subject of the portrait referred to, evidently was a man of culture who dabbled in painting like the English noblemen of his period. In Earl's painting Colonel Taylor poses as an amateur artist, the crayon in his right hand, the painter's stick (seemingly an elegant walking stick adapted to use in the studio) dangling casually from his left. In front of him, propped against a support that is not visible, is his drawing board on which a half-finished study of the landscape seen through the window is displayed. He lays on the contours and shadows with black and heightens the lights with white. The landscape itself which Earl shows through the window frame is a typical English picture, a lovely valley traversed by a peaceful rivulet and fringed with bushes and trees. A hamlet is in the background. The evening sky is partly lighted by the afterglow of the sun, which has obviously just set.

FIGURE 15
RALPH EARL
Portrait of Colonel William N. Taylor
Albright Art Gallery, Buffalo, N.Y.

This bit of mild picturesqueness seems inspired by Earl's English predecessor Richard Wilson. We can take it for granted that the proud maker of the chiaroscuro sketch knew Burke's then famous *Inquiry into the Origin of Our Ideas of the Sublime and the Beautiful* [3] which, since its appearance in 1756, had conditioned the Anglo-Saxon world for the wave of romanticism which later on was to sweep the earth.

The American colonies, apart from sermons, political speeches, folk ballads, and other unpretentious productions, had no literature of their own. Landscape painting was in a similarly humble state of development. There were wall paintings and overmantles [4] which occasionally showed landscapes, but they are mainly decorative and thus outside the scope of this discussion. The roots of the American landscape proper were the topographical drawing, water color, and print.[5] Views of harbors count among the earliest American landscapes,[6] as is shown by a somewhat clumsy picture in the New York Historical Society (Fig. 16). This painting stems from the middle of the eighteenth century and recalls Dutch engravings which, without any doubt, were well known in New York. The Dutch models, however, were not the only influences which inspired the topographical landscape in America. The demand for authentic representations of points of interest was general and stimulated the development of the topographical engraving in the second half of the eighteenth and the beginning of the nineteenth century to a degree of perfection which matched that of the average European production and did not differ from it much in character. The harbor view remained the most popular subject matter, in keeping with the fact that at that time the East Coast was almost synonymous with American civilization. Not far to the west began the wilderness. What the buyer of an engraving wanted was fidelity, and the topographical engraving gave it to him. The style of this type of engraving was sober and clear, and this is true also of the style of the painters of views, whose works like those of Thomas Birch [7] were derived from these topographical engravings. Birch was born in England in 1779, the son of an engraver of views, and came with his father to America in 1794. He began his career as a painter of city views more or less in the manner of his father; an example is his view of Philadelphia in the Historical Society of Pennsylvania (Fig. 17). It is dated 1800. The tradition lasted into the second quarter of the nineteenth century but gradually its austerity softened. This austerity, it should be remembered, was part of the aesthetic tenets of classicism, the period style that controlled the art of the western world at the turn of the century. In his later life—he lived until 1851—Birch painted seascapes of a decidedly dramatic character, such as the *Shipwreck* of 1829 (Fig. 18). He then used a much richer inventory of tones and blended them subtly rather than clinging to the flat, silhouetted, and static mode of expression prevalent in his youth. Birch's evolution echoed the evolution from the glassy seascape of the eighteenth-century French painter, Joseph Vernet, whom he admired, to the atmospheric seascape of Turner—a product of romanticism,[8] the first European literary and artistic movement to find a creative echo in America after its independence.

The romantic poet as well as the romantic painter was in search of the mysterious, of the terrific, of the strange in history and nature. America offered

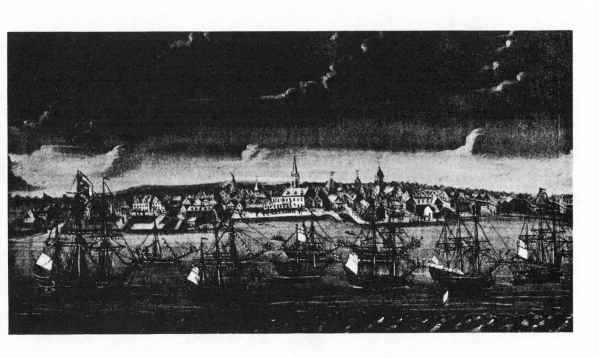

FIGURE 16
Southeast Prospect of the City of New York
New York Historical Society, New York City

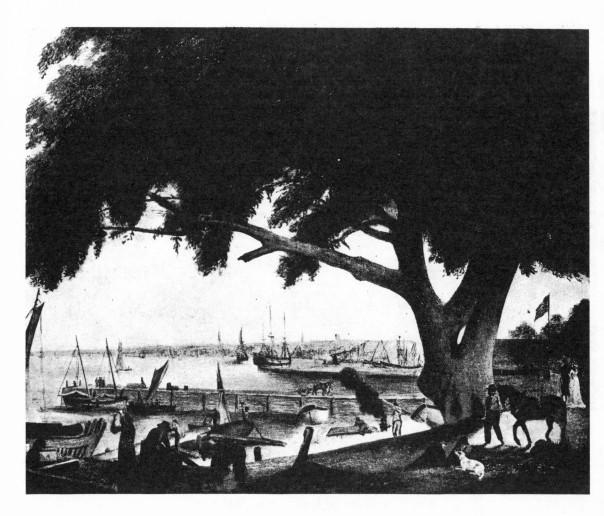

FIGURE 17

THOMAS BIRCH

The City of Philadelphia from the Treaty Elm

Historical Society of Pennsylvania, Philadelphia, Pa.

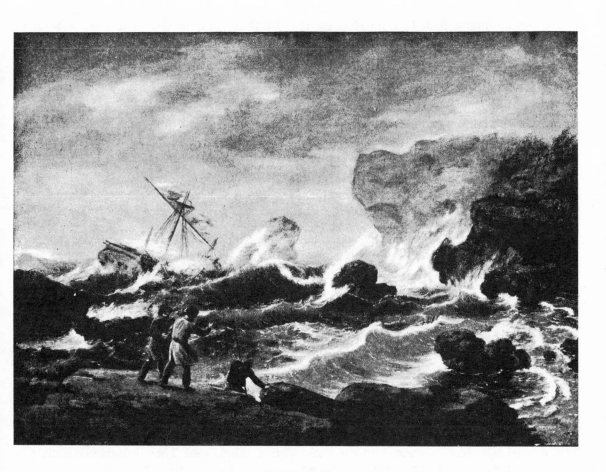

FIGURE 18
THOMAS BIRCH
Shipwreck
Brooklyn Museum, Brooklyn, N.Y.

unexplored rivers, and gigantic, often strangely shaped mountains; moreover, the warfare between the colonist and the Indian was living history. Was not the Indian himself the true image of the "noble savage" with whom the forefather of romanticism, Jean Jacques Rousseau, populated the primeval state of his mythical society? The American Revolution did not sever cultural relations with Europe at all. On the contrary, by gaining independence, the nation grew out of its colonial provincialism. Dormant intellectual energies were released, and instead of living passively on intellectual imports, America selected what suited her and assimilated it. The selection was comprehensive: it covered French rationalism with its concomitant, classicist architecture, and added to it the romantic literature of England—followed somewhat later by the German philosophy of idealism. It is true, American portrait painting and architecture in colonial times had reached a very high standard, but the portraits and buildings, delightful as they are, remain in the English orbit. They are modifications of types developed in the mother country, except for some works of genuine primitive flavor.

Things changed after 1800. Artists appeared who were receptive to the creative ideas of their time without being limited to one school, and a cosmopolitan viewpoint was accepted without question as the proper American attitude. The result was a cultural life which, although it was limited to a comparatively small society and could not boast of artists of the stature of the great Europeans, did not lag stylistically behind the European development. American artists who visited Europe after the Revolution were accepted heartily. The western world, including America, was considered as a unified "culture circle."

The first American artist of importance who represented the new American cosmopolitanism was Washington Allston.[9] Born in 1779, he graduated from Harvard in 1800, and in the next year left for Europe. London, Paris, and Rome were the main centers of his wandering years. Romanticism seems to have been the most natural artistic language to him, and his early paintings show the influence of Turner.

It is important for the understanding of Allston to reconstruct the intellectual and artistic atmosphere of Rome in the beginning of the nineteenth century—a Rome that still was far from being the modern metropolis which has encroached upon the Roman ruins to such a degree that they look like exhibits in an open-air museum. It was still a picturesque array of ivy-clad stone arches, of crumbling laurel-covered walls, of pine groves, medieval churches, and Renaissance palaces, with a population in colorful and arresting costumes. Shepherds let their flocks graze between classic columns, and Roman women, returning from the fountain, carried their water jars on their heads. Artists and poets from all corners of the world congregated in this unique spot. They discussed painting and verses in the shadow of Michelangelo and Raphael. The world, seen from a studio in Rome, appeared deeper, more brilliant and meaningful than at home, more "magic" as the artists of today would call it. Turner himself, the much-admired pioneer of the romantic landscape in England, took deep draughts from the stimulating potion of the Roman circle. It must have been a revelation, an overwhelming experience for Allston. This gifted young man had

eagerly absorbed the best available classic education at home and later on the aesthetic culture of England, in the studio of Benjamin West, his successful American-born teacher. Now he developed a romantic sensibility.

Rome brought Allston in contact with Coleridge,[10] Washington Irving, and Fenimore Cooper, not to speak of the other members of the international group assembled at the famed Café Greco which comprised Shelley, Keats, Hans Christian Andersen, and Thorwaldsen. Here Allston also became acquainted with the brothers Humboldt, of whom one was the Prussian ambassador in Rome and the other famous as an explorer of South America. Madame de Staël, the French writer who discovered Goethe, Schiller, and the German idealistic movement for the outside world, also belonged to Allston's acquaintances.

In the last two years of his sojourn in Rome another young American artist of promise, John Vanderlyn, joined him. Vanderlyn was three years younger than Allston. After a preliminary training at home by Gilbert Stuart, he went as early as 1796 to study in Paris—an unusual step in his time—and with the exception of the period from 1801 to 1803, he remained in Europe. In his Roman days he stayed at a house once occupied by Salvator Rosa, and this choice was by no means without significance. The young American felt attracted to the painter of dramatized wilderness whom the connoisseurs of the eighteenth century praised for his "sublimity." He might have felt himself a true follower of Salvator Rosa when in 1802—the first artist to do so—he painted Niagara Falls, the "scenic wonder" that embodied the spirit of romanticism in all its grandeur.

The heavy freight of ideas which All-

ston took home from Rome was to prove in the long run a burden that stifled his productivity. The second half of his long life was spoiled by the obsession of painting a composition in the "grand manner" of Michelangelo using the theme of *Belshazzar's Feast.* Nothing could be more romantic than the biblical story of the Assyrian king to whom the hand of God announced his impending doom by writing the fatal message on the wall of his palace. The remoteness of the subject matter and the demand it made on the professional proficiency of the painter, however, exceeded his imaginative power and his training. Even if he had been able to overcome all these limitations, New England simply was not the soil in which a work of this character could easily grow.

It was not pure accident that Allston's best work was done in the field of landscape. Here he could apply his newly won romantic sensibility to the full without missing the stimuli of the European studio, for the intellectual romanticism he had acquired was bolstered by the innate romanticism of American nature. Allston's landscape, however, is not American in the topographical sense of the word. His landscape painting is a purely imaginative art. In 1804 he ushered in the development of American landscape painting with two of its most impressive works: *The Rising of a Thunderstorm at Sea* and the *Deluge.* The latter, an unforgettable "arrangement in black" as Whistler would have called it, was a wildly romantic vision of gloom with bodies, flotsam, and serpents floating in the bleakness of the watery desert. The first is now in the Boston Museum of Fine Arts, the second in the Metropolitan Museum of New York.

Ten years after his return to America

Allston produced his masterpiece, *Elijah Fed by the Ravens* (Fig. 19), now in the Boston Museum. Here the spectacular characteristics of his earlier period are sublimated in a truly poetical imagery in which reminiscences of Salvator Rosa and Ruisdael (the Ruisdaelesque barren tree!) have been absorbed. The *Moonlit Landscape* of 1819 (Fig. 20), also in Boston, recalls Claude Lorrain, and occasionally in his later life reminiscences from the Italian sojourn inspired a nostalgic painting with Roman ruins, pine trees, and Italian youths serenading rustic girls—but gradually the creative power of the landscape painter faded.

The impression, however, made by his works and his personality on his compatriots was deep and lasting. The younger generation applied his teachings, with more or less high aspiration. Their work ranges all the way from the mere addition of romantic sensibility in a topographical landscape to the interpretation of nature in terms of mysticism and allegory. Mysticism and allegory were the earmarks of the German school of romantic painters in contradistinction to the French and English schools. A group of German romantics, the Nazarenes, settled in Rome around 1810 and took their inspiration from Catholicism. This colony in Rome was in contact with Anglo-Saxon artists there, both of English and American origin, but this was not enough to explain the undeniable similarity of American and German painters during the early nineteenth century. It probably was due more to the influence of German literature on the intellectual atmosphere in America, which in turn influenced its art. From the 'thirties on, the influence of German philosophy made itself felt clearly in Emerson's transcendentalist circle at Concord. Margaret Fuller's art criticisms,

including an essay on Washington Allston, strikingly recall the style and the ideology of Ludwig Tieck and other German writers of the romantic era.

As early as 1822 Washington Irving had moved in the literary circles of Dresden [11] and met there the archromantic novelist Jean Paul. No less a painter than Caspar David Friedrich was working in Dresden at this time. Intellectual currents often take devious directions, but their latent energies are ready to manifest themselves when they meet with a kindred attitude—and the awe and charm which the untamed nature of his country held for the American made him responsive to the brooding, metaphysical German *Naturphilosophie,* however indirectly it may have reached him. [12]

Allston's pupil Samuel Finley Morse of telegraphic fame traveled in Italy and there painted the *Chapel of the Virgin at Subiaco,* [13] a picture that one could almost take for a German Nazarene. Back in America he dreamed of a fanciful mountain landscape with classic buildings around New York University—then a neo-Gothic, and thus strictly romantic edifice (Fig. 21). A glowing sunset transfigures the scene of his dream. It is well known that the dream was a favorite artistic device of the romanticists. Evidently Morse's dream imagery was inspired by the fact that he had just been made the first professor of art at an American university, namely that of New York, when he painted the picture in 1836. This strange little picture fuses the Gothicized landscape of the German romantic type with the ideal landscape of Claude Lorrain.

In his *View from Apple Hill, Cooperstown, New York* (1828–29), Morse gives a detailed view of the Susquehanna River, the romantic element of which is less ob-

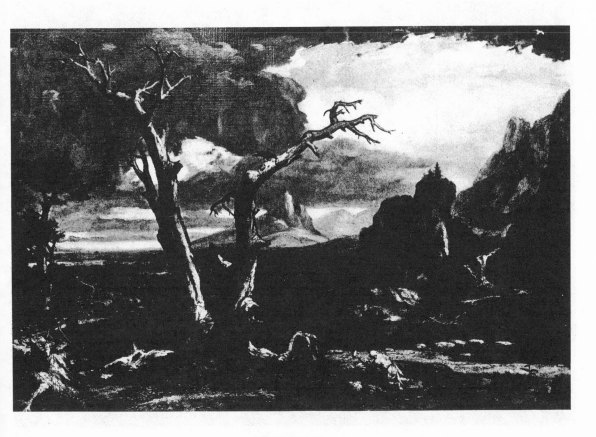

FIGURE 19

Washington Allston

Elijah Fed by the Ravens

Museum of Fine Arts, Boston, Mass.

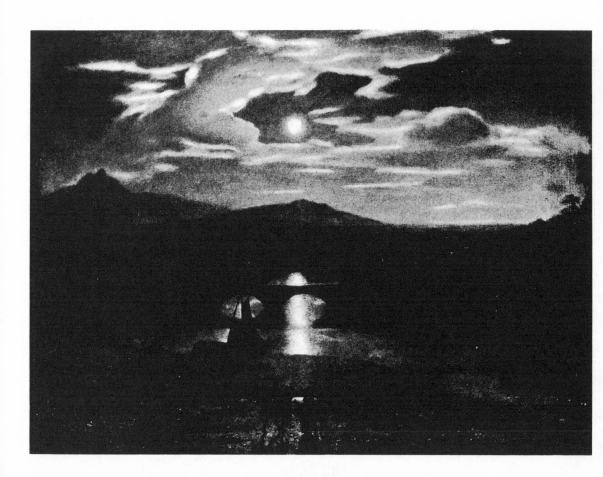

FIGURE 20

WASHINGTON ALLSTON

Moonlit Landscape

Museum of Fine Arts, Boston, Mass.

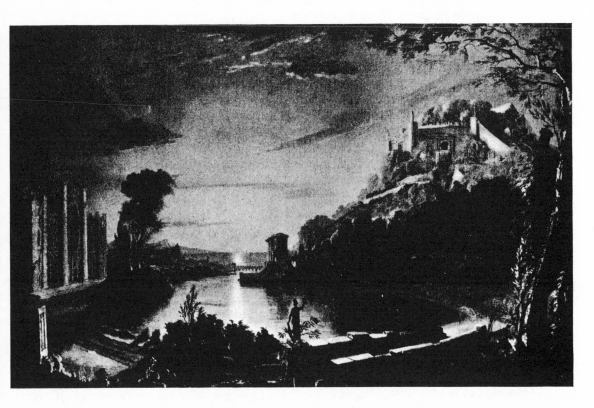

FIGURE 21

Allegorical Landscape

New York Historical Society, New York City

vious but is nevertheless there (Fig. 22). Two girls dressed in the slightly operatic fashion of their period occupy the center of the foreground. One of them faces the spectator, and thus establishes an emotional contact between him and the content of the picture. The other turns her back to the public and seems engrossed in the view, thus leading the eye into the depth of the space and conveying subtly the feeling of romantic abandonment to nature. This device had been used since the beginning of the century by Caspar David Friedrich in Germany and proved most suggestive as an expression of the romantic philosophy of nature which was essentially pantheistic.

It is not by accident that William Cullen Bryant, America's first and leading romantic poet, in his most vigorous creative period—the 'twenties—showed marked pantheistic leanings. "In his early romantic poems of nature," writes Tremaine McDowell,[14] "he weighed the possibility that the universe might be an emanation of God. The wind was his breath; the stars became 'his visible smile'; and the barky trunks, 'the fresh moist ground' were all instinct with him. And when Bryant characterized a delicate forest flower as 'an emanation of the dwelling life,' he fell for an instant into Pantheism." Bryant was very receptive to the phenomena of nature. An inveterate walker, he recorded even the smallest happenings in wood and meadow. Take his "Summer Wind" of 1824 as an example:

. . . All is silent, save the faint
And interrupted murmur of the bee,
Settling on the sick flowers, and then again
Instantly on the wing. The plants around
Feel the too potent fervors: the tall maize
Rolls up its long green leaves; the clover
droops
Its tender foliage and declines its blooms.

And when, after an equally minute and sensitive description of the calm of a sultry summer day, the poet introduces the wind which is to transform the tranquil scene, he does it by addressing it as a being, animated and responsive to human appeal:

. . . Why so slow,
Gentle and voluble spirit of the air?
Oh, come and breathe upon the fainting
earth
Coolness and life! Is it that in his caves
He hears me? . . .
. . . He is come,
Shaking a shower of blossoms from the
shrubs,
And bearing on their fragrance: and he
brings
Music of birds, and rustling of young
boughs,
And sound of swaying branches, and the
voice
Of distant waterfalls.

Bryant's sentiment of nature was eminently suited to stimulate a landscape painter and, in fact, the first generation of American landscape painters found him a source of inspiration and a faithful supporter of their endeavors. When in the familiar introduction of *Thanatopsis* he conceived of nature as a mirror of the soul, he outlined the theory of the landscape of mood, that gift of the seventeenth century. The landscape of mood had survived in Gainsborough during the eighteenth century, though as an undercurrent only, and rose to prominence again in the beginning of the nineteenth century, the heyday of romanticism.

The training ground for America's first authentic school of landscape painters was the Hudson River Valley. The waterways [15] were the most important traffic arteries in a vast continent, the road sys-

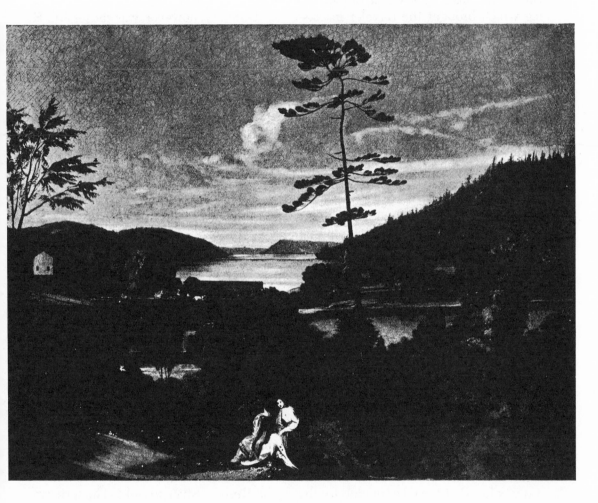

FIGURE 22

<small>SAMUEL FINLEY BREESE MORSE</small>

View from Apple Hill, Cooperstown, N.Y.

Mr. Stephen C. Clark, New York City

tem of which was yet to be developed. The opening of canals, among which the Erie in 1825 was notable, added new occasions for this leisurely type of journeying which brought the traveler in close contact with nature. Some of the skippers, we are told, carried organs on board and on clear evenings the passengers enjoyed music and moonlight as the boat slipped through a rugged gorge—a truly romantic experience in an America which was so often derided for its prosaic style of life. No less a traveler than Dickens testified to the charm of his trips on America's canal boats.

Of all American rivers the Hudson was the first and most important traffic artery before the opening of the Mississippi for navigation. The scenic beauty of its shores impressed itself on the early travelers, and thus a demand developed for adequate pictorial representation of the Hudson River Valley. An Irish-born landscape painter, William G. Wall (1792–1885), published, about 1824, a portfolio [16] containing twenty views of the Hudson River in aquatint. This portfolio was a great success. The prints, colored in soft broken tints among which bluish tones were predominant, combined topographical accuracy with an almost tender feeling for the landscape. This tenderness is even more obvious in the water colors that served as models for the etcher (Fig. 23).

Thomas Doughty was the oldest of the landscape painters who explored the pictorial charms of the Hudson River Valley without adopting the limitations which the topographical view imposed. Born in Philadelphia in 1793, Doughty began his adult life as a businessman but in 1820 abandoned his profession in favor of landscape painting—an audacious undertaking at a time when the market for landscapes was restricted more or less to an accurate representation of country seats commissioned by their affluent owners.

Doughty, however, was successful. He came at the right moment. The public had been prepared by the engraved views for the appreciation of landscape. The romantic writers popularized American scenery by their descriptions. Doughty himself exhibited paintings illustrating James Fenimore Cooper's *Pioneers*. Washington Irving's quaint Hudson stories were interpreted by the gifted narrative painter John Quidor in pictures in which the landscape, though not the main thing, played a not inconsiderable role. The intense pride in their country which was a common and sometimes noisily expressed characteristic of the Americans of this generation manifested itself in the best minds as aesthetic enthusiasm for American nature and its artistic interpretation. An harmonious relationship between the artist and his public developed that lasted for several decades—roughly speaking, until the time of the Civil War.

Doughty did not restrict himself to the Hudson River Valley in the selection of motifs, and he was not even the first to paint there, but his name is firmly linked with the origin and the development of the Hudson River school.[17] The term was coined by a critic in the *New York Tribune* to characterize this group of painters as presumptuous provincials. Gradually, however, the derogatory nickname became the generally accepted designation for the leading movement in American landscape painting during the middle of the nineteenth century. A similar thing happened in France with the term "impressionism" which was first used by a newspaperman as an abusive

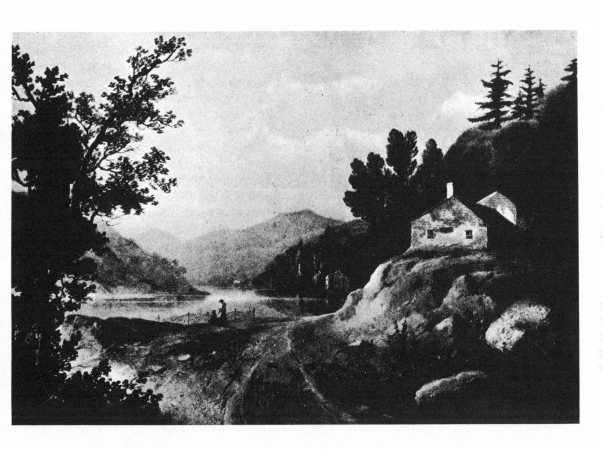

FIGURE 23
WILLIAM G. WALL
View near Fishkill, N.Y.
New York Historical Society, New York City

word. The range of Doughty's expression was limited. He was self-taught but not naïve. Although few European originals of old masters and contemporary painters were then in America, enough prints were accessible to make a painter, especially in a cultural center as varied as Philadelphia, familiar with the style of outstanding foreign artists. In the conventional compositions of Doughty, with their repoussoirs and groups of trees forming naturally grown monuments, the ideal landscape of Claude and Gaspard Poussin survives, however much diluted (Fig. 24). Doughty's technique is summary. He glosses over the more vigorous characteristics of nature in favor of a "genteel," feminine charm. His was a parlor romanticism. He painted a somewhat stage-like lake enclosed by mountains, with a tiny figure seen from the back which seems to view the landscape with awe, and he called the composition *In Nature's Wonderland.* In his later years he must have studied Ruisdael, for in 1846 he painted a landscape with a Roman bridge and ruins which is a copy of one of the great Dutch master's pictures in the Louvre.[18] This landscape is now in the Brooklyn Museum. Although lauded at first, Doughty outlived his early success; and he died, disillusioned and poor, in 1856, long before a new generation looked at him again with sympathetic eyes.

The step from a summarily grasped and traditionally treated landscape to an authentic study of a given locality was made by Asher B. Durand.[19] Durand was born of Huguenot stock in 1796. The son of a painter, he was trained as an engraver, but as early as 1817 attended classes at the American Academy of Arts, and gradually devoted more and more time to painting until he gave up engraving in 1839 to become a professional portrait and landscape painter. A wealthy merchant in New York, Luman Reed, had encouraged him in his development as a painter. Reed was the first collector in America who patronized contemporary American art on a large scale. It was a severe loss for the young painters when he died in 1836, but evidently his example bore fruit. Other men of means and discriminating taste took an interest in the development of American art. Durand found a new patron in Reed's younger partner, Jonathan Sturges, and, although he painted landscapes in preference to the more highly valued fields of the portrait and genre, he was made President of the National Academy of Design in 1845, which in the twenty years since it was founded had developed into the central agency of American art life. Durand held this office until 1861.

In his middle years Durand traveled in Europe, visited London and Paris and stayed in Rome for a winter. His reaction to Europe was in keeping with the romantic pattern: he was enthusiastic over Rembrandt, Rubens, Murillo, and Van Dyck, and, with qualifications, over Claude Lorrain and Salvator Rosa, was disgusted with Jacques-Louis David, the classicist, and his school, and was most impressed by the "picturesque" nature of the Rhine Valley and the Swiss Alps.

Durand's pictures, like those of his Swiss contemporary Alexander Calame, are reminiscent of Ruisdael: rugged trees with knotty branches form the wings of a prospect enlivened by a cascade; sunlight breaks though the green network of foliage and plays on mossy rocks. Rustic people are distributed in the picture space so as to emphasize its depth, but they are not emotional focal

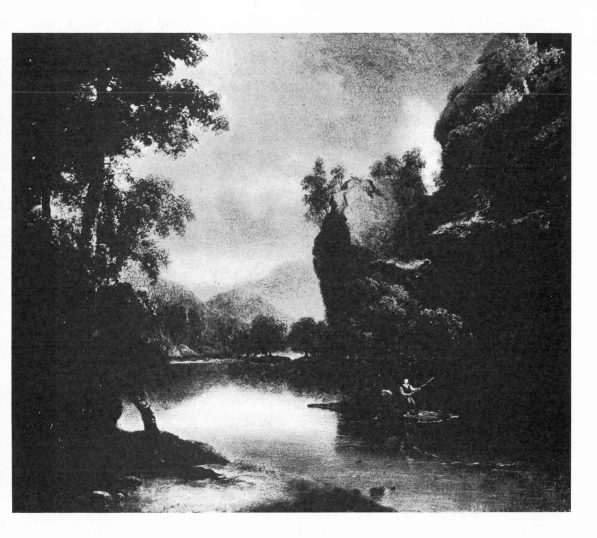

FIGURE 24

THOMAS DOUGHTY

The Raft

Museum of Art, Providence, R.I.

points as in the pictures of Morse and Doughty: farmers or small townspeople, they move quietly along; concerned with their own affairs, they are not lost in the contemplation of nature (Fig. 25).

Durand made careful drawings from nature for his paintings, but he never quite overcame the limitations of his past as an engraver. This is shown by the conventional formulas he used for foliage and other recurrent elements. The authenticity of his work is bought at the price of a certain mechanical dryness in the treatment of color, and this honest, painstaking technique contributed to the establishment of a tradition which characterized American landscape painting during the middle of the nineteenth century—a tradition that was at once its strength and its weakness.

During his activity as an engraver he had illustrated stories by Washington Irving and other contemporary romantic writers. Now, as he painted, he endeavored to integrate his literary taste into the new medium. In 1840, the year in which he left for Europe, he painted two compositions, companion pieces entitled *The Morning* and the *Evening of Life,* now in the National Academy of Design in New York. Both are heroic landscapes. One depicts a young shepherd, a woman with children, and a Greek temple in the background; the other shows an old, lonely shepherd, the broken columns of a Greek temple, and a Gothic church as background. The allegorical content is obvious: the cycle of life is compared with the cycle of civilization, and both are embedded in the eternal rhythm of the times of the day. Pictorial symbolism, however, does not seem to have been a natural way of expression for Durand, for the two paintings remained exceptions in his work. As documents of taste they are interesting, but only on the firm basis of

reality did Durand develop a convincing style. No doubt literary impressions received in his contact with romantic poetry moved him deeply, and eventually he found a pictorial outlet for them in what I should like to call biographical landscapes: views of familiar scenery enlivened by significant figures taken from the romantic circle. One of these landscapes, called *Kindred Spirits,* shows Bryant, the poet, in the company of Thomas Cole, the leader of the romantic movement in American painting, standing on a cliff, engrossed in a discussion of the picturesque view of a waterfall in a wooded ravine (Fig. 26). Huge trees form a natural frame around the contemplative couple—a composition that recalls a painting by Caspar David Friedrich of romantic wanderers contemplating the chalk cliffs of the island of Rügen.[20]

Durand's picture is full of tender feeling. In fact, it is a memorial monument. One year before it was painted, in 1848, Thomas Cole had died prematurely. Bryant wrote the funeral oration for his friend, and Durand, moved by the loss, created a composition expressing the spirit of the epoch which he might have felt had reached its climax and was about to be relegated to a secondary role.

In another somewhat later painting of this type, *Mohawk Valley,* there is a rock in the left foreground on which two painters have settled to sketch the spacious prospect before them, with a railway train making its way between wooded hills (Fig. 27). This picture is full of implications. It faithfully records Durand's habit of painting in the open although it was not painted by him, and it gives the atmosphere in which American romanticism developed, the scenic mountains of the State of New York. The

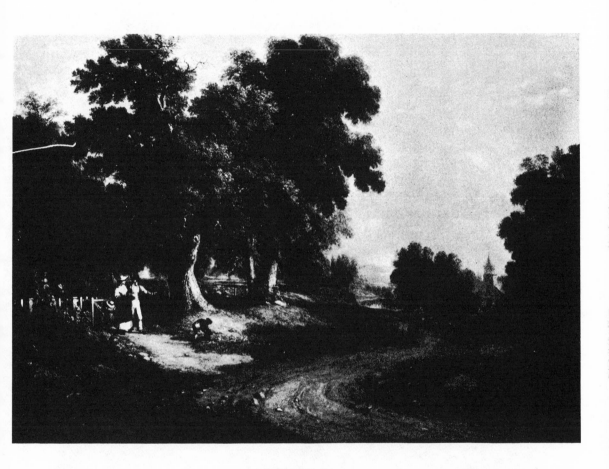

FIGURE 25
ASHER BROWN DURAND
Sunday Morning
New York Historical Society, New York City

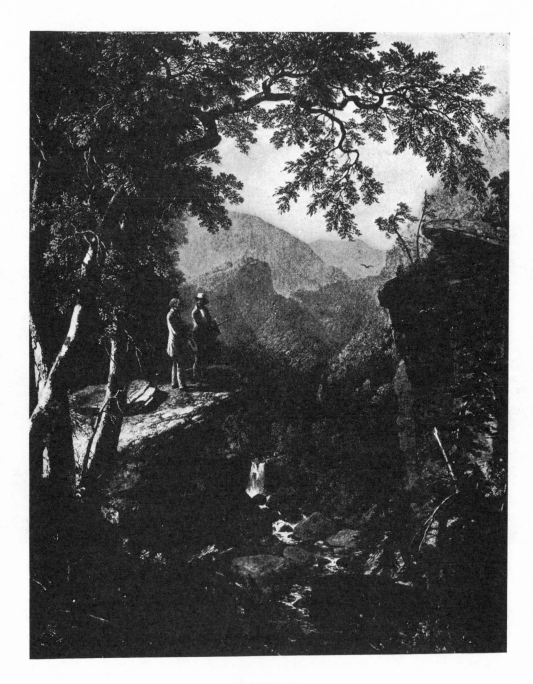

FIGURE 26
ASHER BROWN DURAND
Kindred Spirits
New York Public Library, New York City

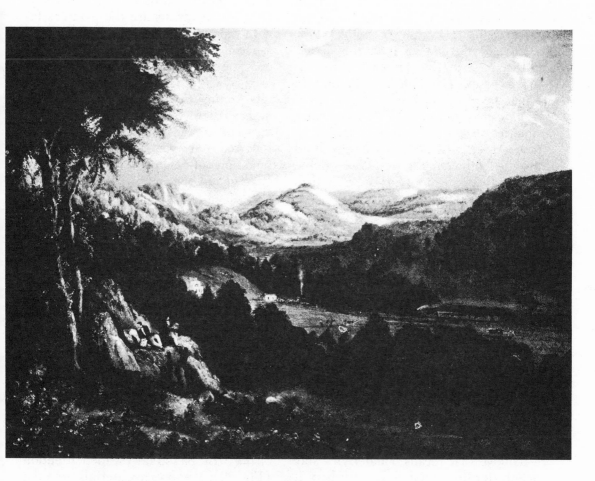

FIGURE 27
UNKNOWN ARTIST (formerly attributed to DURAND)
Mohawk Valley
New York Historical Association, Cooperstown, N.Y.

railway represents the modern spirit—an element considered then no less romantic than a medieval castle. The romanticists evidently did not anticipate that the railway soon would upset the calm world in which alone their introspective art could unfold.

Cole,[21] who died when the Revolution of 1848 dealt the death blow to European romanticism, had been born in 1801 in Lancaster, England, but his family was of American origin. In 1818 they moved to America. Young Thomas, who had been an engraver in Liverpool, struggled hard to get a foothold in the arts. It was a time of heartbreaking toil for the penniless youth who then lived in Ohio. Finally, after a period of hunger and misery, his work was noticed, and beginning in 1825, a year that seems to have been a turning point in American taste, he found friends and patrons, and success followed. The years from 1829 to 1832 were spent in Europe. Cole visited England and traveled through Switzerland and the Rhone Valley to Marseilles, where he took a boat to Italy. His reactions to what he saw were not much different from those of Durand. He disliked the neoclassic art of the French but remained faithful to Claude Lorrain. In Rome he stayed in a studio which allegedly once was Claude's —a move that recalls Vanderlyn's stay in Salvator Rosa's erstwhile workshop. It is worth noticing that in Rome he sympathized with the German and English artists because they "painted with more soul than the Italians." After his return he was swamped with commissions, married and settled down, and the home of his wife's family in the Catskills became his own home. It was situated in his favorite landscape. Another trip to Europe, which led him through Germany, followed, and during his last years he visited Niagara Falls.

Cole began with landscapes from the Hudson River Valley and the White Mountains which combine a loving record of details with intense expression. This expression is tuned to a major key. Dramatic contrasts are the painter's favorite patterns. The sunrise, a motif especially dear to the German romanticists,[22] is not less welcome to their American colleague as a device for visually interpreting the mysterious energies of nature. Highly poetized and dramatized views of American and European scenes followed. Some were limited to the representation of untamed nature, where gnarled and barren trunks recalled Ruisdael's anthropomorphic trees raising their branches like arms in despair (Fig. 28). Others indulged in ponderous allegories illustrating the "Voyage of Life" or "The Cross of the World." The public was swept off its feet, but the connoisseur became somewhat cool. Posterity decidedly favored Cole's pure landscapes, and among his narrative pictures preferred his fairy tale illustrations to the more weighty philosophical compositions.

The year 1833 produced two of these fairy tale pictures. One of them, *The Titan's Goblet,* in the Metropolitan Museum, is well known; the other, *The Maid of the Mist,* has so far escaped attention (Fig. 29). It shows a waterfall from the foam of which a nymph complete with crown and fishtail emerges, a kind of American Lorelei. Cole's *Maid of the Mist* is painted in a much bolder style than the German pictures illustrating folk tales which present a similar subject matter in an equally romantic spirit. Another waterfall by Cole which has no mythological figures attached to it resembles the work of German romanticists much more closely (Fig. 30). This painting, in its detailed and linear style, has

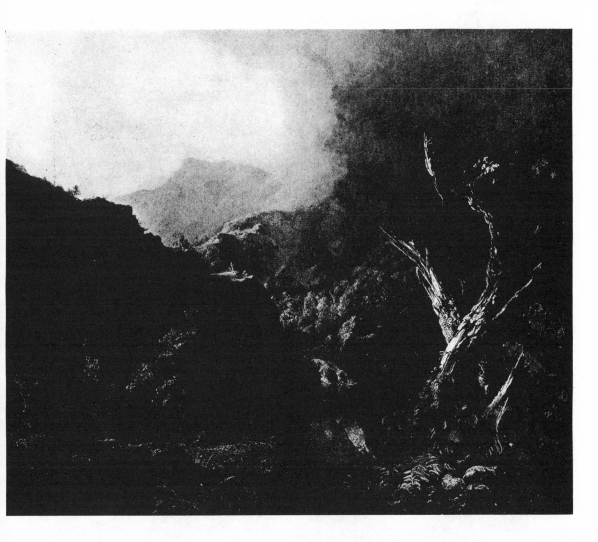

FIGURE 28
THOMAS COLE
Landscape with Tree Trunks
Museum of Art, Providence, R.I.

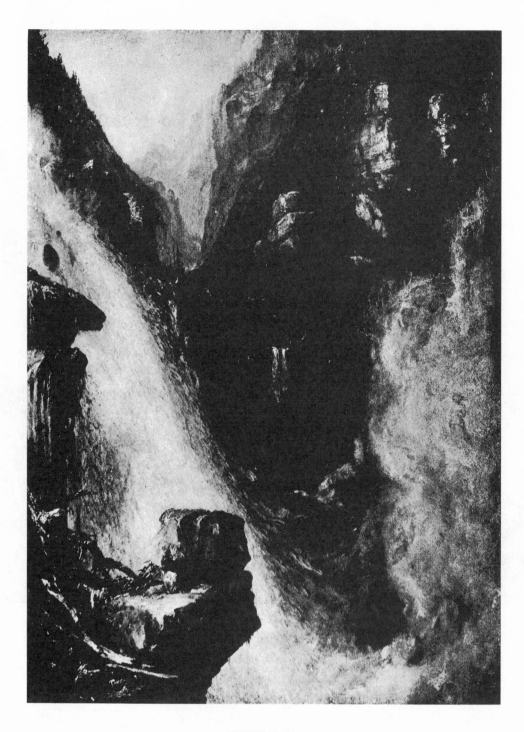

FIGURE 29
THOMAS COLE
The Maid of the Mist
Mrs. L. T. Gager, Washington, D.C.

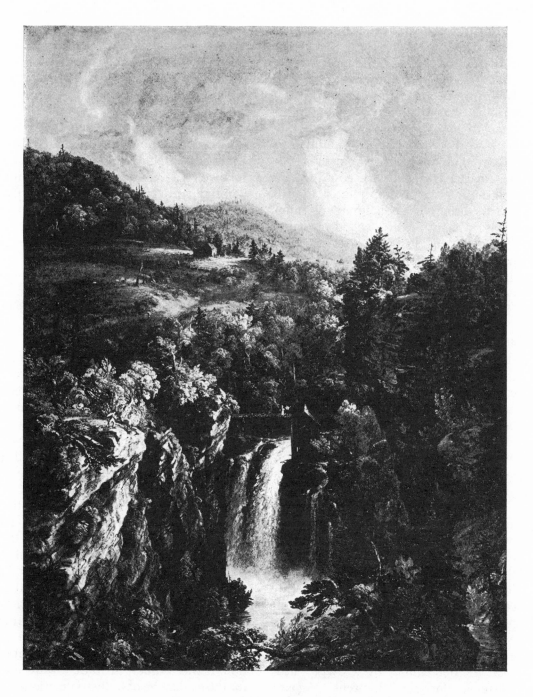

FIGURE 30
THOMAS COLE
Mountain Landscape with Waterfall
Museum of Art, Providence, R.I.

been compared with the *Schmadribach-fall* by Joseph Anton Koch,[23] a member of the German colony in Rome at the time of Cole's Italian sojourn. In fact, the relationship between the two works is so striking that the possibility of an influence cannot be denied altogether. The brushwork of both pictures is miniature-like, smooth and precise, and their subject matter is given with equal fidelity and sense of the picturesque.

This brings us to a group of minor painters conveniently called romantic realists. Alvin Fisher (1792–1863), a portraitist, painted attractive, unassuming landscapes in a style halfway between Doughty and Durand. Robert Havell (1793–1878), John Neagle (1796–1865), and Henry Inman (1801–46)[24] occasionally practiced a sensitive style of landscape painting in the English tradition. Havell,[25] born in England, came from a family of engravers and won fame through his engravings after Audubon. His oil paintings, most of them Hudson River views, are delicate and meticulous and at the same time distinguished by their unorthodox composition (Fig. 31).

Neagle was chiefly a portrait painter and Inman a genre painter. The figures which enliven their landscapes attract more attention by their activities than their size would warrant. Inman's delightful *Picnic in the Catskills* recalls continental painters of middle-class life perhaps even more than the English art with which he had a common background (Fig. 32). There is a painting, *Lieu de Récréation,* by a Swiss "little master," Jacques Laurent Agasse, painted in 1830 and exhibited three years later in London, which by its motif and its mood reminds us of Inman's somewhat later *Picnic.* Inman, however, did not

visit London until 1844, after he had produced this work, and the relationship between the two paintings certainly is not due to the influence of one upon the other but rather to a similarity of the milieu from which they came.

It was in the interval between the death of Cole and Inman that a New England writer, Henry David Thoreau, followed the example of the romantic painters and took to the woods for inspiration. Walden Pond, a small lake near Concord, not different from so many other lakes tranquil in the solitude of forests and hills, became the seat of an important experiment in living. Thoreau was a true disciple of Emerson, who in his treatise on nature had written in 1836: "The use of natural history is to give us aid in supernatural history. The use of the outer creation is to give us language for the beings and changes of the inward creation." The wooden hut Thoreau built for himself was, for more than a year, the place of concentrated thinking on human values, and his thinking was controlled by a steady and penetrating observation of nature. The work done by Thoreau in his intellectual hermitage, the modest volume of exquisite descriptive and analytical prose, *Walden,* at first failed to impress his contemporaries but gradually aroused interest and began to draw more and more readers under its spell. The romantic sentiment of nature began to yield to the sympathetic curiosity of the naturalist. Love of nature grew from a vaguely poetical attitude into an understanding appreciation of its function. It was a timely attitude toward life, for the avalanche of industrialization and commercialization broke lose at this time. When the Civil War had shattered the resistance of the agricultural South, the avalanche swept away the traditional

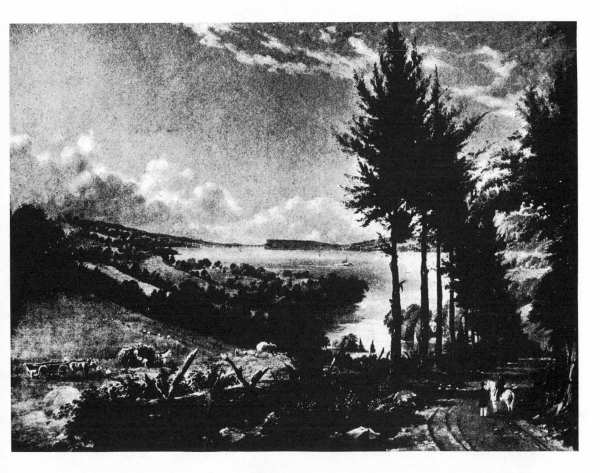

FIGURE 31

ROBERT HAVELL

View of the Hudson River from Horton's Road near Croton

Minneapolis Institute of Arts, Minneapolis, Minn.

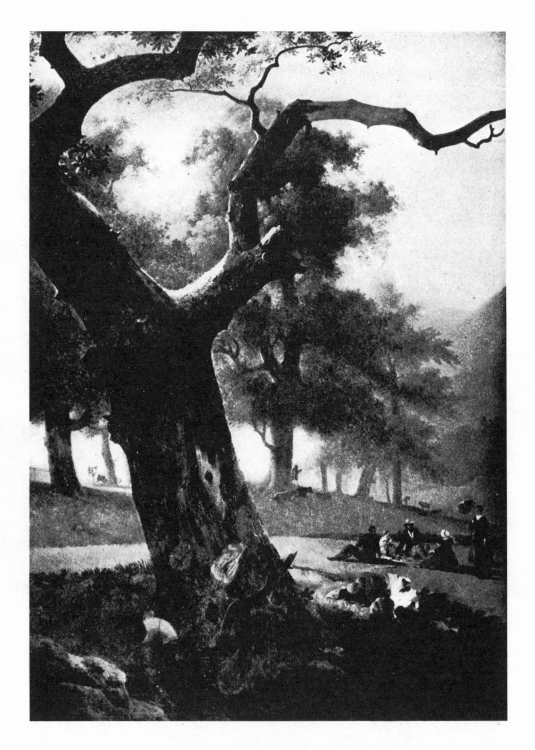

FIGURE 32
HENRY INMAN
Picnic in the Catskills
Brooklyn Museum, Brooklyn, N.Y.

form of living. The cities sprawled. Their fringes, which formerly melted mellowly into the countryside, changed into bleak slums, and the machine age, which at first appeared so romantic, brought forth romanticism's relentless enemy, realism. The reaction against the alienation from nature took the appropriate form of landscaping on a large scale. Frederick Olmsted[26] (1822–1903), who in 1858 designed Central Park in New York and pioneered for the creation of city parks in general, so to speak turned the ideas of Thoreau into practice. The English garden which had developed in Europe in the preceding century offered itself as a model for recreational areas in which as much as possible of the character of untouched nature was made available to the city dweller. In the state parks which soon followed the same idea was realized on a gigantic scale. The Missouri Botanical Garden in St. Louis was founded in 1858, the year in which Olmsted designed Central Park; and similar places were created elsewhere. All these developments tended to substitute a scientific interest in nature for an emotional one. The "Claude Glass," the contraption which in the heyday of the picturesque enabled the sentimental stroller to see nature with the eyes of a painter, was replaced by the magnifying glass of the botanist. *Nature* and other scientific periodicals succeeded the *Magasin Pittoresque* and the zoo transformed the Sunday walk of the family into an extension course in biology enlivened by popular entertainment.

This development, however, took time, and its final effect on painting, the creation of the "scientific" landscape, was still far off. The Biedermeier lingered on in such works as the poetical *Picnic on the Hudson* by James M. Hart (1829–1901),

one of two painting brothers who are usually listed with the later members[27] of the Hudson River school (Fig. 33). In a more general sense they are representatives of the so-called Victorian taste that could better be termed postromanticism, since it was an international rather than an English development.

It was the time when the "second rococo" prevailed in interior decoration, a quaint reinterpretation of the scrollwork, the floral patterns, and the sinuous contours characteristic of the mid-eighteenth century. A faint echo of rococo painting can be found in Hart's *Picnic*. Its oval frame is reminiscent of rococo design, and the subject matter as well as the mellow treatment of the landscape makes of it a sober middle-class interpretation of Watteau's *Fêtes Galantes*.

Boucher's exquisite landscapes with their bluish haze are recalled by pictures such as *Winter Sports* by Régis François Gignoux, although its subject matter recalls Van Goyen and other Dutch seventeenth-century masters (Fig. 34). Gignoux was born in France in 1816, and after training with Delaroche, who popularized French romanticism, came to America in 1840 where he worked until his death in 1882. He specialized in winter scenes painted with an approach the French would call *intime*. The painter is absorbed with the picturesque detail of his motif.

While Gignoux is heir to eighteenth-century French art, the Baltimore painter Alfred J. Miller[28] (1810–74) for a short time represented the spirit of the French romanticists, his contemporaries, in America. After an early training under Thomas Sully, the fashionable portrait painter of his home city, he studied in Paris at the École des Beaux-Arts. In 1837 young Miller joined an expedition to

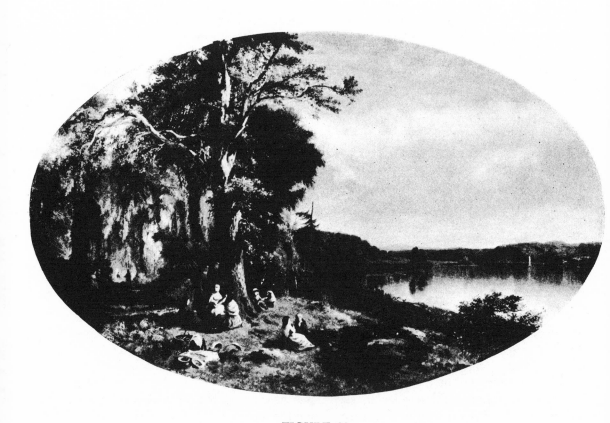

FIGURE 33

JAMES M. HART

Picnic on the Hudson

Brooklyn Museum, Brooklyn, N.Y.

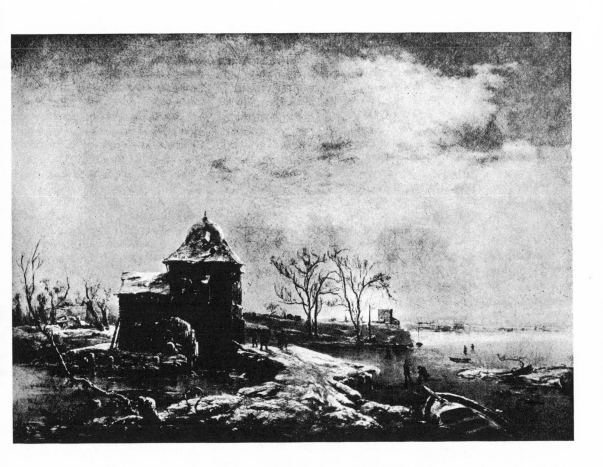

FIGURE 34

RÉGIS FRANÇOIS GIGNOUX

Winter Sports

Robert C. Vose Galleries, Boston, Mass.

the West organized and led by the Scottish explorer Captain William Drummond Stewart. During the trip he produced what was to be his life's work: a series of forceful water colors of Indian life which, with due qualifications, recall the inspired water colors the great Eugène Delacroix made a few years earlier in Algeria (Fig. 35). Forgotten for almost a century, these water colors, as far as landscape is concerned, are unique in their time. Miller himself did not match them in his later years. Except for a stay in Captain Stewart's country seat in Scotland, where he painted Indian scenes for his patron and friend, he lived in Baltimore as a painter of conventional portraits.

Miller's French touch was an exception in the America of the second quarter of the nineteenth century. The prevailing tendency was toward a sober and correct rendering of nature. Sometimes this tendency was tinged by a modest dose of sentimental idealization which does not unduly intrude itself upon the spectator but is a legitimate expression of affection for the native soil, as in the engaging verses of Whittier. It was a period of "little masters," of regional painters who after a long eclipse have emerged from the dusty attics into which the pretentious taste of a later generation had banished them. They are fresh, genuine, and thus convincing—qualities that are missing only too often in the art of the then famous artists. As a matter of fact, it is in this modest undercurrent that the period was at its best. And it is noteworthy that the *œuvre* of one and the same painter sometimes is divided into two strata: one of them in keeping with the popular taste of the time is now all too often dated, whereas the other, an authentic expression of the artist's original attitude to-

ward nature, is of a timeless character. It is often but not always the case that these authentic paintings are either sketches or works of the youth of the artist. The more the public taste was influenced by science and technology, the less interest could an artist expect for the landscape of mood.

The Currier and Ives lithographs offer an illuminating comment upon the artistic taste of the time. They were popular and they were addressed to a public that certainly was not too discriminating and well informed. The most engaging prints were made when postromanticism was still alive. When the sentiment of nature disintegrated under the influence of industrialization, a vulgar streak became apparent. Uninspired cartoons and coarse chronicles pushed the serene and peaceful farm pictures, river views, and hunting scenes into the background. George H. Durrie [29] (1820–64), a Connecticut painter whose early death cut short a promising career, was the most gifted among the landscape painters who worked for Currier and Ives. His winter scenes display a brittle gracefulness and a restrained affection for their subject matter that make them most lovable documents of the rural life which existed before the era of mechanization (Fig. 36).

Some of the painters who formed the second generation of the Hudson River school exhibited similar tendencies, a sort of belated Biedermeier taste. One of the most successful among them was Jasper F. Cropsey [30] (1823–1900). His autumnal forests enjoyed a great popularity thanks to their sonorous color harmonies. After half a century of eclipse they have regained their popularity by means of other qualities which, at least to the modern spectator, seem more pertinent: namely the directness and freshness of

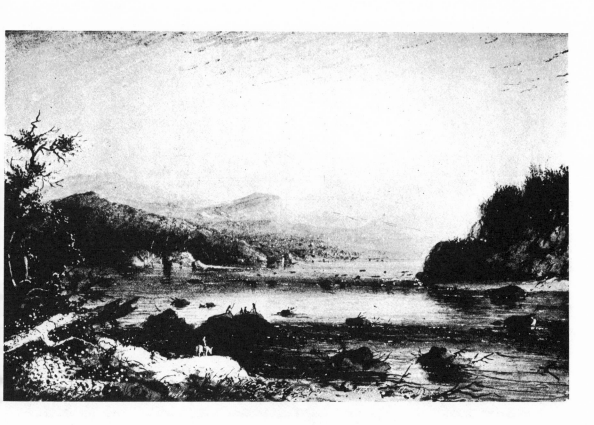

FIGURE 35
ALFRED J. MILLER
Green River, Oregon
Walters Gallery, Baltimore, Md.

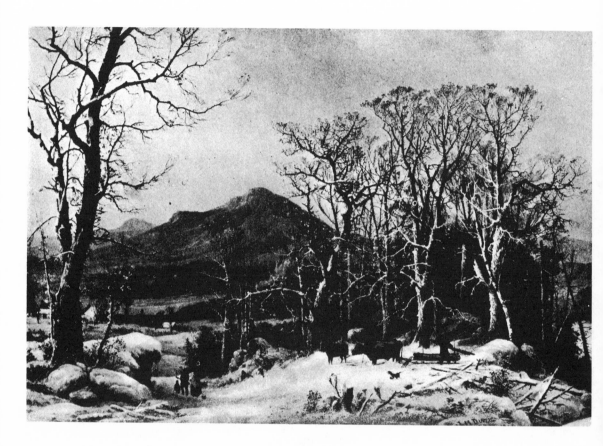

FIGURE 36
GEORGE H. DURRIE
Wood for Winter
New York Historical Society, New York City

their pictorial style. Cropsey knows how to capture the translucent air of a clear September day in the mountains (Fig. 37). In addition to his quality as a painter's painter, he displays a lovable temperament that is quite disarming in its frank limitation to the idyllic. When he paints Niagara Falls, he avoids the exaltation in which his early romantic predecessors indulged (Fig. 38). He sees the "scenic wonder" with different eyes. What appeared to a Vanderlyn and a Trumbull as spectacular was to him a pretty sight which provided a fashionable couple of vacationists an opportunity for sentimental conversation. The charm of the scene is enhanced by its arrangement inside a frame with a rounded top: the picture recalls a glance from a window. In a picture of an old shot tower Cropsey recorded a quaint suburban motif with a sympathetic understanding of its oddness that is not far from Charles Meryon's affection for the vanishing medieval architecture of Paris (Fig. 39).

William Louis Sonntag (1822–1900) loved the warm glow of an evening sky stretched out over hills and valleys from which rose the bluish smoke of bonfires. He was competent, neat, and easy to understand. People liked him more than the critics did, and they had a right to do so, for Sonntag had integrity as well as popular appeal.

The success of all these painters was overshadowed by that of John Frederick Kensett [31] (1818–72), the most beloved Hudson River man of his time. His river views drew prices that seem somewhat out of proportion today; for although his work is engaging and honest it lacks the exciting quality which is usually considered the prerequisite of a wide success. Kensett preferred the calm noon when a cloudless sky is reflected in mirror-like water. He painted his landscapes with small, carefully applied brush strokes, toning down the glare of the sun to a pleasantly warm shimmer (Fig. 40). Kensett has never been wholly forgotten, although the interest in his works had decreased until he lately came to the front again.

There were other landscape painters in Kensett's day whose success was considerable and who now have fallen almost completely into oblivion although they deserve to be remembered at least as much as he. David Johnson [32] (1827–1908) is perhaps the most striking example of undeserved neglect among the later Hudson River painters. Practically self-taught, Johnson reached a high level of professional skill comparatively early. In his *Old Mill, West Milford, New Jersey*, painted in 1850, he captured the relentless brilliancy of an American summer day in a technique similar to that used by Waldmüller to portray Alpine scenery (Fig. 41). It is a technique that combines a high-keyed color scale with an extreme attention to detail. Paintings of this character seem to anticipate the plein-air but retain the linear character of the beginning of the nineteenth century. Gradually, under the influence of French art that had become increasingly familiar to American artists and their friends, his style softened. This development, however, did not prove to be constructive. The new freedom of expression led the artist away from his serene but somewhat severe style, and he ended as one of the many indistinguishable painters of landscapes that crowded the walls of the exhibitions of the 'eighties and 'nineties. Disregarding the end of his career, David Johnson deserves an honorable place among the truly sincere artists who suc-

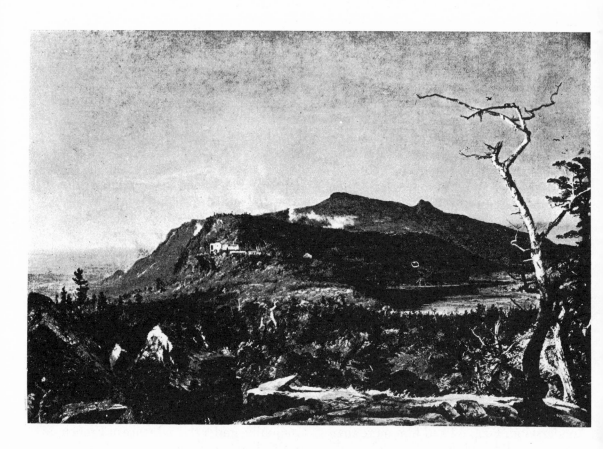

FIGURE 37
Jasper F. Cropsey
View of the Kaaterskill House
Minneapolis Institute of Arts, Minneapolis, Minn.

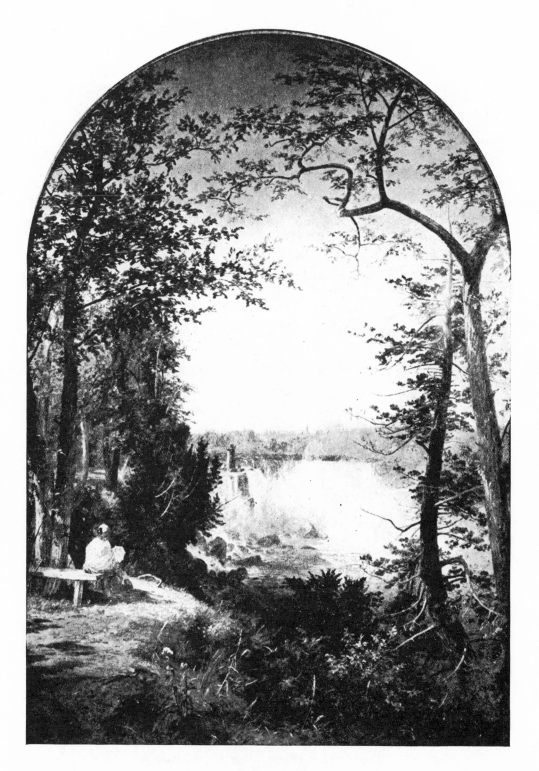

FIGURE 38
JASPER F. CROPSEY
Niagara Falls
Brooklyn Museum, Brooklyn, N.Y.

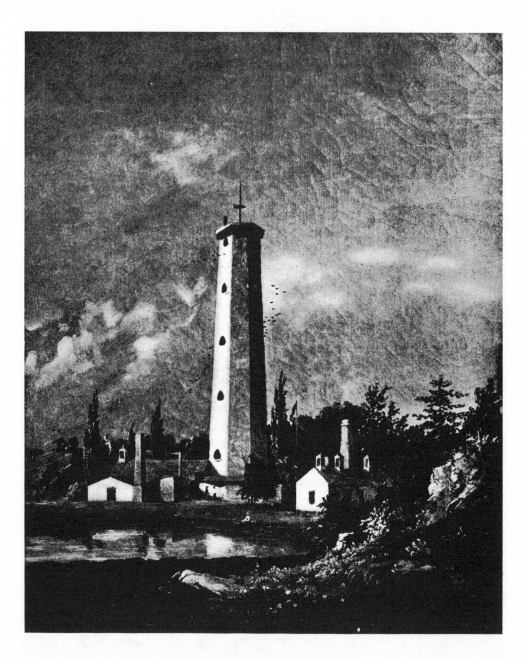

FIGURE 39

JASPER F. CROPSEY

Youle's Shot Tower—East River Shore

New York Historical Society, New York City

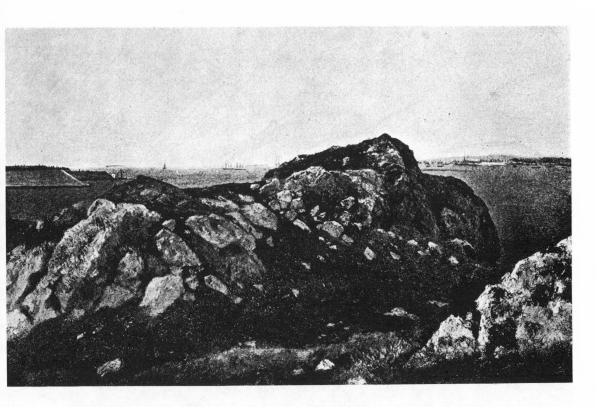

FIGURE 40

JOHN FREDERICK KENSETT

Newport Harbor, Rhode Island

Mr. and Mrs. Edward Kesler, Philadelphia, Pa.

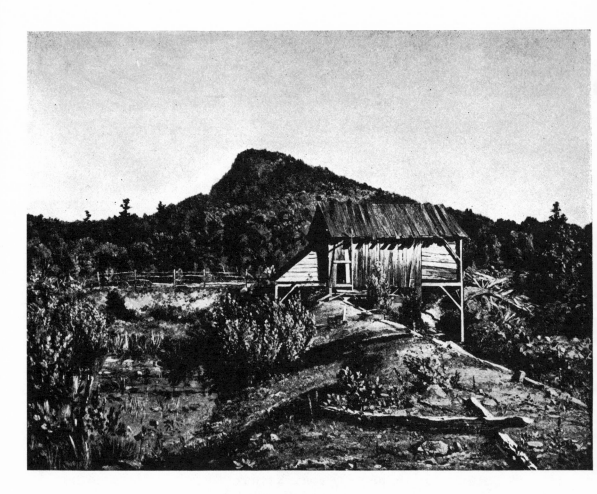

FIGURE 41
DAVID JOHNSON
Old Mill, West Milford, New Jersey
Brooklyn Museum, Brooklyn, N.Y.

cessfully recorded American nature without dramatizing or diluting its peculiar brisk charm.

Jerome Thompson (1814–86), who has entirely dropped out of sight although he was a well-known genre and landscape painter in his time, does not belong to the Hudson River school in the strict sense of the word but is close enough to it to be discussed with the Hudson River men. Like Johnson, Thompson in his early period recalls Waldmüller. His *Harvest in Vermont,* with its linear and transparent treatment, captures the fragrance and freshness of a perfect day in the mountains (Fig. 42).

The development of George Caleb Bingham [33] (1811–79) was similar to that of Johnson in so far as this regional artist did his best works before he fell under foreign influence. Like Johnson, he was self-taught; except for the instruction of another self-taught artist, the portrait painter Chester Harding, and a short stay at the Pennsylvania Academy. Self-taught—this ought to be kept in mind—does not necessarily imply primitivism, since at this period a young artist in America was not cut off from all opportunity of studying reproductions of works of art, and of seeing, at least occasionally, originals by artists of renown. Bingham, a born Virginian, moved to Missouri with his family as a boy of eight. When he began to paint, it was the view of the great rivers, the Missouri and the Mississippi, that offered him the subject matter for his pictures. He depicted the life of the boatmen and traders of St. Louis and the political life of Kansas City realistically but with feeling. His river scenes belong to the most compelling "landscapes of mood" in American art. There are a few Bingham landscapes without genre scenes which, although not quite as strong as the backgrounds of his genre paintings, show him as a sincere and capable interpreter of nature (Fig. 43). Unfortunately the painter, after he had developed his individual style, saw fit to go to Europe for further study, and following the trend of the time, chose Düsseldorf. The technical proficiency valued by the Düsseldorf Academy and indoctrinated in its pupils could not be anything but detrimental to a talent that was as distinctly regional as Bingham's, and in fact the training he received there ruined his painting. It was perhaps the realization that his art was declining that caused him to abandon his vocation. He became a politician and that he remained to the end.

The successful painter of homespun genre scenes, William Sidney Mount,[34] who was a few years older than Bingham (he lived from 1807 to 1868), evidently appraised himself more correctly than did Bingham. He began as a sign painter, studied for a short time in New York, and spent the rest of his life on the family farm in Stony Brook near Setauket, L.I. Many of his scenes are placed in the open air, and they derive a great deal of their attractiveness from the artist's understanding of nature. When he concentrated on the landscape, omitting all storytelling, his work increased in strength—at least for the modern spectator. He painted very few pure landscapes. The most beautiful is *Long Island Farm Houses,* a picture of his family's homestead, done with a loving and tender hand (Fig. 44). The painting has a rare silvery luster. All forms are clear, the colors almost transparent. One feels the texture of the wooden boards which form the walls of this simple structure, and one smells the brisk air. Mount painted the spring without recourse to sentimental association. If one looks for parallels, one has to go to faraway Den-

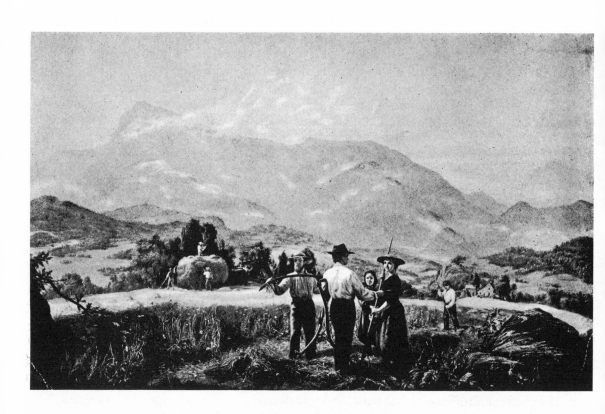

FIGURE 42

JEROME THOMPSON

Harvest in Vermont

Mr. Ernest Rosenfeld, New York City

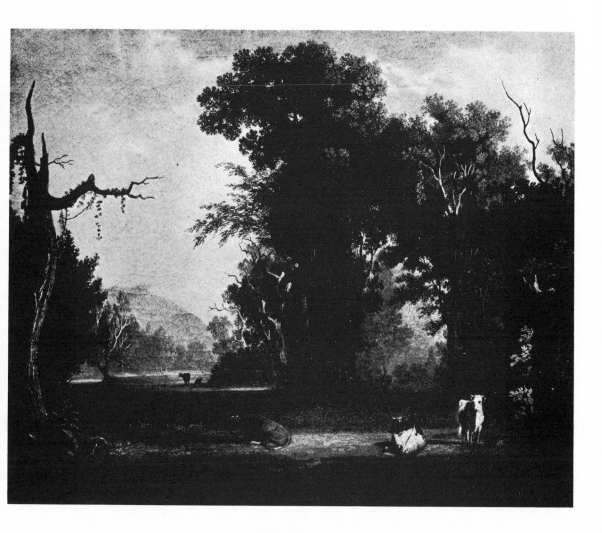

FIGURE 43

George Caleb Bingham

Missouri Landscape

City Art Museum, St. Louis, Mo.

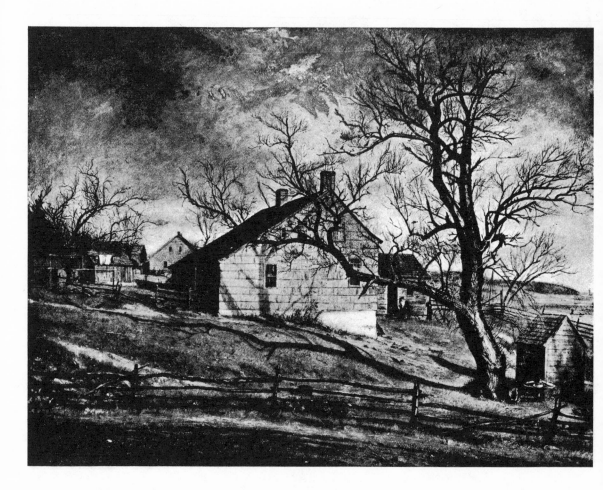

FIGURE 44

WILLIAM SIDNEY MOUNT

Long Island Farm Houses

Metropolitan Museum of Art, New York City

mark where a regional school of romantic realists followed a similar line at the same time.

The works of a regional painter such as Mount are self-contained to a degree only achieved in a well-balanced society. When industrialization began to exert its influence on the way of life, this balance was upset. Unrest filled the air. In contrast to the regional painter, a new type of artist developed, the traveling painter. He hunted for inspiration outside of the narrow world of his home. This attitude toward life made his work inconsistent whether he liked it or not. Whatever his inborn mode of expression might have been, he had to adjust it to the requirements of the foreign scene. The exotic flavor of his travel paintings appealed to the public that shared his own restlessness. Often, however, the successful globe-trotter returned to his regional origin as a side line. In small and unassuming canvases he gave vent to his nostalgia for the cozy feeling of a past that was lost at the dawn of the technical age. Such a man was the German born Albert Bierstadt [35] (1830–1902), famed for his monumental views of the Wild West. One is surprised to discover him as the painter of delightful intimate scenes of country life such as his *Couple Driving* (Fig. 45). This is a simple little picture: a country road on a rainy day with a horse and buggy making its way through the mud. A spacious umbrella protects the driver and his companion and a dog trails after the vehicle. The foliage of the tall trees that flank the road is heavy with water, and moisture envelops house and hill with a pearly gray veil.

Bierstadt's English-born colleague who specialized in western scenes, Thomas Hill [36] (1829–1908), also created *paysages intimes* aside from his big canvases. A charming picture, the *Fishing Party in the Mountains* illustrates this aspect of his art in a most attractive form (Fig. 46). A party of ladies and gentlemen dressed in the dainty and complicated fashion of the 1880's displays the temperate joy of life that recalls the days of Biedermeier—a psychological situation that in the meantime had pretty well died out in daily life, surviving only in the carefree atmosphere of the summer resort.

The most restless of all American painters probably was Martin J. Heade [37] (1814–1904), whose biography is practically a travel diary. He lived in various places in the United States—Pennsylvania, New England, the Middle West, and Florida, painting sunsets and storms with an exactitude more akin to the scientist than to the romanticist—but not without an emotional overtone that links him with the painters of the sentiment of nature (Fig. 47). In 1864 Heade went to Brazil with an explorer and painted close-ups of orchids and humming birds. These studies, done in the style of heightened realism close to the trompe l'oeil, were to serve as models for color lithographs in an ornithological book that never materialized. The painter became engrossed in the pictorial representation of tropical nature for its own sake, and in his paintings of the jungle his interest in natural history competed with the aims of painting as an art (Fig. 48).

Joseph Rusling Meeker (1827–89), a St. Louis painter who hailed from New Jersey, specialized in the representation of the Louisiana bayous. The exotic character of their vegetation seems to have attracted him in the same way that South America attracted Heade. Although his style is less rigid and literal, it has a similar documentary character (Fig. 49). Art, eventually, fell in line with the spirit of the time.

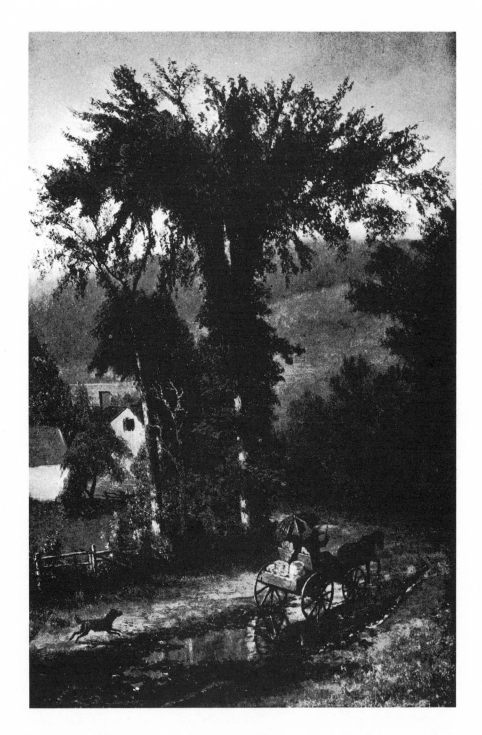

FIGURE 45
ALBERT BIERSTADT
Couple Driving
M. Knoedler & Co., New York City

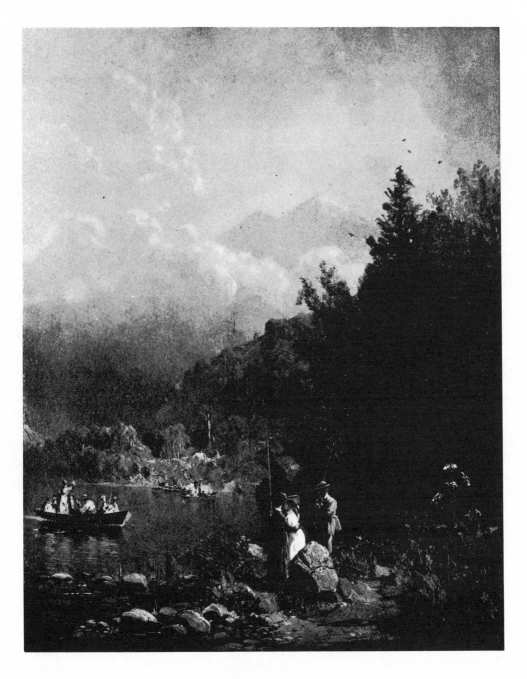

FIGURE 46

THOMAS HILL

Fishing Party in the Mountains

M. H. de Young Memorial Museum, San Francisco, Cal.

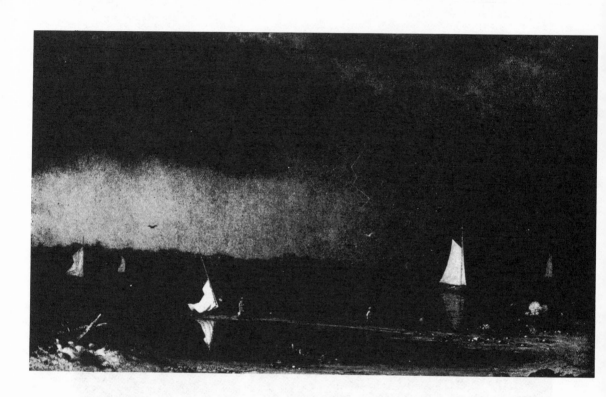

FIGURE 47
Martin J. Heade
Storm over Narragansett Bay
Mr. Ernest Rosenfeld, New York City

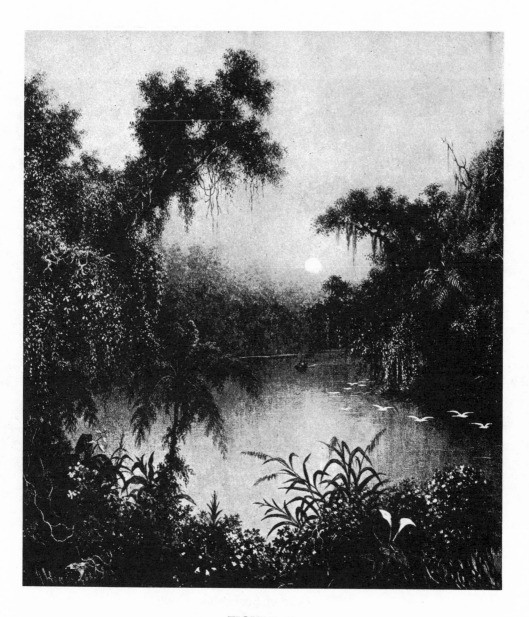

FIGURE 48
MARTIN J. HEADE
Tropical Landscape
Newhouse Galleries, New York City

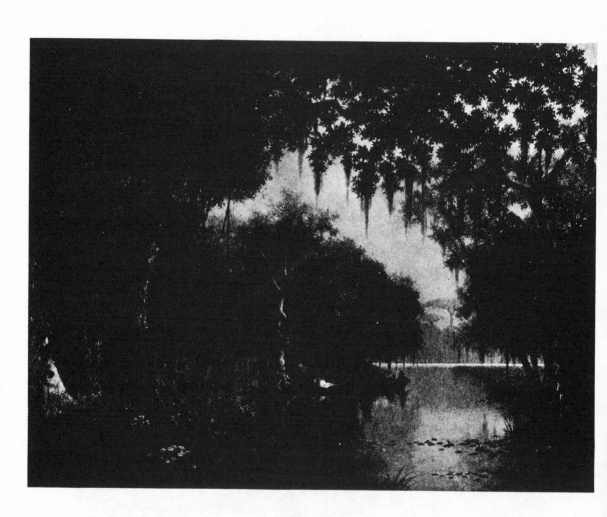

FIGURE 49

JOSEPH RUSLING MEEKER

The Land of Evangeline

City Art Museum, St. Louis, Mo.

CHAPTER THREE

THE PANORAMIC STYLE

THE trend toward scientific documentation that gradually won the upper hand over the sentiment of nature during the postromantic decades was not a new development. It had been dormant during the heyday of romanticism, but it was as old as the United States itself. Charles Willson Peale (1741–1827), a painter of considerable merit, set the pattern for the type of the artist-scientist, represented by Robert Fulton and Samuel Finley Morse. Both began as artists before they became inventors—Fulton, it is true, with a rather limited talent, but Morse as a painter of great promise.

Peale has no popular inventions to his credit but he founded, in Philadelphia, one of the first two museums in America, which contained, besides his portraits of famous contemporaries, a collection pertaining to natural history. Moreover, he placed his artistic talent in the service of this science by illustrating zoological books and painting backgrounds for his zoological specimens. Setting the latter up in artificial landscapes he created the first "habitat groups," a device introduced later on by natural history museums all over the world.

The principle of this display technique comes close to the panorama with its combination of "real" foreground and painted backdrop. In 1785 Peale designed a landscape show-box [1] that seems to have been an imitation of Loutherbourg's Eiduphysicon. Among the spectacles offered by the painter in this miniature stage were "moving pictures" of naval battles and views of romantic scenery in changing light effects.

Peale did not take the step from this device to the panorama, but another American, Robert Fulton, then in Europe, was instrumental in its development. Not long after Fulton had introduced the panorama to the public of Paris in 1800, the idea spread to America. As early as 1807 a panorama of the siege of Tripoli was exhibited in Salem and Marblehead, Massachusetts. Its painter was the Neapolitan stage decorator Michele Felice Corné,[2] who after a period of compulsory naval service had succeeded in freeing himself and becoming a mural painter in Boston. His panorama was sixty feet long and ten feet wide. It is, however, not recorded whether it was exhibited in a small rotunda or on a long wall. If we are correct in judging from some seascapes by Corné that have been preserved for us, it was painted in a clear and sober, almost mechanical style.[3]

The earliest examples of panorama painting in America that have come to us are two views of Niagara Falls by John Trumbull (1756–1843), whose fame rests in his historic pictures and portraits.

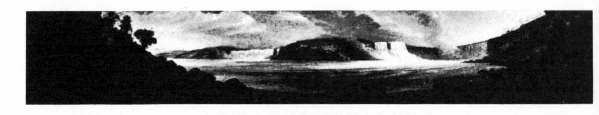

FIGURE 50

JOHN TRUMBULL

View of the Falls of Niagara Taken from the Road Two Miles
below Chippawa

New York Historical Society, New York City

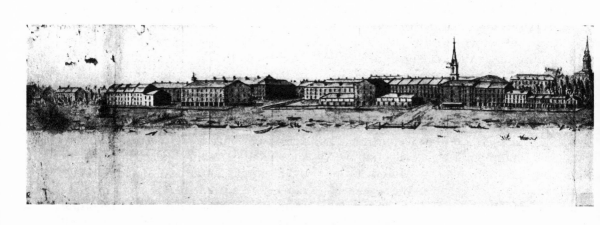

FIGURE 52a

HENRY LEWIS (attributed to)

St. Louis after the Great Fire

Mr. Monroe C. Lewis, St. Louis, Mo.

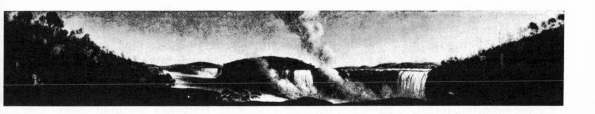

FIGURE 51

JOHN TRUMBULL

View of the Falls of Niagara Taken from under the Table Rock

New York Historical Society, New York City

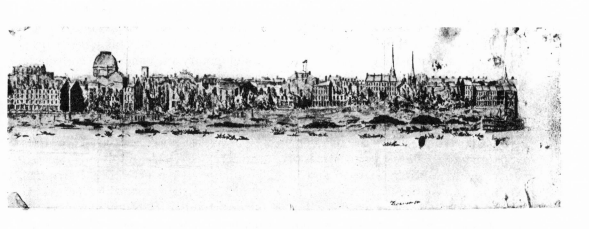

FIGURE 52b

HENRY LEWIS (attributed to)

St. Louis after the Great Fire

Mr. Monroe C. Lewis, St. Louis, Mo.

The views are painted on long narrow strips of canvas and are the property of the New York Historical Society (Figs. 50, 51). Trumbull visited the falls in 1804, and about four years later made an easel painting of them that displayed a considerable dramatic effect. It is in the Wadsworth Atheneum at Hartford, Connecticut. We know that he did not carry out his original plan to paint a panorama of Niagara.[4] Evidently the two strip-like canvases in New York were the small original models from which the actual panorama might have been painted.

The first large-size circular panorama in America was the work of John Vanderlyn,[5] who during his stay in Paris was in contact with Fulton. In 1814, before he left France, he made sketches for a panorama of the palace and the park of Versailles. After his return to America, he painted the panorama and erected a circular building for it which he called the New York Rotunda.

The style of Vanderlyn's *View of the Palace and Gardens of Versailles* was influenced by French classicism. It appears to modern eyes somewhat static, but its decorative character was well fitted to the purpose (Fig. 53). In the following years Vanderlyn exhibited panoramas of Paris, Athens, Mexico, Geneva, and of several famous battles of Napoleon. The panorama was a popular artistic entertainment and made a lasting impression on the public.

Unfortunately the cost of the rotunda had exceeded the estimate, and this involved Vanderlyn in financial difficulties from which he never recovered. Although the patronage of the institution was encouraging, and he hoped that it would become a permanent feature, he was deprived of it in 1829 by the same city administration that had financed him.

In 1838 the English-born architect and explorer, Frederick Catherwood,[6] opened a new rotunda in New York in which he showed panoramas with prodigious success until the building burned down in 1842. Catherwood had worked in London for Robert Burford, and showed Burford's panoramas in New York, including views of Jerusalem, Niagara, and Lima. After New York, the panoramas were exhibited in Philadelphia, New Bedford, Providence, and Boston. No attempt was made after the fire to establish a permanent panorama in New York, and only in the last thirty years of the nineteenth century was the panorama in its new form as cyclorama with "real" figures and objects in the foreground introduced from Europe. Cycloramas of battles from the Civil War became popular. One of them has survived in Atlanta, Georgia.

An anonymous memoir written by a contemporary of Vanderlyn contains a discussion of the function the panorama had for the society of the time; "Panoramic exhibitions," runs the text, "possess so much of the magic deceptions of the art, as irresistibly to captivate all classes of spectators, which gives them a decided advantage over every other description of pictures; for no study or cultivated taste is required fully to appreciate the merits of such representations. They have the further power of conveying much practical, and topographical information, such as can in no other way be supplied, except by actually visiting the scenes which they represent, and if instruction and mental gratification be the aim and object of painting, no class of pictures have a fairer claim to the public estimation than panoramas." [7]

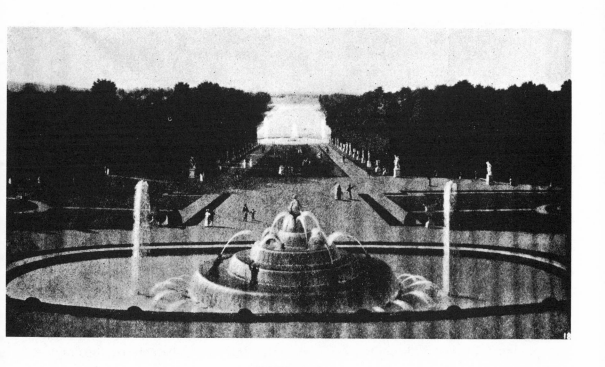

FIGURE 53

JOHN VANDERLYN

Panoramic View of the Palace and Gardens of Versailles
(section showing the *Basin of Latona*)

Senate House Museum, Kingston, N.Y.

This sounds pedantic to modern ears but it shows how seriously the panorama was taken and what effect it had on the public. In contrast to Europe where people grew up seeing old paintings in churches and public buildings, if not in homes, no preconceived ideas as to how a painting should look interfered with the impression the panorama made on the average American spectator. Thus it could not fail to influence American taste. Moreover, the panorama was in harmony with an innate trend of the American mind, then only in its preliminary stage but destined to grow from year to year: a trend toward the realization of the vastness of the country, of its unlimited horizon. In 1803 Lewis and Clark set out for their voyage of discovery to the West Coast that paved the way for the western expansion of the next half century. In 1826 *The Last of the Mohicans,* Fenimore Cooper's novel of the frontier, appeared. During Andrew Jackson's administration, which began in 1829, the drive toward the West gained momentum. The new form of frontier life swept past the old established states, through primeval forests and endless prairies, over mountain ranges and rivers.

The influence of the frontier on the aesthetic attitude of America was strong. Americans began to see their country as the continent it really is, an immense stretch of land over which the imagination could wander unrestrictedly. What a difference from, say Germany, with the art of which the American romanticists had so much in common! In Germany the traveler in his stagecoach could scarcely make a few days' trip without being stopped at a frontier, for the country, in itself small compared to America, was subdivided into dozens of principalities, duchies, and little kingdoms—each a unit of its own, with its own regional culture. It was a cozy but narrow world. When America began to spread from the shore of the Atlantic toward the Pacific it gained an unprecedented measure of living space. This new situation placed a new problem before the American landscape painter: how to express the peculiar reaction of the individual to the gigantic landscape spread before him.

Not all landscape painters could be expected to feel the challenge, for the stable part of American society clung to its habits and for this reason was slow to develop a new artistic taste. Consequently the artists who catered to this part of the population remained faithful to the charms of their well-defined regional sphere, or, if they were not sure of themselves, wavered between the old and the new attitude. One cannot put one's finger on the dividing line—but one can show who the painter was and the circumstances under which he created what was to be in the future a momentous movement, the panoramic style in landscape painting. The man was Thomas Cole. It would be difficult to trace any of the traits that characterize the era of expansion in the life and work of this radical romanticist, but even an artist preoccupied with a symbolic interpretation of nature could not remain unaffected by current developments if he were as sensitive as Thomas Cole.

In 1829 Cole made his first trip to Europe. He remained in London for almost two years and studied the paintings of his English colleagues, especially Turner to whom Allston had directed his attention. Cole admired Turner's earlier work, which was comparatively clearly drawn, but resented his later style because of the emphasis it placed on color effects at the expense of form.

So far as it is known, Cole made no remarks about having seen a panorama in London, but the new invention was then greatly in favor with the public. The old panorama on Leicester Square, and similar establishments, drew enormous crowds. The newspapers covered every new production with praise, and even the artists did not turn up their noses since Sir Joshua Reynolds had given his acclaim to Barker's panorama. Cole could not have escaped the panorama; in fact, it can be proved that he saw at least one in London.

In the year in which Cole arrived there, Robert Burford exhibited a panorama of *Pandemonium* from Milton's *Paradise Lost,* in the old rotunda on Leicester Square. It was painted by Burford from designs by H. C. Slous. An outline drawing of the panorama formed the frontispiece of the program booklet that explained the show. The composition of *Pandemonium* was borrowed by Thomas Cole for a painting he made for Luman Reed after his return to America.[8] Reed commissioned him to paint a series of monumental paintings in which the artist illustrated what we would call an historic cycle: *The Course of Empire.* In five stages the rise of a civilization from the "savage state" to the splendor of world power and its subsequent decline are delineated. The work of man is set against the background of nature. The landscape echoes the human drama.

As works of art the pictures do not stand up too well; they were an unfortunate attempt to revive with inadequate means the "grand manner" of the classicists. As documents of the history of art, however, they are significant, for they form the first step in the development of the panoramic landscape. The fourth of Cole's pictures, *Destruction,* is the one

that is patterned after Burford's *Pandemonium* (Figs. 54, 55). In the right foreground of Cole's painting a giant statue of a warrior stands on a square pedestal. In the right foreground of Burford's panorama a huge dragon perches on a column. The foreshortened buildings of the doomed city in Cole's paintings are almost identical in form with the foreshortened halls of *Pandemonium* as they extend from the right foreground to the left background. Finally, the distribution of land and water, the relation between sky and earth, the distribution of figures in the space are very similar in both works. There can be no doubt that the panorama served Cole as the main source for his painting.

In the same year as the *Destruction of the Empire,* 1836, Cole painted his first panoramic landscape, the *Oxbow,* now in the Metropolitan Museum (Fig. 56). A painting of the same motif, a famous scenic point on the Connecticut River, is now in the Cleveland Museum (Fig. 57). It is not signed, but was attributed to Cole until recently. Since the same landscape composition can be found in an engraving that bears the name of the well-known English draftsman W. H. Bartlett [9] (1809–54), this attribution has been questioned by Lloyd Goodrich. Bartlett made the sketches for his American views in the early 'thirties.

The landscape is seen from above. The slope supporting a kind of shelter is in the foreground. A group of tourists is resting on the top of the slope. A mountain range is in the middle ground. Both the slope and the mountain descend to the right and open a vista onto the plain where a river describes an incomplete circle, the "oxbow." A mild sun gilds the whole. The "mood" of the landscape is not different from that of European mountain land-

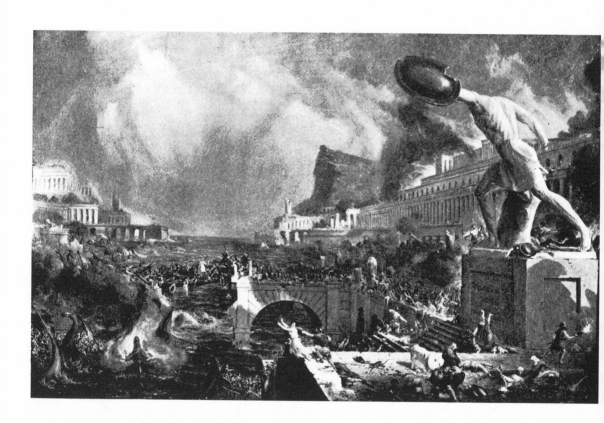

FIGURE 54

THOMAS COLE

Destruction (No. 4 of the series *The Course of Empire*)

New York Historical Society, New York City

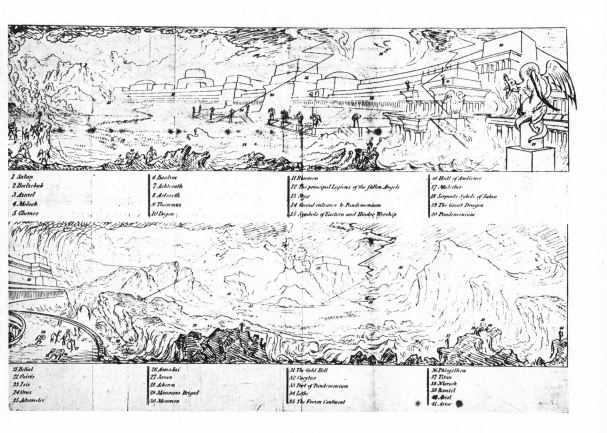

FIGURE 55

Robert Burford

Pandemonium from Milton's Paradise Lost

Metropolitan Museum of Art, New York City

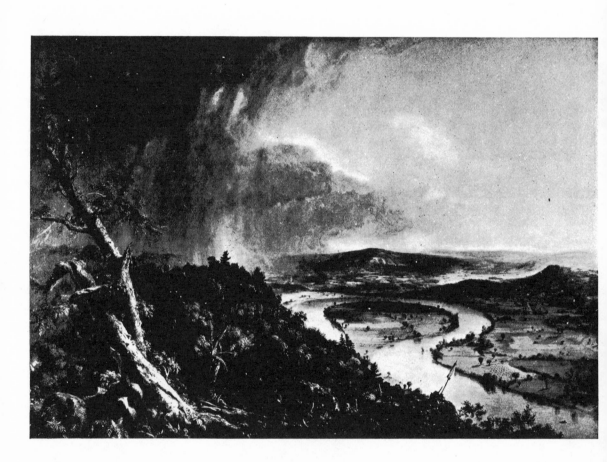

FIGURE 56
THOMAS COLE
Oxbow
Metropolitan Museum of Art, New York City

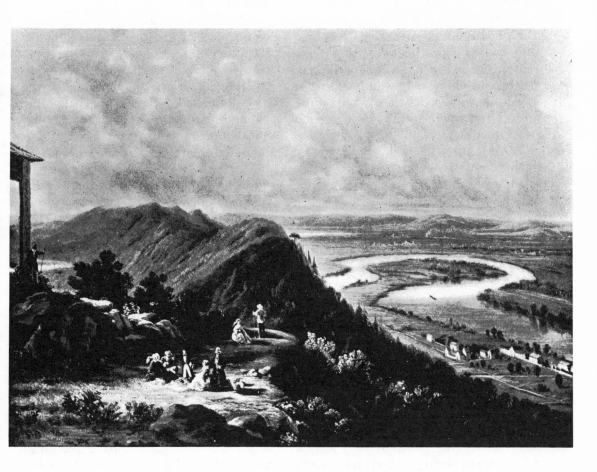

FIGURE 57
UNKNOWN PAINTER (formerly attributed to THOMAS COLE)
Oxbow
Cleveland Museum of Art, Cleveland, Ohio

scapes of the same period. It would, how- ever, be difficult to find an exact parallel in European art to Thomas Cole's *Oxbow* in New York. Turner, it is true, had painted broad vistas of landscapes from a comparatively high viewpoint, but one could always take them in at a glance. This one cannot do with Cole's painting. One has to enjoy it by letting one's glance wander horizontally over the canvas, looking at one part after the other as if one enjoyed the view from a mountaintop or from the platform of a circular panorama. The new pictorial principle is an equivalent of the wide-angle view in photography. I should like to call it the shifting vanishing point, and in the New York painting it is carried through with a determination clear enough to form a break in style. The spectator is expected to disregard traditional aesthetic standards such as unity of space and pictorial quality in favor of what might be called a cosmic stage effect. The landscape is summarily treated so that peak and rock, tree and water are like props taken from a storeroom and set up for the performance of the night; the mood of the landscape is not analyzed and faithfully recreated by the painter but transformed into a melodramatic spectacle. The tourists have disappeared. The sun has given way to a raging storm from which a painter seeks shelter in the underbrush. The river is not the silvery band any more, veiled in the haze of the distance, but forms its circle under the very eyes of the beholder. Its gigantic curve stands out with a quite unnatural sharpness.

Cole's *Oxbow* gives us an excellent opportunity to judge the merits of the new style and to take stock of the profits gained and the losses incurred in its creation. It cannot be denied that the losses are considerable. There is little of the sensuous delight which is an essential element in the enjoyment of good painting. As a result of the smooth treatment of texture and of the formalization of nature, a certain mechanical coldness prevails. The landscape appears remote, however sharp may be its single elements. The eye is forced, more than in the Cleveland version, to scan the giant canvas point by point horizontally. In brief, the easel painting has adopted the technical peculiarities of a real panorama without sharing the advantages a circular installation offers to a panorama painter.

On the other side of the scale, however, is the suggestive power of the panoramic style. The fact that the vanishing point is shifting prevents the spectator from developing the same reaction he would show in the face of a European Renaissance or post-Renaissance painting; the spatial effect of these is based on the principle that the painter does not change his position while he paints a certain scene, for he can arrange what he sees in a unified composition only if he retains the same position. Thus he creates a picture space in which everything can be perceived with one glance. The spectator feels "at home" in the picture. He is not asked to explore the unknown but is put at ease. There was a time when this demand was not fulfilled by a painting: namely the middle ages. When Memling in 1480 painted *The Seven Joys of the Virgin* [10] he led the spectator along the path from the far-distant East where the Three Holy Kings saw the star of Bethlehem to Jerusalem, showing one event after the other, transforming the sequence in time into simultaneity. This medieval device of "continuous narration," however, presupposes that the spectator views a picture as a symbolic communication rather than as a

FIGURE 58

FRANCES PALMER (BOND)

Across the Continent, Westward the Course of Empire Takes Its Way

Old Print Shop, New York City

representation of reality. Disregarding the stratum of primitive folk art, a nineteenth-century painter and his public took it for granted that a picture represents objects or actions according to the laws of perspective, and generally speaking, in a form that is scientifically correct. In the panoramic style an art form of the middle ages reappeared under modern conditions—conditions that, at least in Europe, seemed to contradict the basic principles of the art form.

America, although it belongs culturally to the West, as does Europe, developed its civilization under different geographic conditions. The space-feeling of an American who moves freely in his vast continent is necessarily different from that of a citizen of a European nation who is hemmed in by the narrow boundaries of his country. Even if he were a citizen of a Utopian United States of Europe he could not travel very far before he would arrive at the sea, or at the Russian steppes which are the natural and political borders of Europe. It is true, these differences in the relation of the individual to his environment did not become manifest on a large scale before the development of the railway which brought home the vastness of America to the average American citizen. In 1830 America had only 23 miles of railroad tracks. Ten years later it had 2,800, and in 1869 the Union Pacific Railway was completed. Currier and Ives gave expression to the feeling which this momentous event in the history of traffic released in the American people, in one of their most arresting prints: *Across the Continent, Westward the Course of Empire Takes Its Way* (Fig. 58). Its designer was the sensitive English-born Frances Palmer (Bond) [11] (1812–76).

In order to convey the idea of the gigantic extension of the new railroad from coast to coast the artist chose an imaginary elevated point of view. Looking from above on the prairie, we see a train on the new track, straight as a line. The track forms a diagonal that eventually merges with the horizon. Since the point of view is high up in the air, everything appears in bird's-eye perspective, and the horizon is close to the upper rim of the picture. The artist who designed this popular print evidently used a device of the panoramic style to express visually the space-feeling of the American people.

It is true, the lithograph does not have the narrow form of a true panoramic painting, but the artist did everything in her power to suggest a horizontal extension of the picture space. The extension of the prairie to the side is emphasized by the simple but effective device of cutting it sharply by the vertical borders of the picture; only in the left-hand corner is something like a repoussoir. It is significant that the panoramic style in 1869, the year of the completion of the Union Pacific Railway, had reached the colored lithograph, the artistic diet of the masses. Evidently the popularity of the panoramic landscape as an American art form increased in the same proportion as the network of railways. The history of the panoramic style, roughly speaking, covers the time from 1840 to 1870, with a certain period of initial growth in the 'thirties and an aftermath in the late part of the century when the inevitable process of vulgarization that besets every ageing style overtook it.

The circular panorama, which had set the development of the style in motion, soon found itself overshadowed by the moving panorama, which caught the fancy of America and developed there to a degree unprecedented in Europe. As a

matter of fact the moving panorama was reintroduced to Europe by America after it had been developed successfully into a new form of popular entertainment. The case is similar to that of the cinema which was invented in Europe but developed into an entertainment for the masses in America. Few people realize that a bond exists between the modern film and the old moving panorama, for these panoramas were called by their contemporaries "moving pictures," a name that was adopted by the modern movies.

A moving panorama, I have indicated, was a strip of canvas wound on a cylinder; it passed before the eyes of the spectator before it was wound on a second cylinder. Why did this invention not supersede the stationary panorama in Europe when it did so in America? A geographic interpretation of the facts may offer a satisfactory explanation similar to that given for the development of the panoramic style in American painting. It is, for this reason, important to know where in America the moving panorama originated and developed to maturity. It was in St. Louis, the "western metropolis" of the pre-Civil War period, before the railroad connected Chicago with New Orleans and killed the river traffic on the Mississippi.[12]

The "Father of the Waters" was to the people who settled along its course almost what the Nile was to the Egyptians: a provider and a means of communication. It bore the vessel of the fur trader and the raft of the lumberman, the barge of the cotton merchant and the passenger steamboat with its enormous paddleboxes and tiers of observation decks; and the brisk trade thus developed made the modest settlements on its shores grow into thriving towns. No wonder that the river inspired an awe in the inhabitants of

its valley comparable to the veneration with which its African counterpart was held in antiquity. It is true, awe in America took a form very different from that in ancient Egypt. The Mississippi had no chance to become an object of worship—but it became the object of a tender pride, of a modern myth, the chronicler of which was not a solemn priest but a popular wit—Mark Twain. It even inspired the finest of all regional painters of America, George Caleb Bingham, to some of the finest of American genre paintings. But while all this happened, the Mississippi engendered the idea of the river panorama as a pictorial epic—an art form that excited America more than any other branch of the visual arts has ever done, except the movies— and to the historically minded observer it seems probable that the Mississippi panorama formed the first manifest step in the development of the typically American taste that in the next century provided the background for the growth of the movies in America.

St. Louis with its population derived from the old French stock of its founders, from German immigrants and Anglo-Saxon settlers, with its sprawling water front on which Mississippi boats unloaded their cargoes, with its ambition to become a cultural as well as a commercial center of America, was the place where the lore of the Mississippi eventually found its most authentic interpretation. Panoramas of various types were popular there as elsewhere in the 'thirties. The word panorama, however, at that time meant all kinds of shows in which painted scenery was the main attraction, and was not clearly distinguished from diorama.[13] The latter, invented by the Frenchmen Daguerre and Bouton in 1822, produced the illusion of sunrise, nightfall, or

changes in weather by means of translucent backdrops painted on both sides and lighted from behind. Enterprising stage designers in London and Paris made use of the diorama almost immediately for background effects. New York followed suit and developed the idea with remarkable ingenuity. In 1828 the versatile William Dunlap produced a play on the New York stage: *A Trip to Niagara, or, Travelers in America.*[14] The piece was, as the author admitted, written with an eye to the employment of dioramic scenery. The characters of the play were on a stationary steamboat. A moving diorama in the background produced the illusion of a voyage from the wharf in New York up the Hudson to the Catskills, Albany, the Erie Canal, and Niagara. The spectator experienced a storm, fog, and a moonlit night. Dunlap's arrangement anticipated the pleorama in Berlin by three years. Since the success of Dunlap's play was great and lasting, his moving dioramic scenery may have inspired some enterprising showmen to produce similar spectacles outside the theater with less pretension to illusionism than the diorama with its complicated machinery afforded. As moving panoramas were known in Europe, the idea of making a river the theme of such a display was not far fetched, and not even new. There was the pleorama in Berlin and reports on this might have been a contributing factor in the development of the Mississippi panorama. The information about the early panoramas published so far does not always indicate the type of panorama. High-sounding names such as cosmorama mainly were new trademarks for the modified peep shows and dioramas that enjoyed a long popularity. A "Grand Cosmorama"[15] or a "Picturesque Voyage Around the World" was, according to the impresario, "imported from Europe." Nothing, however, indicates that actual moving panoramas were imported. The fame of having produced the first truly successful moving panoramas in America rests with the painters of Mississippi panoramas,[16] and although St. Louis had no priority in the production of Mississippi panoramas, it certainly became the main production center for them almost immediately, and remained the point of their dissemination as long as the fashion lasted.

In 1839 the stage painter John Rowson Smith (1810–64) exhibited a moving panorama of the Mississippi in Boston where he had painted it. This artist, son of a drawing teacher and grandson of the English landscape painter "Derby" Smith, enjoyed a considerable fame in his time. According to his own statement he was the originator of the moving panorama in America. It is known that Smith worked in St. Louis and New Orleans as a scene painter from 1832. During this time he seems to have made the sketches for his work. His panorama was destroyed by fire, but by 1844 he had completed a new one with the assistance of John Risley, an acrobat by profession. Smith and Risley showed their panorama in several capitals of Europe. It was a big success, crowned with a command performance at Balmoral where Queen Victoria applauded warmly.

The most famous of the Mississippi panoramas was by John Banvard (1815–91), a self-taught painter who, incidentally, was also a prolific writer. Banvard first tried his hand at a diorama and had a "museum" in St. Louis in the middle of the 'thirties, but only in the 'forties did he produce his masterpiece, "a picture of the beautiful scenery of the Mississippi, which should be superior to all others in

point of size, as that prodigious river is superior to the streamlets of Europe." He began the work in 1840 and completed it seven years later in Louisville. Allegedly it covered three miles of canvas, but this claim was vastly exaggerated. When it was mounted behind the gigantic frame that hid the cylinders and Banvard opened the show, it seemed a complete failure. It was a rainy day and nobody came. But Banvard was not the man to be discouraged; he was a born showman who knew how to handle such a situation. The next day he distributed tickets freely to the boatmen of whom there were plenty ashore every day, and they were enthusiastic; it was their world which passed before their eyes in a heightened, romanticized form. Although the panorama unfortunately has been destroyed and no traces of it are left, we are entitled to the assumption, based on the fact that a program booklet exists which contains a glowing description of Banvard's painting, that he dramatized the views in the manner of a stage designer. At any rate, the boatmen spread the fame of his work through the city, and this proved to be the way to popular success.

Success followed Banvard when he showed his panoramas in the East: more than 400,000 people attended his performances there. A tour in England was even more successful and was crowned, like Smith's, with a show before Queen Victoria, this time at Windsor Castle.

Between 1846 and 1848 a St. Louis artist, the English-born stage carpenter Henry Lewis, painted an even larger Mississippi panorama. Unlike Banvard's, which only showed the lower Mississippi, it covered the whole course of the river from the Falls of St. Anthony to its mouth. Lewis took his panorama to Europe and aroused the same enthusiasm that greeted Banvard and Smith. He did not return to America but settled in Düsseldorf for the rest of his life. His panorama is said to have been carried to India and to have disappeared there. Lewis' paintings show that, at least in his early period, he was a sensitive artist. An illustrated book on the Mississippi Valley which he published in German is not necessarily an exact reproduction of this panorama, for the style of the illustrations recalls that of the topographical prints popular at that time. There is, however, a drawing of the river front of St. Louis, in the possession of the family of the artist in St. Louis, indicating by its narrow form that it was a sketch for a panorama (Figs. 52a and b). It shows the ruins of the city after the great fire in 1849. This drawing, rather than the colored lithographs in his book, is in the style of the lost panorama. A third Mississippi panorama was painted by the French-born St. Louis artist Leon Pomarede and exhibited in 1849. A fourth, also in St. Louis, was shown by Sam Stockwell in 1848, and a fifth by a certain Hudson. None of these seems to have survived, but fortunately at least one Mississippi panorama has been preserved and has found a refuge in the University Museum in Philadelphia.[17] This did not belong, however, to the St. Louis group. It was painted by an otherwise little-known artist, John J. (or I. J.) Egan, probably an Irishman who stayed in America temporarily and worked for a Philadelphia physician and amateur archeologist, Dr. Montroville Wilson Dickeson. Dr. Dickeson was one of the first to investigate the Indian relics in the Mississippi Valley, and he used the then popular device of a panorama to publicize his discoveries—so to speak in the form of a documentary film or movie travelogue. Egan carried

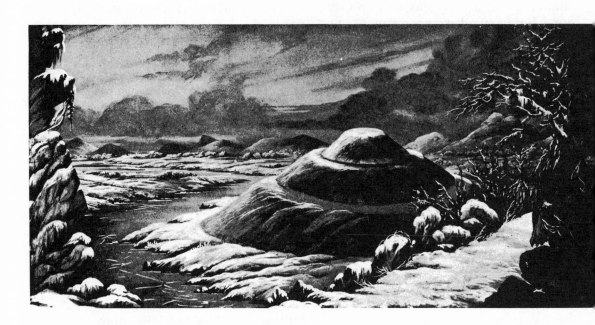

FIGURE 59

JOHN J. EGAN

Terraced Mound in a Snow Storm at Sunset (section of a panorama)

University Museum, Philadelphia, Pa.

FIGURE 60

John J. Egan

Distant View of the Rocky Mountains (section of a panorama)

University Museum, Philadelphia, Pa.

FIGURE 61

John J. Egan

Colossal Bust at Low Water Mark, Used as Metre by the Aborigines
(section of a panorama)

University Museum, Philadelphia, Pa.

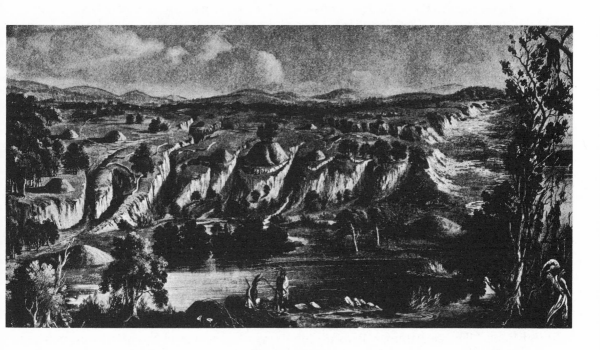

FIGURE 62

<small>JOHN J. EGAN</small>

Lake Concordia and Aboriginal Tumuli (section of a panorama)

University Museum, Philadelphia, Pa.

the panorama out after sketches by the doctor, and the latter traveled through the country exhibiting the panorama together with an archeological collection, the relics of this excavation of Mississippi mounds.

The good doctor does not seem to have been above the tricks of his nonacademic colleagues such as Banvard, for he advertised his panorama as "covering more than 15,000 feet of canvas," whereas it is only 2,500 square feet. The handbill which informed the public about the show contained lurid descriptions of single scenes such as "Louisiana Squatter Pursued by Wolves," "Extermination of the French in 1729," and "DeSoto's Burial at White Cliffs." These "thrillers" evidently served to make pictures of a scientific character more palatable to the paying visitor (who may have resented their "educational" slant no less than the modern movie-goer, who shies from documentary films); for the panorama showed mostly informative representations such as the "Exhuming of Fossil Bones," "Lake Concordia and Aboriginal Tumuli," and a "Hanging or Hieroglyphical Rock." The sensational pictures, incidentally, do not seem to have made up for the "educational" ones, for according to the available sources the panorama was not exhibited after 1851.

Dr. Dickeson's panorama is painted in two sections, each about eight feet in height; one is some 190 feet in length, the other about 130 feet. It is well preserved, although the medium is a thin muslin— a material light enough to reduce the weight of the panorama to a mere hundred pounds. It is interesting that the various scenes blend into one another, almost as in a Chinese scroll. The style of the panorama is that of a stage painter who handles his brush with daring ingenuity and with little inhibition as to conventional composition.

It is true, archeological details such as mounds and walls are emphasized far beyond their pictorial role and probably are exaggerated in size, but the total impression is compelling even today. The moving panorama—this can be said on the evidence of Dr. Dickeson's and Egan's work—was a popular art form superior to any other entertainment of the period including the circular panorama. It did not depend upon the tricky optical effects of the latter. It limited its means to painting alone and it relied on the imagination of the spectator more than its successor, the film. In the hands of a gifted artist such as Egan obviously was, the huge strip became a painted epic, haunting and arresting. Few examples of legitimate landscape painting in America have the weird, fascinating quality of the *Terraced Mound in a Snow Storm at Sunset* (Fig. 59), and rarely has the appearance of mountains in American art been captured as impressively as in the *Distant View of the Rocky Mountains* (Fig. 60). When we follow with our eyes the curves of the Mississippi where a "colossal bust" forms a watermark (Fig. 61) we experience the mysterious silence of the primeval river landscape, and with *Lake Concordia* we are under the spell of an area permeated by Indian lore (Fig. 62).

The moving panorama presupposes a visual attitude on the part of the spectator similar to that held toward the circular panorama. It does not reveal its contents at a single glance but demands of the public the same kind of "reading" as does the circular panorama. The eye, in scanning it, takes in point after point connecting the picture horizontally. It cannot be doubted that the Mississippi

panoramas and their imitations were almost as popular with the American people of that time as the movies are today. And there can be no question about the fact that the visual experiences gathered in the exhibition halls where the moving panoramas were shown added greatly to the taste for panoramic views previously acquired by the American public in the circular panorama. Thomas Cole has been spoken of as having drawn inspiration from the latter. We would like to have a similar proof of the effect of the moving panorama on American painting. Such a proof is available, if only indirectly, for Charles Wimar,[18] a pupil of the St. Louis panorama painter Pomarede, developed into a professional painter in his own right and, in spite of training received by the Düsseldorf Academy after his apprenticeship with Pomarede, stuck to the panoramic style in the pictures of the life of the Indians which made him famous in his lifetime. Wimar was born in 1828 in Germany, came as a boy of fifteen to St. Louis, returned to Germany in order to study art from 1852 to 1856, and died prematurely in St. Louis in 1862. His paintings, apart from dramatic figural scenes with a landscape background, also include landscapes which are enlivened with figures, and these usher in a new type of panoramic painting. In Wimar's paintings the eye glides over vast prairies or valleys (Fig. 63). Bare mountain ranges form picturesque fringes between the plain and the sky. Glassy and shrill colors perform a kind of icy fireworks. Wimar's sphere is the West. His work points in the direction of the expansion which was then in full swing. And thus he belongs to the avant-garde of a school of travel painters who at about the same time set out to explore the pictorial pos-

sibilities of the fabulous territories recently opened by enterprising adventurers. It has been said that the success of the Mississippi panorama in Europe stimulated the immigration of Europeans, especially Germans, into the Mississippi Valley. In America itself it stimulated painters from the East to "go West" in their search for interesting subject matter.

Long before this happened, the panoramic views of Thomas Cole had been imitated by his contemporaries and immediate followers. The painting of the Mohawk Valley in which a follower of Asher B. Durand commemorated the painting excursions undertaken by the romantic artists comes close to the panoramic style, and so do Thomas Doughty's landscapes, *Curving River* [19] (Pennsylvania Academy of Fine Arts, Philadelphia), and *On the Banks of the Susquehanna* (Fig. 64). The Hudson lent itself especially well to a panoramic treatment. Its broad mass of water had molded, through millions of years, a spacious valley, limited by hills, slopes, and crags which shade into a mountainous plateau. When seen from one of the numerous adjacent peaks, the whole forms one of the most panoramic views in the world. The eye feels the urge to wander along the horizon, freely following the rhythm of the landscape as the summer clouds project their changing shadows.

Photography was still in its swaddling clothes, and the panoramic camera was not yet invented—the apparatus that would, by moving the lens in a circle, produce panoramic views in a so to speak "additive way." The development of panoramic photography in the second half of the nineteenth century may have contributed to the popularity of the panoramic style in painting, for these picture

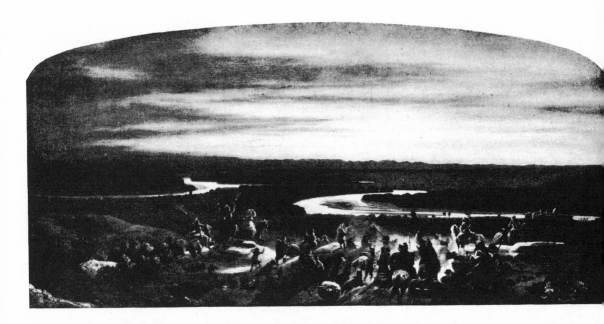

FIGURE 63
CHARLES WIMAR
Indians Approaching Fort Benton
Washington University, St. Louis, Mo.

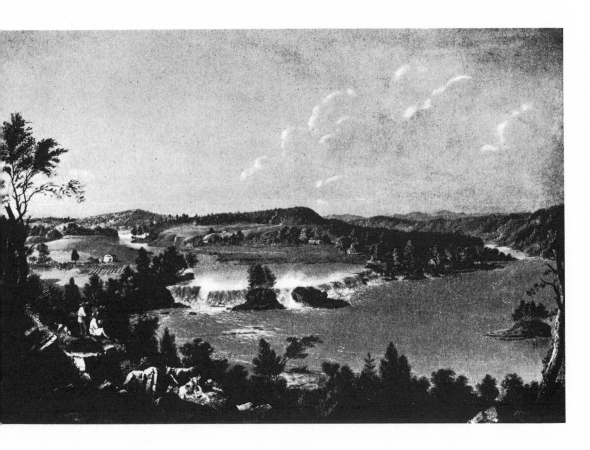

FIGURE 64
THOMAS DOUGHTY
On the Banks of the Susquehanna
Private collector

strips in which a sequence of views was fused together accustomed the beholder to the process of digesting such a new form of pictorial representation. In viewing a panoramic landscape the spectator must imagine that he slowly turns his head, as the artist actually did when he painted the picture.

The bend of the Hudson River where West Point is situated gave an excellent opportunity for panoramic landscapes. Following in the footsteps of his father, a Hudson River school painter, John Ferguson Weir (1841–1926), who was Dean of the Yale School of Fine Arts, painted views of the Hudson River which, in spite of their somewhat summary treatment, manage to convey to the spectator the artist's reaction to the space-quality of his motif (Fig. 65). An echo of the panoramic principle can be found in numerous Hudson River landscapes by painters such as Kensett, Cropsey, John W. Casilear (1811–93), and Gignoux, who were known to be representatives of a more traditional romantic landscape style. The names of Sanford Robinson Gifford (1823–80), Jervis McEntee (1828–91), and the brothers William M. Hart and James MacDougall Hart (1828–1901) could be added to the group of later Hudson River painters who at times felt the influence of the panoramic style. Landscapes in the form of rectangles far longer than they were high became increasingly popular in America. It is true that Andreas Achenbach in Düsseldorf at the same time showed a tendency to emphasize the horizontal extension of the canvas at the expense of its height, but he did not really relinquish the unity of his composition in favor of a panoramic form of seeing, as did the Americans. His example, however, might have encouraged the American painters to go further in the same direction, especially since the Academy of Düsseldorf, where Achenbach taught, still attracted many American art students.

There are two painters who on special occasions made use of the panoramic style in a very original way: David Johnson, the romantic realist, and George Loring Brown,[20] a celebrity in his time like Johnson, and equally forgotten today. In a comparatively small painting, *Mount Marcy,* Johnson developed the panoramic style into something like a *paysage intime à l'Americaine*—combining the sharpness and clarity of contour so characteristic of American atmosphere with the breath and feeling of vastness attained by Cole and his disciples in their vistas—an attainment, however, that was achieved at the expense of charm and exactitude (Fig. 66). George Loring Brown, in contrast to David Johnson, arrived at an authentic interpretation of nature in America not by a methodical and consecutive study of the American landscape but by a detour that led him to Italy and to a postromantic version of the picturesque. During his stay in Florence Nathaniel Hawthorne befriended him. In Hawthorne's *Italian Notebooks* [21] is a description of his first visit to the artist's studio in 1858. "I seemed," the novelist noted, "to receive more pleasure from Mr. Brown's pictures than from any of the landscapes by the old masters." It is true, we must not overrate the critical acumen of Hawthorne, who after years of staying in Italy could write: "Cimabue and Giotto might certainly be dismissed, henceforth, and forever, without any detriment to the cause of good art"; but his report on Brown is valuable because it contains the fragment of a conversation with the painter that sheds light on Brown's attitude toward nature. The art-

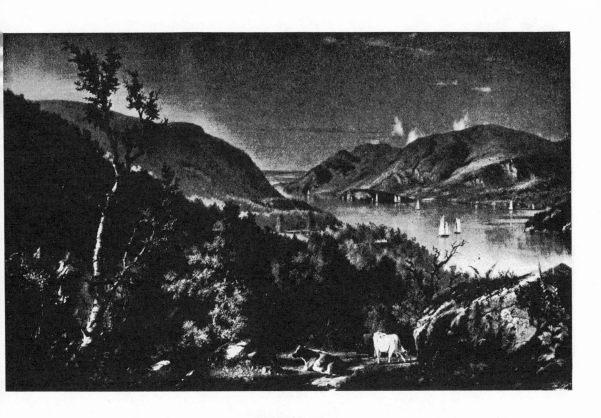

FIGURE 65
JOHN FERGUSON WEIR
View of the Highlands from West Point
New York Historical Society, New York City

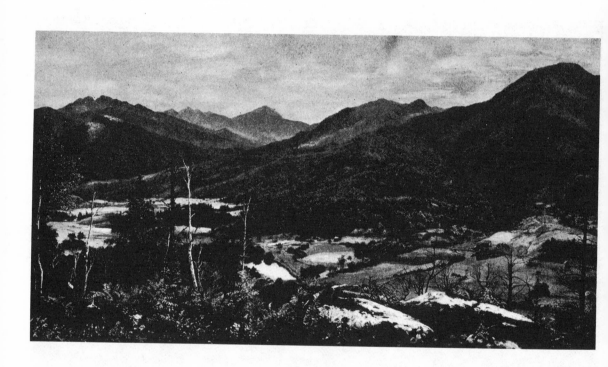

FIGURE 66
DAVID JOHNSON
Mount Marcy
Mr. and Mrs. Edward Kesler, Philadelphia, Pa.

ist showed Hawthorne some minutely detailed drawings which served as studies for his paintings. "We complimented him," Hawthorne continues, somewhat pedantically, "on his patience; but he said, 'Oh, it's not patience,—it's love!' In fact it was a patient and most successful wooing of a beloved object, which at last rewarded him by yielding itself wholly."

To this report we may add Henry T. Tuckerman's lengthy and warmhearted appraisal of Brown in the *Book of the Artists* of 1867—a kind of biographical and critical sketch that contains a moving story about Brown's struggle to go to Europe, the beloved land of his enthusiastic artist's dreams. After many laudatory comments, however, Tuckerman makes the surprising statement, drawn from a current criticism, that the successful paintings of Brown's Italian period did not represent the best the artist had to give. Speaking of Brown's post-Italian, American period the critic, whose name is not given, said: "His color is now marked by a pearly-gray tone, which is restful and quiet in comparison with the lavish use of reds and yellows which characterized his work in other years. At the same time he elaborates his picture, finishing the smallest detail with sober, conscientious care."

There is in the Isaak Delgado Museum in New Orleans a view of the Tiber River in Rome by George, or, as his contemporaries called him in friendly malice, Claude Loring Brown, that confirms the verdict of the critic—a very brownish "prospect" with an all too rosy evening sky, summarily brushed on the canvas to recall the effect of darkened gallery pieces. In 1860 this painting addict of Baedeker exchanged his abode in the city of the Medici for his native

New England. And here, on the windswept coast, under a less halcyonic sky, he developed a style of his own: sober, meticulous, and honest. Paintings such as *View of Norwalk Island* in 1864 (Fig. 67), and *Medford Marshes,* now in the Boston Museum, are most impressive examples of authentic American landscape painting.

The change of Brown's style suggests two things: first, that he found himself when he began to paint the landscape that was familiar to him and did not contain overtones which he was not sufficiently sensitive to catch; secondly, that he was influenced by the American art form of the panoramic landscape. In his post-Italian work he took over the narrow shape and the "additive" arrangement of motifs fused together in a horizontal row which was characteristic of the panoramic painters.

There are points of contact between Brown's literal portrayal of details and panoramic composition and the late landscapes by Heade (Fig. 68). Stray works such as Lars Gustav Sellstedt's (1819–1911) *Buffalo Harbor from the Foot of Porter Avenue,*[22] dated 1871 and now in the Albright Gallery of Buffalo, belong to the same group. But the real heyday of the panoramic landscape was already under way when Albert Bierstadt[23] set out in 1859 with the expedition of General Lander for the Rocky Mountains. A year earlier he had returned from a four years' stay in Düsseldorf trained to cope in a virtuoso manner with every difficulty nature could offer. This manner included unfailing formulas for all types of trees, mountains, clouds, waters, stones, and so forth. It also included the tricks of a stage designer translated into the smooth taste of the Victorian parlor. And it included, as its

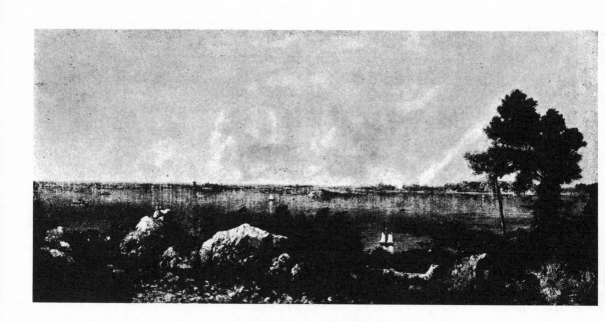

FIGURE 67

View of Norwalk Island

Addison Gallery of American Art, Phillips Academy, Andover, Mass.

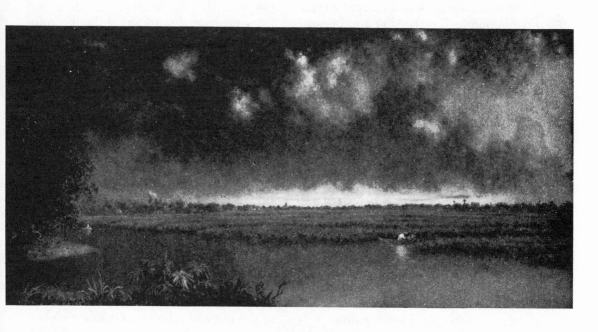

FIGURE 68

MARTIN J. HEADE

On the St. Sebastian River, Florida

Harry Shaw Newman Gallery, New York City

most constructive element, an astounding draftsmanship.

Bierstadt typified the German mentality of the Bismarckian era which wavered between the old love of the idyllic and the new spirit of aggression. The same painter who could become deeply engrossed in the charms of country life, as illustrated by his *Couple Driving,* plunged headlong into the great adventure of American expansion and became its most successful pictorial interpreter. Thus with a side glance he took in the military operations of the Civil War. In a battle piece, the *Bombardment of Fort Sumter,* he used the panoramic style more effectively than any of his predecessors (Fig. 69). The eye follows the military operation free from all obstruction. The spectator feels as if he were in the gondola of an observation balloon. The air is limpid. The sea is calm. No detail escapes the artist, from the gun emplacements in the foreground to the tiny torpedo boats in the distance, but all these details are integrated into a truly monumental landscape. Bierstadt had an unusual feeling for the earth itself. Under his hand topography became alive.

After his first voyage to the Rocky Mountains with General Lander he visited the West repeatedly, fascinated by the spectacular scenery; an indomitable tourist in search of what the guidebook calls the "wonders of nature": snow-covered peaks, thundering waterfalls, primeval forests. This love was not affected. Eyewitnesses tell stories of his enthusiasm: how he defied all hardships of travel in the wilderness to get a favorable view of a ravine or a rugged rock, how he sketched in a frenzy, in rainstorm or scorching heat. Bierstadt's effusive temperament projected itself into the subject matter: it was quite natural to

him to exaggerate what he saw. The glaciers grew into oceans of ice, the peaks rose up into cloudlike towers of Babel, the forests became taller and denser, the lakes more shining and diaphanous (Fig. 70). When the painter, at home in his New Bedford studio, turned his outdoor sketches into exhibition pictures, he gave a smooth finish to his geographical fantasies that made the ruggedness and awe-inspiring grandeur of their prototypes slick enough to fit into any elegant parlor. Tradition had it that he gave to the picture of a mountain which had as yet no name, that of one of his wealthy patrons, and by this method induced him to buy the painting—at an excessive price, it goes without saying! The painting, thanks to the frankly idealized rendering of the motif, was an immediate popular success. Everybody talked about the magnificent mountain, until the nameless peak actually received the name Bierstadt had bestowed on it.

There is something of the adolescent atmosphere of an adventure story in his pictures, a braggadocio disarming in its obviousness. A trapper on his horse stops at the edge of a forest to wait for a comrade whose silhouette appears in the distance, while the sun sets on the horizon, coloring the clouds with all shades of pink and yellow. Or a lone wolf lopes along the shores of a forlorn lake and a somber pine wood stands at the foot of gigantic mountains. In another painting fierce rays of sunlight pierce through the tops of enormous Sequoia trees while a torrent plunges down the boulder at their feet and a deer shyly steps through the underbrush. It needs imagination to create such effects and to make them credible.

The gorgeous scenery of the West soon attracted other painters. After Bierstadt

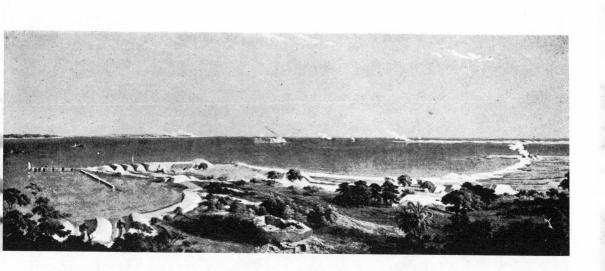

FIGURE 69

ALBERT BIERSTADT

Bombardment of Fort Sumter

Union League of Philadelphia, Pa.

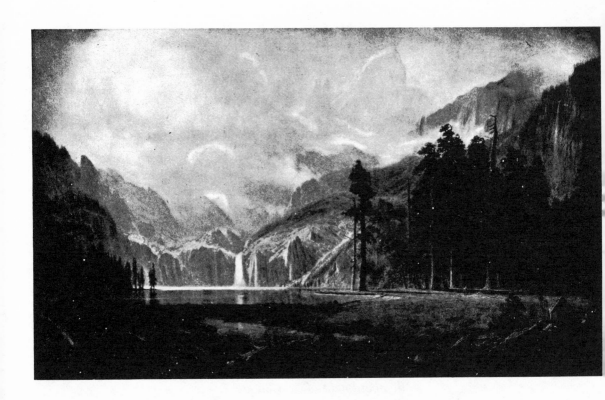

FIGURE 70
ALBERT BIERSTADT
Mount Whitney
Minneapolis Institute of Arts, Minneapolis, Minn.

came Thomas Hill [24] who, like his German-born colleague, painted both colossal panoramic landscapes and genre scenes such as the *Fishing Party* discussed previously as an example of intimate feeling for nature. There is, however, not such a great discrepancy between the two fields of Thomas Hill's artistic activity as between Bierstadt's monumental landscapes and his idylls. Hill's panoramic views of the Yosemite Valley are much looser than are those of Bierstadt, and as a genre painter Hill had more breadth (Fig. 71). In brief, his style was more uniform and he did not indulge in the stage designer's tricks which came so naturally to Bierstadt.

English born, like Hill, was the third and latest of the painters of the spectacular West, Thomas Moran [25] (1837–1926), who came to America at the age of seventeen. When only twenty he painted *Spit Lights, Boston Harbor,* a broad and supple seascape that points toward Turner, whose enthusiastic admirer he became when he visited London five years later. The picture is now in the collection of Mr. A. Wesley Bradley, Cleveland. Back in America Moran turned to Yellowstone Park, Yosemite Valley, and the Grand Canyon for inspiration. What he saw evidently excited him to as high a degree as it did Bierstadt. But in contrast to Bierstadt the somewhat younger Moran was primarily a man of color. It was, it is true, not a subtle sense of color that controlled his work. It seems as if whirlpools of colored fire haunted his imagination, and that he tried to find a realization for his fantasies in the purple rocks, in the azure haze of gorges, and in the fiery sunsets of the Colorado scene. What he painted, however, was not a mere report of his topographical finds tinged with his individual color vision—

it was an outright, uninhibited orgy, a pictorial fire music more Wagnerian than Wagner if this were possible. Bierstadt and Hill are dwarfed by and appear pale in comparison with this furious display of glowing mountain ranges, dizzy abysses, and thundering cataracts brushed on canvases so big that one thinks the next step would be a life-size portrait of Pike's Peak (Fig. 72). The people who enliven these marvels are pathetically small. They move aimlessly in a labyrinth of cosmic proportions (Fig. 73). As an historic phenomenon, Thomas Moran has carried the unsound doctrines of the late period of Turner to the extreme. But since the world, rightly or wrongly, accepts Richard Wagner, it has no right to belittle Thomas Moran. His was no mean talent, and in his most convincing works he displays a true mastery of the panoramic style. His space feeling is akin to that of the men who covered the ceilings of Baroque churches with illusionistic frescoes—only they raised their eyes to the heights of the sky whereas Moran, placing his easel on a choice observation point, looked down into the crevices of the earth.

In the meantime another representative of the panoramic style, Frederick Edwin Church (1826–1900), had embarked on an even more pretentious undertaking in search of "bigger and better" motifs. The landscape of the United States did not satisfy his unquenchable thirst for the thrilling. He began as Cole's pupil and painted lovely views in the romantic vein of his master. But when he read in Alexander von Humboldt's famous book *Kosmos* the explorer's report of his travels in South America, he was so enraptured with the description of tropical nature that he too decided to travel in South America. He

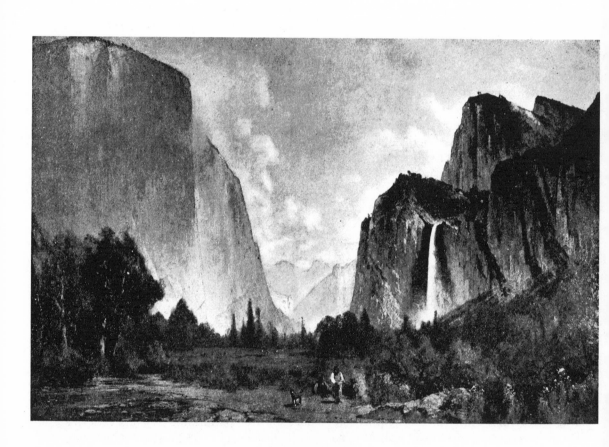

FIGURE 71
THOMAS HILL
El Capitan, Yosemite Valley near Mirror Lake
Robert C. Vose Galleries, Boston, Mass.

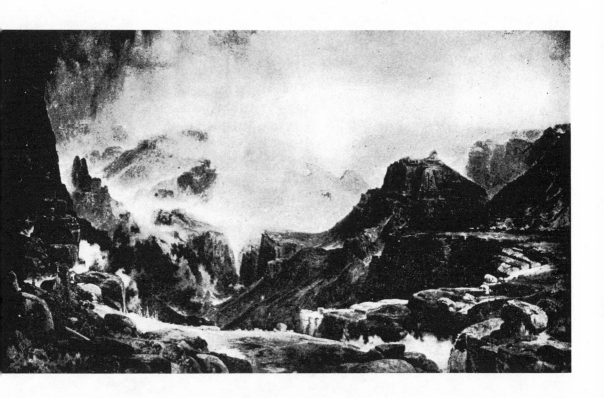

FIGURE 72

THOMAS MORAN

The Chasm of the Colorado

Capitol, Washington, D.C.

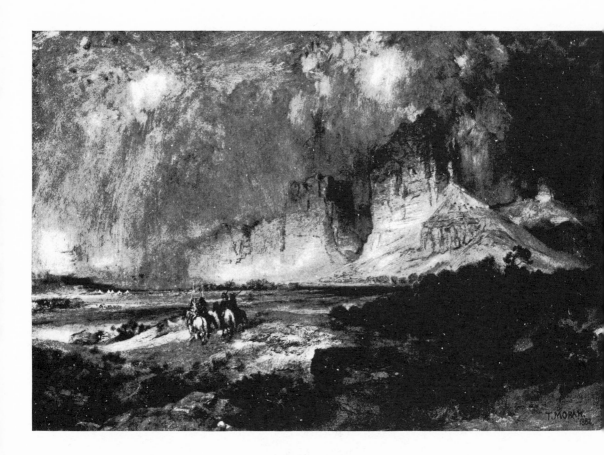

FIGURE 73

THOMAS MORAN

Cliffs of the Upper Colorado River, Wyoming Territory

National Collection of Fine Arts, Washington, D.C.

did so as early as the 'fifties, and filled his sketchbook with studies of the remarkable things he had seen. Humboldt in his *Kosmos* recommended that the artists of his time paint panoramas of the most remarkable scenery of the earth. His book, which appeared in Germany in 1845 and had its first American edition five years later, evidently reflected the vogue of the circular panorama at the beginning of the century. Church formed his style during the 'fifties, which saw both the decline of the circular panorama in Europe and the heyday of the moving panorama in America. He was an artist of the educated classes if ever there was one, and would scarcely have stooped to what he must have considered a vulgarization of a scientific concept—the field of a Banvard and other showmen; but he adopted the art form of the panoramic landscape and he handled it with an ease and grandeur that dazzled his contemporaries. He painted, to use a jesting term coined by the critics of the day, "full-length landscapes," [26] in which he unfolded a whole compendium of South American natural history, beginning with the vegetation around inland waters and ending with a volcano emitting a column of smoke (Figs. 74, 75). When his paintings were exhibited, in a special room fitted out with footlights and dark draperies, the public stood in deep respect, whispering learned comments that a bombastic textbook supplied. Art had definitely turned scientific and educational. But it speaks for the third quarter of the nineteenth century that it had a public that enjoyed these somewhat ponderous pictorial classroom demonstrations. And the public remained faithful to Church when he turned from the tropics to the far north and, high up in Labrador, painted icebergs from nature, or finally,

trying to lift up his audience with classic reminiscences, traveled through the Mediterranean and brought home a view of the Parthenon, the marble columns reflecting the red and gold of a sunset. The public followed him and paid him so well that he eventually could realize the learned travel painter's ideal—a comfortable villa in the Catskills, magnificently overlooking the Hudson, built in what he considered an authentic Moorish style. America and the Orient were, so to speak, at hand to inspire the painter to ever new flights.

The end of his career was tragic. Both his hands were paralyzed: he struggled courageously and in silence against his fate, fastening his brush to his arm, until the growing paralysis compelled him to live out his life in the enforced leisure of his fantastic home.

After Church everything in the same line could only be an anticlimax. When Conrad Wise Chapman [27] (1842–1910) painted a panoramic view of the Valley of Mexico in 1865, he reproduced the subtropical landscape sensitively in a matter-of-fact manner which strikingly contrasts with the travelogue romanticism of the flamboyant painters of the westward expansion and reminds one somewhat of Velasco,[28] his Mexican contemporary (Fig. 76). It is true, Chapman did not go to Mexico in search of the picturesque. He had been a Confederate soldier and was looking for a refuge; thus a foreign city appeared to him in a considerably more prosaic light than it did to men like Church. After all, Chapman was the predecessor of a generation to which traveling at home and abroad was to become routine, and which lacked the psychological impulse to paint exciting panoramic landscapes. Gradually the panoramic landscape lost

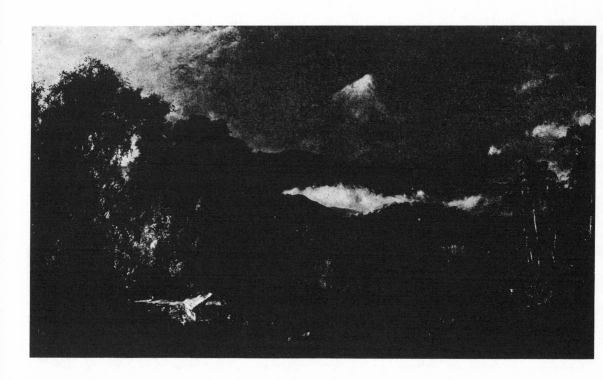

FIGURE 74
FREDERICK EDWIN CHURCH
Chimborazo
Mr. William Church Osborn, New York City

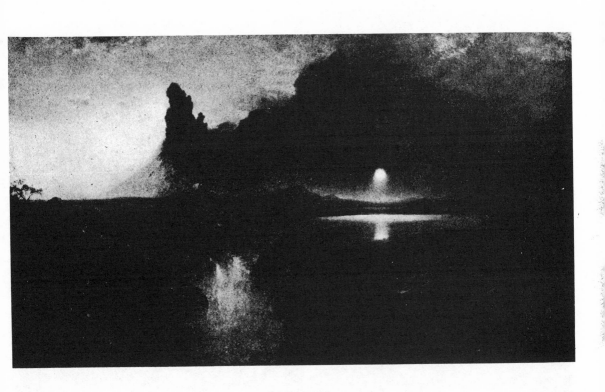

FIGURE 75

<small>FREDERICK EDWIN CHURCH</small>

Cotopaxi, Ecuador

Mr. John J. Astor

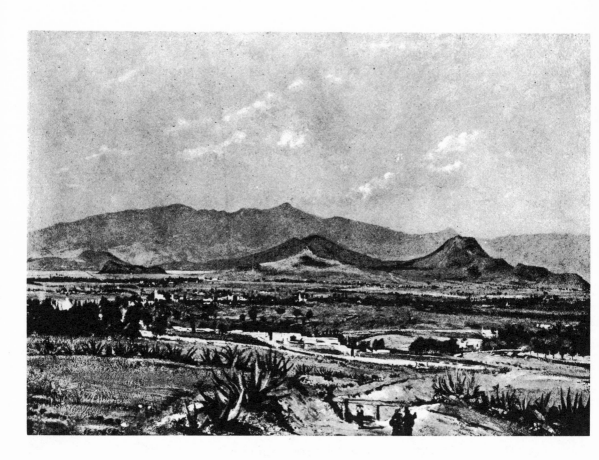

FIGURE 76
CONRAD WISE CHAPMAN
The Valley of Mexico (section of a four-part panorama)
Valentine Museum, Richmond, Va.

its appeal to that part of the public which was seriously interested in art. The inevitable stage of vulgarization turned it into hackneyed murals decorating the waiting rooms of railway stations.

In retrospect, however, the significance of the panoramic landscape must not be underrated simply because its aftermath was banal and left an unpleasant memory. The distance of time from which we judge it has become great enough to see it in its proper perspective. The panoramic school conjured up aspects of nature hitherto scarcely approached by painters. The panoramic style is a parallel to the style of trompe l'oeil practiced by William Harnett and other American still-life painters at about the same period, for in both cases the science of optics formed the ultimate source of an art form. In both cases the artist tried to convey his reaction to nature by means of illusionist devices that transcended the limitations of traditional art forms. The "heightened realism" of the trompe l'oeil and the wide-angle view of the panorama painting with its shifting vanishing point are characteristic of America in so far as they are developed from an urge for exact documentation.[29] The trompe l'oeil makes the painted object appear tangible; the panoramic landscape unfolds a comprehensive view before your eyes in such a way that it appears to you as though you look at it from a mountaintop or from an airplane.

The panoramic style gave visual expression to an important stage of American culture no less convincingly than impressionism manifested the spirit of France at an equally significant period. Both movements overlap each other in time, but while French impressionism conquered the western world, the panoramic style remained an American affair and eventually fell into disfavor, for its artistic quality was limited by its very objective: documentation at any price. Aesthetic reasons, however, do not fully explain the change of taste, because the achievement of the panoramic painters is, on the whole, too impressive to be overlooked. It was rather the psychological background of the panoramic school that conditioned its effect: namely, the mentality of the American expansion, for that was a dynamic experience restricted to America itself. It was shared least of all by a Europe that had been long static. Even in America the attitude toward life has changed fundamentally since no "frontier" now exists, and it is difficult for a modern American to feel as the public of a Bierstadt, a Hill, and a Moran felt. The panoramic school demands an historic approach in order to be correctly appraised. If, however, this historic approach is taken, it will be clear that the painters of the panoramic school, in spite of their weakness for melodrama and showmanship, have made a decisive contribution to the interpretation of the American landscape; for they felt that the central problem of American landscape painting was the visual representation of a unique space-feeling. This problem will pose itself before every generation trying to paint America, and nobody who sets out to do it can ignore the work of the panoramic school.

CHAPTER FOUR

WITH FRESH EYES

THE painters of romantic landscapes either studied in art schools or otherwise acquired the equivalent of academic training. Many had access to the educational institutions of Europe. Some were born abroad and had their early training at home. Their patrons belonged to an educated stratum of society, which was more or less concentrated in the large cities. This is true of the whole movement from Washington Allston and his circle of early romanticists to Thomas Moran and the postromantic school including, with qualifications, the regionalists Mount, Bingham, and other "little masters." This reservation is made with regard to the latter category because they form a connecting link with another stratum of artistic production, a stratum that lacked professional training and was patronized by people not belonging to the selected group that enjoyed the privilege of higher education. It is impossible to limit this stratum of art and its consumers to a single "class." American life, especially during the nineteenth century, was too fluid to allow a clear-cut sociological classification. Expansion and immigration kept its social structure from becoming static, and in the old established communities the factor of distance, that peculiarity of vast and sparsely populated countries, formed a great obstacle to the spread of higher education. For all these

reasons the art of the advanced groups had a limited scope. The masses which labored in the growing industrial plants were not yet touched by the culture of the upper stratum. The variegated group of men who carried civilization into the wilderness was cut off from the sources of advanced culture by the very fact that they were laying the foundation of a future civilization. It cannot, however, be assumed that the uncounted thousands of the ever-growing population outside the cities were without any creative urge or had no demand for artistic values. The degree of both the creative urge and the demand for art varied according to the various social and educational levels, and thus the traditional distinction between the level of what is pedantically called the fine arts and what is condescendingly called folk art is not satisfactory. It does not even fit the European situation too well, but in Europe at least peasant art formed so strong a stratum of artistic production that the terms folk art and peasant art were used synonymously. Peasant art in America was for all practical purposes limited to transplanted groups such as the Pennsylvania Germans. American folk art, however, covered a great variety of production, from the cigar-store Indian to the jigsaw patterns on frame houses; from the ornamental quilt to tinsel painting. And it included a rich output of pic-

tures in all media; pictures that ranged from the crudest wall decoration to the work of provincial artists who are scarcely discernible from the "little masters" listed here as regionalists.

The term American primitives has been coined for the stratum of self-taught artists who are distinguished by a non-realistic approach. This term is excellent as far as it goes, but it characterizes only a part of the field of art production outside the strictly professional sphere. This field includes perfectly "naïve," untrained men in the hinterland, amateurs who, from popular manuals or occasional contact with professional artists, picked up a rudimentary technical knowledge, itinerant limners who had acquired a certain proficiency in portraying people and objects with results more quaint than aesthetically satisfactory, and finally house painters, sign painters, craftsmen, and scene painters who, among other works, turned out panoramas. Wayward characters who, in spite of being trained to produce art for the exhibitions, preferred to cater to the "little people" in out-of-the-way places also belong to this variegated group which has in common only one thing: the ingenuousness of its approach.

Primitive painting other than that of the middle ages and the Orient was not appreciated before the art of the Douanier Rousseau was discovered by modern critics. This happened shortly before the first World War. Since that time only a small number of genuine primitives have come to light in Europe. The opportunities for artistic training are so numerous there that few gifted youths grew up with the naïveté of the primitive. In the case of Henri Rousseau peculiarities of temperament and unfavorable social conditions seem to have stunted his intellectual growth without arresting his artistic de-velopment. The situation was different in America. The selected few who participated in the art life of the cities were not in proportion to the gifted people all over the country who were left to their own devices. When these people took up painting, they did not try to "imitate nature" by means of a technique which the student acquires in a professional school. They tried rather to produce something "beautiful." This implies that they followed a stable concept formed in their minds instead of being guided by the visual impression of the moment. The art of the primitive, in brief, is not perceptual but conceptual.

The art of the middle ages was fundamentally primitive, and thus conceptual. The Renaissance developed the sciences of perspective and anatomy and its innovations rendered the language of medieval art obsolete. The man of the Renaissance demanded of painting what medieval art could not give: optically correct representation of space and volume. The new attitude was strictly perceptual.

When Hawthorne described Cimabue and Giotto as incompetent and extended this censure to all whom he considered primitives, calling them "Pre-Raphaelites," he represented the average man of his time who clung to the ideals of the Renaissance. Charles Dickens during his American travels poked fun at what he considered hilarious daubs encountered in a small town in Ohio: [1] some stiff and naïve family portraits which evidently were the work of an American primitive and might now be carried home proudly by a modern collector who had "discovered" them.

A traveler in Dickens' time could easily have stumbled upon one of the numerous copies of the *Peaceable Kingdom* by the

Quaker preacher Edward Hicks [2] when he walked into the house of one of the Friends in Pennsylvania. Hicks lived from 1780 to 1848 the life of a humble sign and coach painter, probably not less pleasing to God than was Fra Angelico who, four hundred years earlier, covered the walls of his monastery with holy pictures.

The eleventh chapter of the Prophet Isaiah had captured Hicks' fancy. It is a prophecy of peace on earth that will come when the wolves will graze with the sheep, and he painted this Utopia including all the animals listed by the wordy prophet. In the background Hicks depicted significantly William Penn's treaty with the Indians.

Occasionally he painted a landscape with animals which had no allegorical implications—but since his world was closer to the world of a medieval bestiary than to the nineteenth century, every animal displayed a well-defined character: courageous or cunning, humble or haughty as in the fable. This old sign painter was a touching personality and certainly Fra Angelico would not have sneered at him.

The untutored artistic efforts of forlorn mystics in out-of-the-way workshops remained unnoticed by their educated contemporaries in the cities. The carpenter who in his leisure time whittled all kinds of figures from a spare block of wood, the schoolmistress in the forgotten little schoolhouse somewhere in Missouri or Kentucky who created with water colors her own little imaginary world, the small-town clerk who felt the desire to put down in paint the scenery of his favorite Sunday walk—all these were repressed artists. [3] Given the conditions of Europe where an art school was to be found practically everywhere, they might have be-

come competent artists, or if their talent was too weak, they might have become part of the artistic proletariat that clogs the great art centers of Europe—a joyless mass of bohemians.

In America the humble practitioners of the fine arts lived under conditions not too different from those that prevailed during the middle ages in Europe and in the Orient up to modern times. They belonged to a basically agricultural, not yet industrialized society, in which the crafts were a living tradition and even penmanship was an art rather than a technique. The American primitives in their best achievements display, as did the European painters of the middle ages, a convincing power of expression, a high quality of design, and a decorative sense of color that is altogether disarming. [4] It is true that lithographs and other prints communicated the current fashion of art even to remote places, in a more or less belated and hackneyed form, and the traces of these influences can be found in many primitive paintings. But they remain slight overtones only and rarely mar the style of the picture. This is true even in the comparatively frequent cases where the primitive used a nonprimitive painting or print as a model for his own work. Sometimes these influences from the "upper" stratum lead to very interesting results, as when the anonymous painter of a *Hudson River Landscape with Sailboats* [5] transforms the space vision of the panoramic school into an almost flat decorative composition (Fig. 77). He certainly had not heard anything of Poussin or Claude Lorrain, but he produced a kind of formalized heroic landscape with a tree planted in the center of the picture and silhouetted against the background—a natural monument if ever there was one. Even the repoussoir ap-

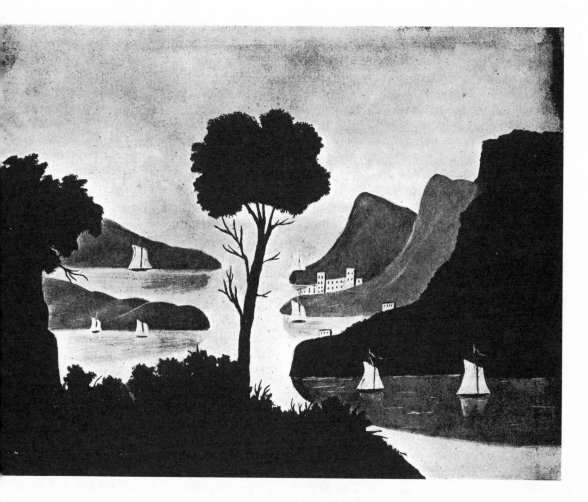

FIGURE 77
UNKNOWN PAINTER
Hudson River Landscape with Sailboats
Museum of Art, Providence, R.I.

pears, true to the best academic principles.

While the anonymous painter of this *Hudson River Landscape with Sailboats* reinterpreted a defunct classic tradition in terms of primitive art, another primitive painter who occasionally signed his works Thomas Chambers [6] was inspired by the same landscape to an entirely different type of picture. His *"Under Cliff," Hudson Valley* shows the winding river with equally winding roads, the conical trees and jagged rock formations known to us from Joachim Patinir and other Flemish artists of the fifteenth and sixteenth centuries (Fig. 78). Evidently this similarity is not the result of an influence; how should an American primitive have had the opportunity of studying the late Gothic art of the Low Countries? It is a genuinely parallel development between individual and society.

The northern contemporaries of the early Italian Renaissance were first termed Flemish primitives in the nineteenth century. As a matter of fact, the only primitive elements in their refined art are remnants of the conceptual approach and the symbolism of the later middle ages, such as multiple perspective, and a sense of wonder. These are the elements that are paralleled by the style of the American primitive. The archaic concept of a world in which rivers are curved silver bands, mountains vertical crags, trees cones or spheres, and houses like building blocks from a toyshop can be traced through the development of both Oriental and medieval painting. The American primitives (who are, after all, linked with modern civilization) more often invite a comparison with periods in which perceptual elements were about to supersede conceptual elements than with periods of a strictly conceptual character. Or, in other words, they are, for all their nonrealistic quality, not rigidly abstract.

It can be concluded from this observation that the most primitive among the American primitives would resemble the art of more archaic periods. A study of the material supports this reasoning.

There is a picture by a primitive who, apart from his signature, W. Ranford Keefe, is unknown. Because of its somber character this picture is given by its present owner the name of *Tree of Foreboding* (Fig. 79). The ominous tree stands behind a dark pool of water. A weird organism with twisted branches, it sprouts fan-shaped bunches of leaves. The miniature painter who illustrated the manuscripts of the Romanesque period employed a pictorial formula for trees surprisingly similar to that of the American primitive who probably was no more conscious of the uncanny effect of his tree than the Romanesque painter of the quaintness we see in his work. In fact, a hay wain on a meadow in the back of the American picture suggests that the painter intended to paint a familiar and peaceful aspect of nature. If, in spite of this, something like "foreboding" crept into the painting, it was unconscious. All primitive art is closer to the unconscious than is realistic art, and for this reason it is bound to bring to the fore the anxiety that is buried in the depth of the mind.

An unknown painter of a pastel attributed to the 1860's approached, in the imaginative spirit of an Italian painter of the fifteenth century, a mountain motif that a Durand might have chosen for a realistic landscape (Fig. 80). The scene is that of a ravine; steep rocks form walls between which a river rushes in cataracts. Giant boulders are piled up by the

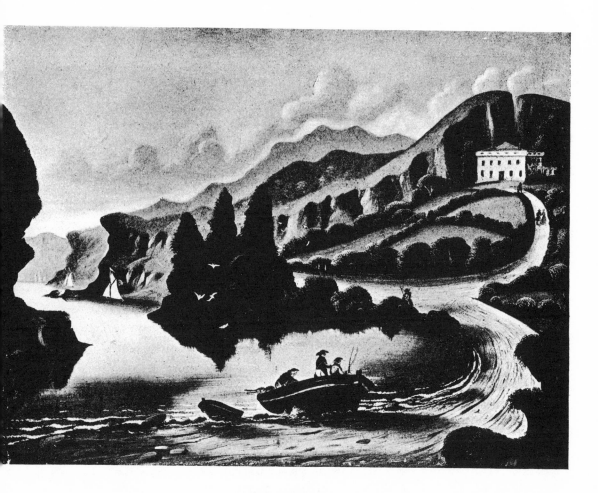

FIGURE 78

THOMAS CHAMBERS

"Under Cliff," Seat of General George P. Morris, near Cold Spring,
Hudson Valley

Museum of Art, Providence, R.I.

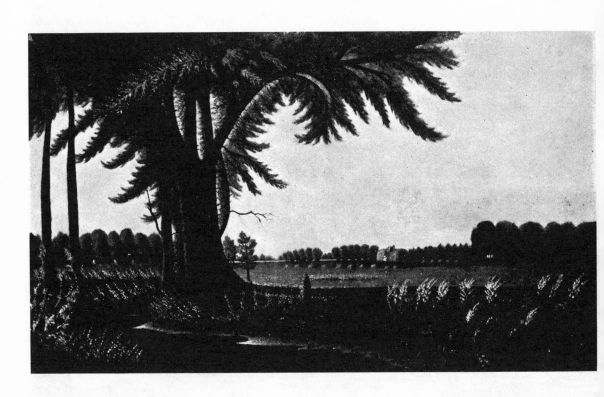

FIGURE 79

W. Ranford Keefe

Tree of Foreboding

Harry Stone Gallery, New York City

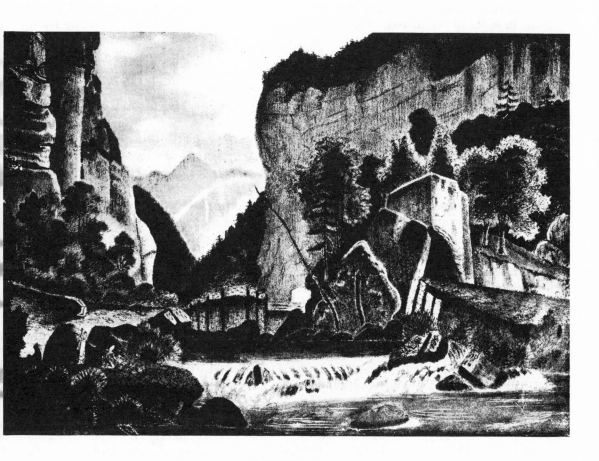

FIGURE 80
UNKNOWN PAINTER
Mountain Landscape
Museum of Modern Art, New York City

hands of nature like the broken towers and walls of an enormous city. Trees are cut out like wings and arranged in planes parallel to the walls of the rocks. No unessential details deflect the spectator from the essential of the composition. It is, in spite of its unassuming presentation, a solemn soliloquy of nature, to which we are admitted by an artist who had little dexterity but much reverence —a quality highly valued by medieval artists. Without trying to raise the importance of the humble pastel above its rank, I should like to remind the reader of Giovanni Bellini's famed *Religious Allegory* in Florence. The river landscape forming its background is like a masterly version of the theme played timidly by the anonymous American.

After the 1840's bird's-eye views appeared rather frequently among American primitives. The view from a moderately elevated standpoint was used by American primitives even earlier than this time as an artistic device. A picture of a country seat in Cincinnati with the steamboat *The Washington* on the Ohio River probably was painted before 1820 (Fig. 81). *The Washington*, which was built in 1816 as the first doubledecker to sail the Mississippi, blew up the next year. Evidently it was the novelty of the vessel that prompted the artist to depict it as conspicuously as he did. Besides, the style of the building that was the chief motif of the picture was of the beginning of the century; it probably was rather new when it was "portrayed." The geometric pattern of the fence, the decorative treatment of the foliage in the right foreground and other elements of the composition are strikingly archaic. One finds such traces in late Gothic tapestries.

A water color of 1848 signed and dated by Susan Merrett of South Weymouth, Massachusetts, represents, in a real bird's-eye view, a Fourth of July picnic (Fig. 82). The scene is a slope of a hill dotted with stiff and carefully detailed trees. Tiny figures are standing in leisurely groups or walking round a huge table set up parallel to the picture frame. The whole is done in a manner that recalls inlay work: the figures are cut out of paper and pasted on, each one forming a patch of color. One thinks of the style of Pieter Brueghel the Elder, the Flemish painter of peasant life, who distributed his tiny figures as little patches on a landscape seen from above and extending high up in the picture space.

During the 'sixties Joseph Hidley,[7] a versatile craftsman in Poestenkill, a small town in upstate New York, painted a series of views of his home town in bird's-eye perspective (Fig. 83). Like a toy city the little houses are distributed on the slopes of the rolling country, each carefully outlined and combining topographical interest with emotional attachment. The memory of the great Pieter Brueghel arises again, with the due qualification imposed by the comparison of an amateur with a great master.

An otherwise unknown primitive painter, J. Peters, Sr., recalls the Flemish masters in general in his picture of a mail coach passing a water mill in a valley (Fig. 84). A river winds its way among bridges past a small town nestled among mountains. A few people, two children and two adults, admire the spruce vehicle which is decorated by an ambitious coach painter with scrolls and the words "The Good Intent," an amusingly apologetic name for a public conveyance. The coach also bears the signature of Peters, a hint perhaps that the artist and the coach painter are identical. The water mill and the winding river, for all their Flemish

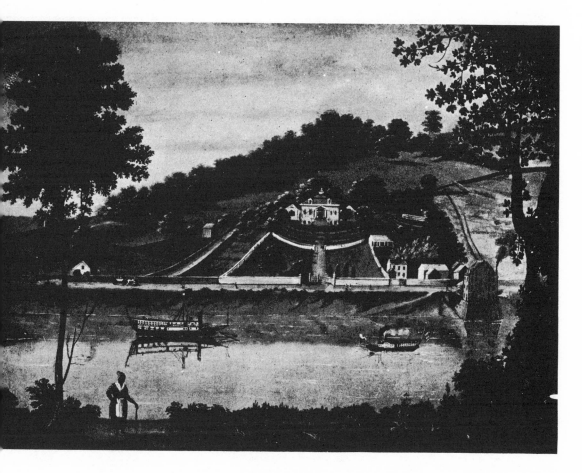

FIGURE 81
UNKNOWN PAINTER
"The Washington"—First Double Decker on the Mississippi
Harry Stone Gallery, New York City

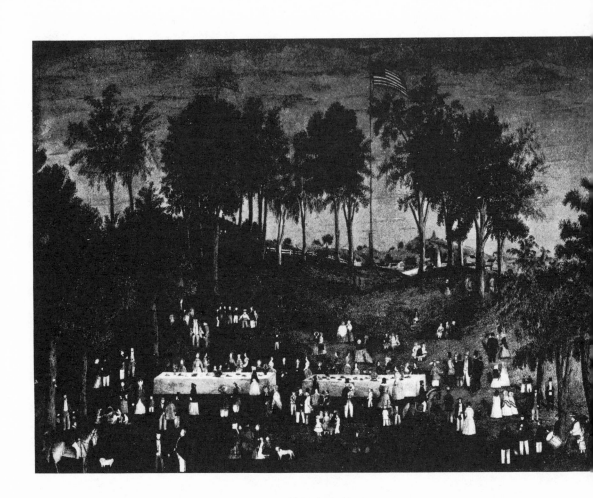

FIGURE 82
Susan Merrett
Fourth of July Picnic
Mrs. Henry G. Vaughan, Boston, Mass.

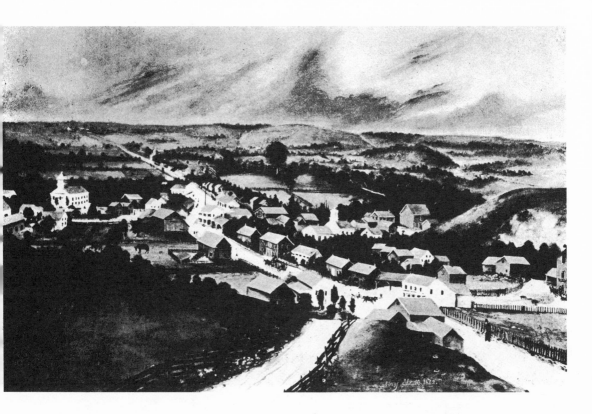

FIGURE 83
JOSEPH H. HIDLEY
View of Poestenkill
New York State Historical Association, Cooperstown, N.Y.

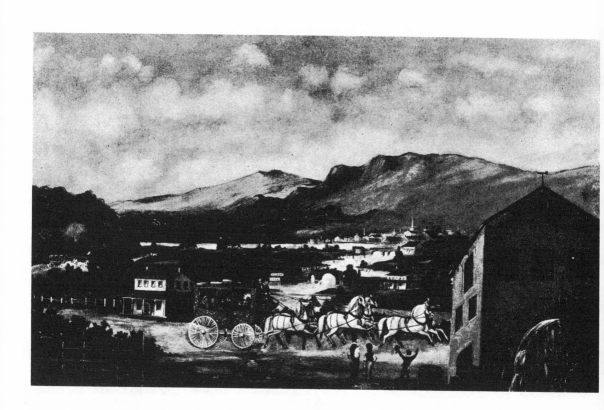

FIGURE 84

J. PETERS, SR.

The Good Intent

Downtown Gallery, New York City

reminiscences, are authentically American.

No American primitive paintings, perhaps, show more parallels to Brueghel and at the same time more genuinely American characteristics than do the winter scenes which are a favorite subject of artists in the North and East. Some of them are undiluted primitive, but most of them belong to a stratum which more or less approximates professional standards without losing the charm of naïveté. One may recall Brueghel's *Winter*, which shows a group of hunters tramping through deep snow on a hill overlooking a village (Fig. 2). The dark silhouettes of men and trees are set against a light background of mountains which rise above a pond, where tiny figures of skaters are moving. The dogs step carefully, their tails curled up. And it is surprising how much of the mood of Brueghel's winter scene is unconsciously recaptured in the lovely painting of an unknown American (c. 1840) which depicts a sleigh with two horses making its way through the snow-covered highway of a village between the dark skeletons of the bare trees (Fig. 85).

Or one may remember Brueghel's *Massacre of the Innocents*, with the isolated figures of the mothers, their slaughtered infants, and the soldiers of Herod set against the snow-covered square of a Flemish village, and compare it with the view of Brooklyn painted in 1816–17 by Francis Guy [8] (1760–1820), (Fig. 86). Disregarding the difference between the ordinary American scene and the gruesome story of the Gospel, the similarity is striking. The neatly outlined houses with the white snowcaps, the silvery sky, the isolated patches of the people in the foreground—all this has parallels in Brueghel's work. Guy belonged to a group of four landscape painters who came from England in the last years of the eighteenth century, but he was the only one who was self-taught. It is interesting to observe that the works of the other three are dated today and have only historic interest whereas Guy's work is as fresh and vigorous as when he painted it—or perhaps even more so; for its intrinsic quality fully reveals itself only to a generation trained to appreciate primitive paintings of postmedieval origin.

Whereas Francis Guy was an Americanized Englishman, the unknown primitive painter of *Chouteau's Pond, St. Louis* (Fig. 87) might have been an Americanized Frenchman, for he displays a leisurely elegance which faintly echoes the *ancien régime* in France. St. Louis had not yet lost the characteristics of its French origin in the 1840's, the time when the charming picture was painted, as indicated by the costumes of the figures in the foreground.

One wonders who the painter W. H. Titcombe was, who in 1853 signed a winter landscape of a most delicate style (now at an art gallery). The wooden buildings of a farmyard with their simple geometric forms stand out clearly against the soft rolling countryside, the filigree of the trees, and the heavy leaden sky. The unrealistic sizes of cattle and men betray the primitive even more than does the tendency to emphasize the pattern of details, such as the clapboards and fences, at the expense of visual unity. The general character of the last two pictures suggests a certain influence of the romantic painters. The activity of the primitive painters reached its highest level by the middle of the century; one almost could call their production a school in the sense in which we speak of the Flemish or Italian primitives as a school. Very soon the development of photography and the in-

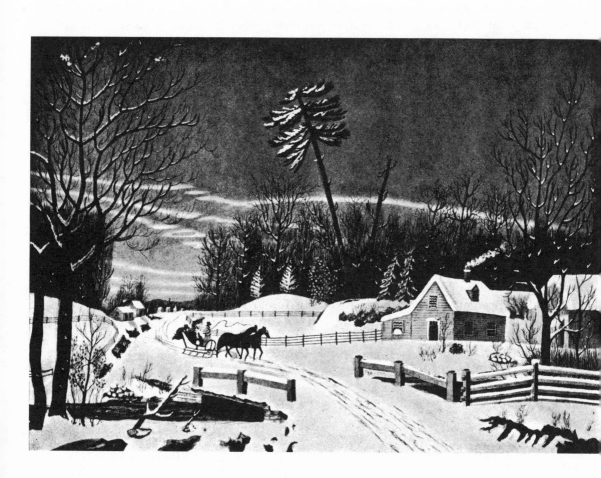

FIGURE 85
UNKNOWN PAINTER
Winter Scene
Henry Shaw Newman Gallery, New York City

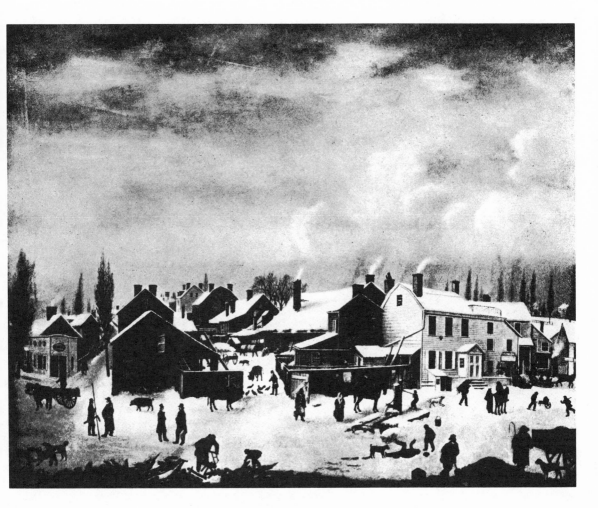

FIGURE 86

FRANCIS GUY

Brooklyn in 1816–17

Brooklyn Museum, Brooklyn, N.Y.

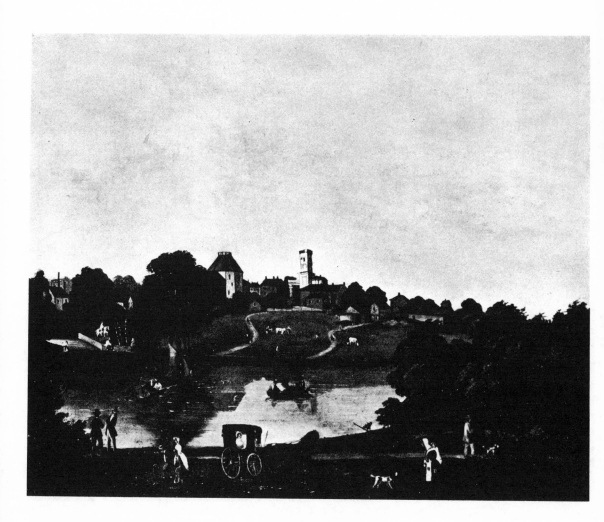

FIGURE 87

UNKNOWN PAINTER

Chouteau's Pond, St. Louis

Missouri Historical Society, St. Louis, Mo.

creased spread of cheap reproductions broke up the school and left only a scattered undercurrent of primitivism. The more sophisticated among the mid-nineteenth-century American primitives naturally tended toward a more romantic style. Romanticism had become popular, and romantic paintings appeared in sufficiently great numbers to be known to a comparatively broad stratum of people. In brief, the influence of the romanticists on primitive painters could now be expected to make itself generally felt because the romantic attitude was no longer restricted to the highly educated townspeople.

The anonymous painter who left us the curious *View of the Schuylkill Waterworks, Philadelphia*,[9] which might have originated about 1840, used a drawing by W. H. Bartlett as his model, but he romanticized its sober character (Fig. 88). The waterworks on the Schuylkill River are designed in a neat classicist style—but in the painting they loom uncannily like the castle of a mysterious prince. One senses all kinds of horrors behind the thick walls with their dark, gaping windows. The hilly promontory, somber and lonely, is accessible by a covered bridge, the pointed form of which is exaggerated and recalls the Rialto in Venice—adding a haunting touch of the exotic to the composition.

A view of Barnstable dated 1857 shows a similar style (Fig. 89). A wide-angle view, it covers the center of a little country town, with a church on a hill to the right and a spacious mansion with a fenced-in garden to the left, probably the home of the elegant people in the foreground and the middleground: a young lady in a broad feathered hat and her cavalier on horseback, a dignified couple about to step into a hansom, and two well-

groomed boys playing with a big dog. The church shows the characteristics of the then fashionable Gothic revival. The American flag is displayed conspicuously, obviously to commemorate a festive event. Clouds project changing shadows on the terrain. A certain lack of coherence gives to this otherwise romantic picture its slightly primitive quality.

If the view of Barnstable holds a place between primitive and romantic art, the work of George Harvey [10] combines the primitive and the scientific approach. Harvey was an Englishman who made America his home and explored it, watercolor pad in hand. He claimed to have invented a new art form, the "atmospheric landscape"—a pictorial interpretation of nature as a meteorological spectacle. His treatment of water color was rather hard and tense, and his sense of nature that of an amateur scientist; but, after all has been said, these water colors reveal an unusual talent that improvised an ingenious style. Rarified color combinations lend an exciting character of newness to every scene (Fig. 90). Harvey intended to publish his travel paintings in the form of portfolios, but the plan did not materialize. So he changed his method, enlarged his studies, and organized travelogues in America and England. In both countries his illustrated lectures seem to have aroused much enthusiasm.

Comparatively little is known about Harvey's life. He was born about 1800 and was still living in 1877, as is proved by a letter dated in that year. His work as a painter, so far as it is known, was done between 1828 and 1844, and his sojourn in America lasted from 1828 until about 1838. He apparently died in England.

Harvey's interest in science sets him apart from the other primitive or semi-primitive painters. He seems to have an-

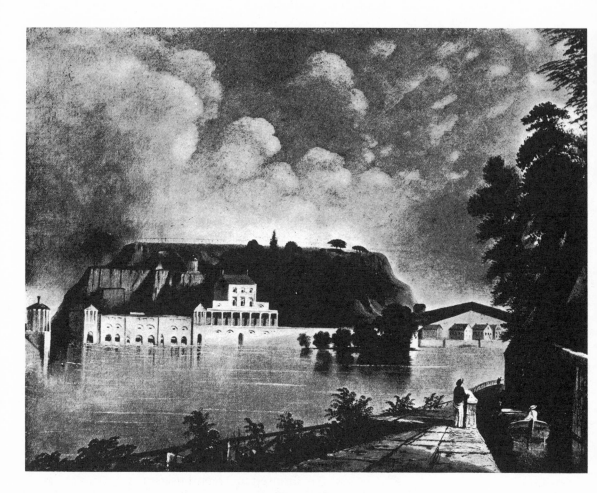

FIGURE 88

UNKNOWN PAINTER after WILLIAM HENRY BARTLETT
View of the Schuylkill Waterworks, Philadelphia
Detroit Institute of Arts, Detroit, Mich.

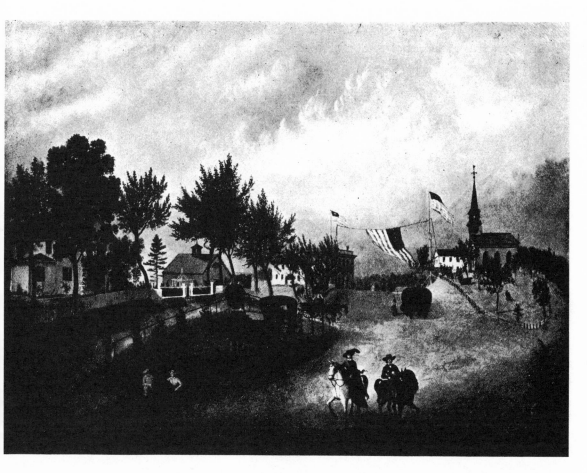

FIGURE 89

UNKNOWN PAINTER

View of Barnstable

Addison Gallery of American Art, Phillips Academy, Andover, Mass.

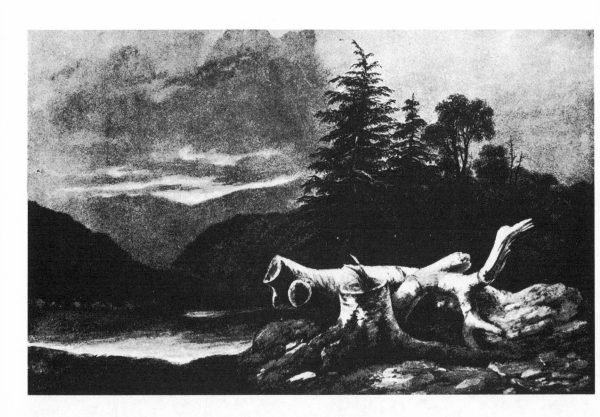

FIGURE 90
GEORGE HARVEY
Amongst the Allegheny Mountains
Brooklyn Museum, Brooklyn, N.Y.

ticipated the interests of Heade and the painters of the next generation.

Seth Eastman's (1808–75) interests, like Harvey's, tended more to science than aesthetics.[11] A professional soldier, he was drawing instructor at West Point from 1833 to 1840, and later on was stationed as commander of Fort Snelling on the upper Mississippi. It was here that he painted scenes from the life of the Indians, a subject that fascinated him, since he was interested in anthropology. His pictures from the frontier are arresting documents, primitive in style and refreshingly honest in their approach (Fig. 91).

Albertis D. O. Browere [12] is representative of the trained provincial artist with primitive overtones. This painter, born in Tarrytown, New York, in 1814, was the son and pupil of a sculptor who made a name for himself by making life casts of famous personalities. Young Browere studied for a short time at the National Academy of Design, but being of a somewhat adventurous spirit, he tried his hand at prospecting in California during the Gold Rush at the end of the 'forties. After his return from the fabulous West, which does not seem to have provided him with wealth but did not leave him without stimulating impressions, he spent a peaceful life in Catskill, painting the native scene with gusto and ignoring academic rules and standards. The result of his erratic and unmethodical activity is, paradoxically, a style of rare homogeneity—a style that in its ingenuous charm attracts more and more admiration as his scattered and forgotten paintings come to light. In his views of California the painter has given a truly romantic report of the days when the would-be nabobs rode the long way to the new Eldorado, where a landscape of bold contours and lush vegetation awaited them

(Fig. 92). He saw the country with fresh eyes and put down on canvas its picturesque crags and waterfalls, as well as its bare mining towns such as Stockton. Browere painted a masterly panoramic view of this town, with quaint figures distributed cleverly throughout the space—a space that is convincingly portrayed by means of a path that leads into the background (Fig. 93). The painter seems to have won considerable acclaim in his time by his narrative paintings from the life of the miners.

Attractive though these and other genre paintings by Browere are, his lasting contribution to American art is his landscapes, such as his simple *Catskills* which was painted in his home town in 1849 (Fig. 94). In this picture we find a tenderness, a loving absorption in the delicate charms of nature which, on a quite different level, corresponds to the attitude of one of the truly great in the history of landscape painting, Constable. Browere died in 1887 in Tarrytown, at a time when the progressive painters of America had scarcely an eye for the belated Biedermeier of their provincial colleague.

It would, however, be an error, if we assumed that the undercurrent of a primitive version of Biedermeier painting died with Browere. More and more forgotten painters come to light whose works display a similarly naïve absorption with details and an aloofness from the current naturalism that was not at all forced.

In the 'seventies and 'eighties Joseph Lee [13] painted in California. Little is known about him, except that his contemporaries wondered about his habits. He seems to have been a restless and elusive character who continually changed his studio in San Francisco and from time to time dropped out of sight

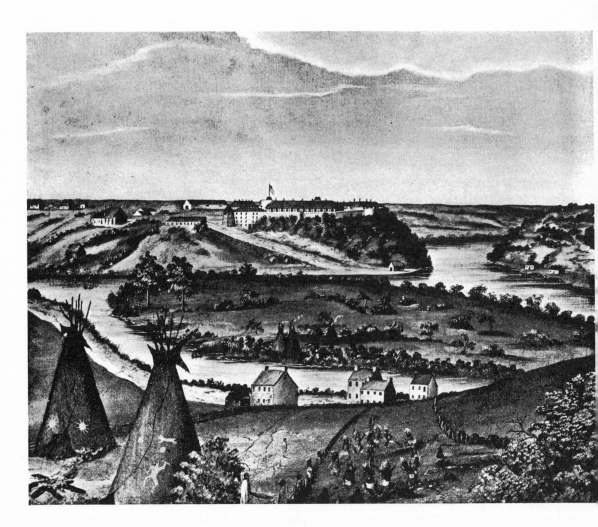

FIGURE 91
SETH EASTMAN
View of Fort Snelling
Minneapolis Institute of Arts, Minneapolis, Minn.

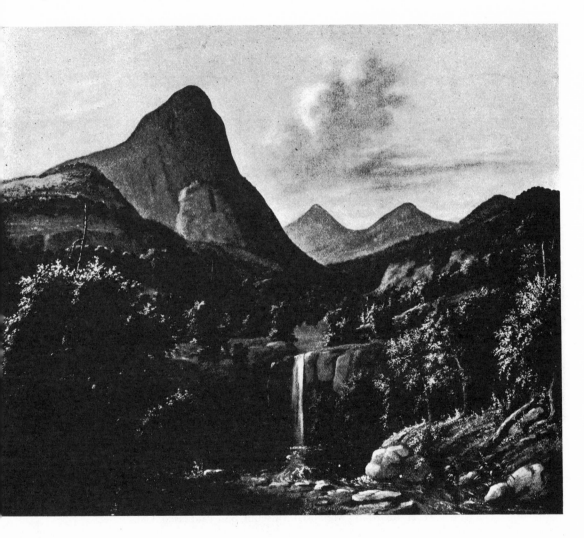

FIGURE 92
ALBERTIS D. O. BROWERE
The Falls of San Joaquin, California
Art Institute of Chicago, Chicago, Ill.

FIGURE 93
ALBERTIS D. O. BROWERE
Stockton, 1856
M. H. de Young Memorial Museum, San Francisco, Cal.

FIGURE 94

ALBERTIS D. O. BROWERE

Catskills

Brooklyn Museum, Brooklyn, N.Y.

completely. We do know, however, that his ships and landscapes were considered too meticulous and pedantically drawn. Among them are such gems as *Alameda Shore* and *Oak Knoll, Napa* (Figs. 95, 96). *Alameda Shore,* panoramic in its composition like Browere's *Stockton,* has as its main motif a long footbridge, the wooden posts and railing of which form a pizzicato rhythm around which is twisted a counterpoint of grotesque trees and sharply cubic houses. A hunter with two dogs seems strangely foreign in this immovable world. *Oak Knoll* is an equally meticulous report on an opulent wooden mansion designed in what was known as Italianate style. A large park surrounds the homestead. Various tame animals are grazing on the lawns and playing on the paths. A pleasure vehicle with a tent roof is ready to take the owners of this proud place on an outing. The painter evidently looks at the motif with awe and does not omit a leaf from his faithful record. In spite of this, one does not feel a lack of coherence, for a subtle and unerring sense of design unites the countless single factors.

Lee represented a comparatively sophisticated primitive version of the Biedermeier that survived as an undercurrent, but even the undiluted type of primitivism found its representatives in modern America. There was, to give one example only, the carpenter, Joseph Pickett (1848–1918), who in a series of naïve paintings reconstructed the history of his home town, Coryll's Ferry.[14] His style comes close to the art of the child (Fig. 97).

A farm woman in the State of New York, Anna Mary Robertson, or Grandma Moses (1860–),[15] as she became known after her discovery, paints with the ease of a child, guided only by an uncanny sense of design and an intuitive knowledge of color. Her inner eye has stored innumerable familiar images. Anna Robertson converts these memory images into pictures without linear and aerial perspective, without any traditional technique: direct and simple—but these direct and simple pictures have style; they are consistent and convincing (Fig. 98). Her motifs are the same as those of the early American primitives and they are treated in the same manner. Only their colors are brighter and clearer —pure, unbroken hues, put on the canvas unhesitatingly as if she belonged to the fauves in Paris, of whom she never heard.

The phenomenon of a more than seventy-year-old farmer's wife who in the enforced leisure of old age takes up painting and as an octogenarian reaches the full power of her talent, is of great significance. It demonstrates that primitive painting is yet a living factor in American art.

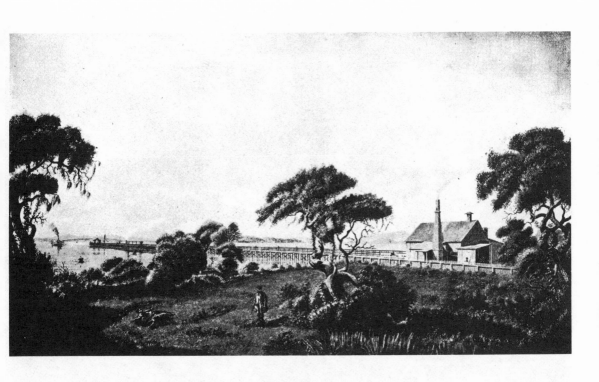

FIGURE 95

JOSEPH LEE

Alameda Shore

M. H. de Young Memorial Museum, San Francisco, Cal.

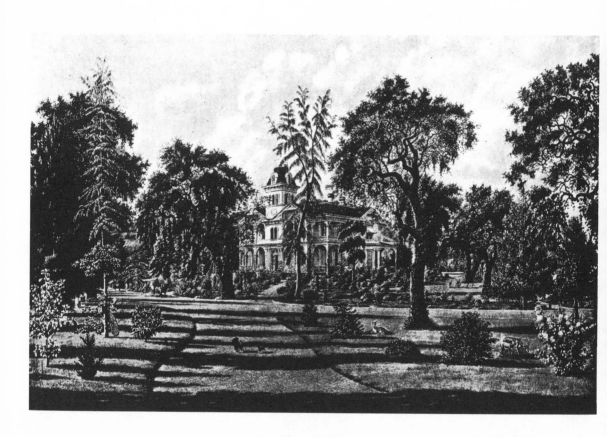

FIGURE 96
JOSEPH LEE
Oak Knoll, Napa
M. H. de Young Memorial Museum, San Francisco, Cal.

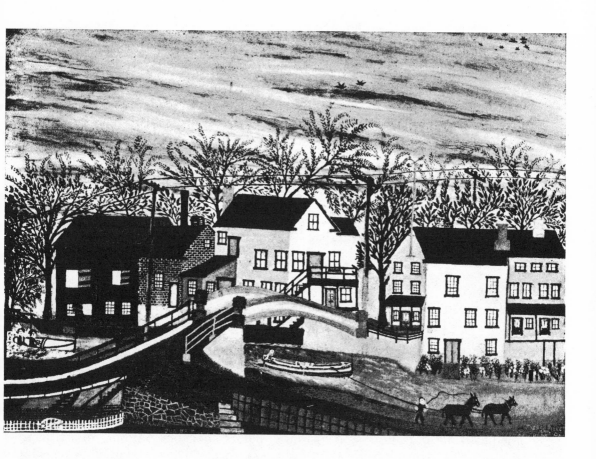

FIGURE 97

JOSEPH PICKETT

Lehigh Canal, Sunset, New Hope, Pa.

Galerie St. Etienne, New York City

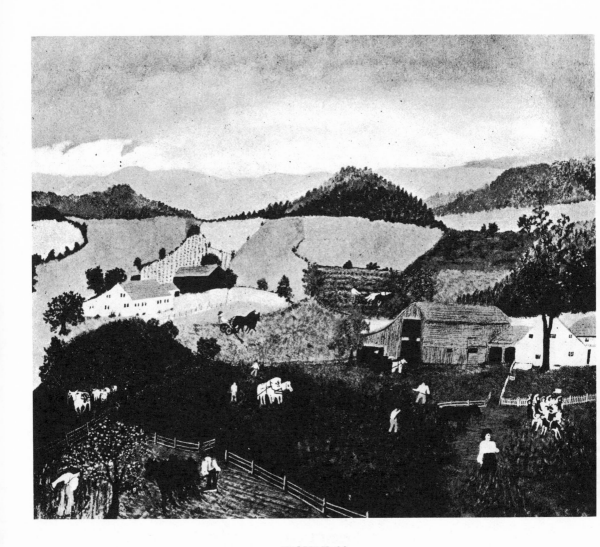

FIGURE 98

ANNA MARY ROBERTSON (GRANDMA MOSES)

McDonell Farm

Phillips Memorial Gallery, Washington, D.C.

CHAPTER FIVE

PAINTERS OF TONE AND LIGHT

WHEN, after the Civil War, the vast territory of the United States grew into a unit, life in America was not what it had been. The expansion was over. A new social structure began to manifest itself. To the artist this meant, among other things, a change of patronage. The *nouveaux riches* bought works of art in increasing numbers, but their taste was different from that of the discriminating men who were the first collectors of American art. Enterprising new art dealers imported both real masterworks and the favorites of the day from Europe. The latter included Tyrolese girls in phony folk costumes, Venetian fisher boys in picturesque rags, nudes posing as allegorical figures, and other fashionable subjects painted in the smooth manner that appealed to a shallow taste.

The homes of this period were styled after the dusky interiors of old museum pieces, but the people who lived in them were addicted to the gospel of industrialization that was shattering the aesthetic values of the past. The situation was confusing and bewildering.

Whereas the man on the street took things as they came, sensitive people set out to analyze what had happened. America witnessed the appearance of an art criticism of its own. James Jackson Jarves [1] wrote *The Art-idea* in which he interpreted the development of American art in the light of the development of European art. When he criticized the panoramic school unfavorably he did so for reasons that at the moment were pertinent enough, for the success of the travel painters blocked the way to success for the young painters who represented the forces of evolution. Jarves objected to the paintings of Bierstadt and Church, saying that they degraded the spectator to a mere "looker-on" whereas "the effect of high art is to sink the artist and spectator alike into the scene." Speaking of Bierstadt's most spectacular landscape, *The Rocky Mountains,* Jarves quoted the remark of an unsophisticated man from the country who, after looking for a while at the picture with the expression of waiting for something, asked when "the thing was going to move"; [2] the man evidently mistook the painting for a moving panorama.

The naïveté of the spectator does not seem to us as crude as it seemed to Jarves, for we consider the panoramic landscape a legitimate American art form. A sensitive observer in the 1860's, however, could not feel at ease when he saw that the American public isolated itself from the great movements abroad. As early as 1850 England had launched Pre-Raphaelism and France had launched naturalism, the first challenging the evils of materialism, the second praising ma-

terialism as a liberating force, but both united in their opposition to an art that was blatantly imitative and conventional.

In 1863 a well-written but short-lived art magazine bearing the esoteric name of *The New Path* appeared in New York. It was the voice of a small group, the American Pre-Raphaelites,[3] gathered around a gifted young painter and critic, Charles Herbert Moore (1840–1930),[4] who drew his inspiration from Ruskin.

Pre-Raphaelism, in spite of its name, was not so much interested in the revival of a past period as in applying its teachings. It is true, the painters of this group turned to the late Gothic and early Renaissance in their quest for "truth," but since no medieval tradition survived in America, the antiquarian tendencies of the English Pre-Raphaelites were of lesser importance to their American followers. The realism of the Pre-Raphaelites was rigid in its attention to detail but at the same time precariously coupled with a tendency toward idealization. Moore began as a sensitive Hudson River man (Fig. 99). During the 'sixties he painted landscapes in the Catskills which subtly idealized the familiar American countryside. His *Old Bridge*[5] (1868), without being forced into an alien pattern, has a decidedly Pre-Raphaelite touch (Fig. 100). In 1871 he joined the faculty of Harvard University as drawing teacher. Professor Charles Eliot Norton, the pioneer art historian of America, who was a partisan of the Pre-Raphaelites, took an active interest in the young man and furthered his academic career. For thirty-eight years Moore taught the theory and practice of art in this congenial atmosphere and concluded his successful career as Director of the Fogg Museum there. Moore's activity as a painter practically ceased with his appointment at Harvard, but his influence on the younger generation must not be underestimated. His teachings contributed substantially to the assimilation of European innovations.

Of the two European movements that advocated a close study of reality, namely, English Pre-Raphaelism and French naturalism, the latter was by far the more vigorous. Its leading American apostle was William Morris Hunt[6] (1824–79). Born into a well-to-do New England family, Hunt had every opportunity to develop his natural good taste and he made admirable use of it. When in Europe for an extensive period of study, he found his way from Düsseldorf to Paris; and, when there, from the fashionable studio of Couture, the most sought-after teacher in Europe at this time, to Millet, then still struggling with poverty in his humble farm home in Barbizon. The young American became his most enthusiastic pupil and, after his return to America, spread the gospel of Millet from his Boston studio with the zeal of a true apostle. It was not so much Hunt's work as a painter that achieved this goal —for his talent was rather weak—but his activity as a teacher and adviser of collectors. It was mainly through Hunt that the work of Millet and the painters of Barbizon found a ready market in America and that—a fact that is perhaps less known—an important work by Courbet, *The Quarry,* was bought by an art society in Boston as early as 1864. The French paintings made a profound impression upon the more sensitive among the young American painters, and their influence on the taste of the collectors was truly revolutionary. The pictorial qualities rather than the dramatized presentation of the subject matter came to be

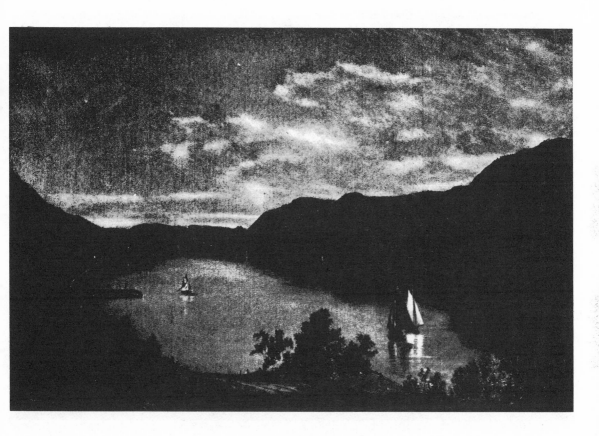

FIGURE 99
CHARLES HERBERT MOORE
Down the Hudson to Westpoint
Vassar College Art Gallery, Poughkeepsie, N.Y.

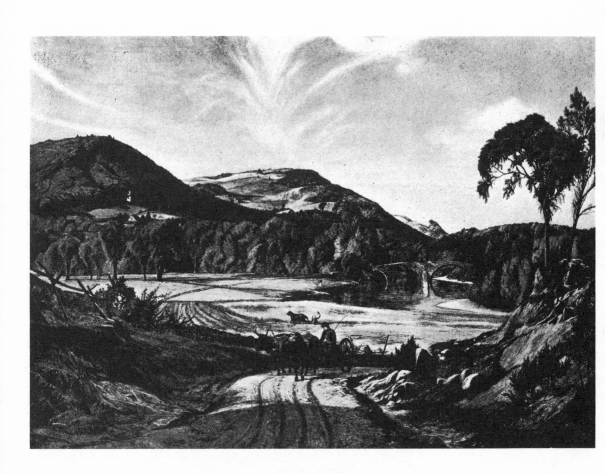

FIGURE 100
CHARLES HERBERT MOORE
The Old Bridge
Mrs. Juliana Force, New York City

considered the essential elements in a painting.

William Morris Hunt considered that his own failure to develop into a truly creative artist lay in his return to America. It is true, he never recaptured the quality of the studies made in his student years in France, but it is doubtful whether he would have achieved what his critical mind considered worthwhile even if he had expatriated himself.

The influence of France was as varied as its sources, for its points of departure were both the poetic and diaphanous landscapes of the romanticist, Corot, and the sober and firmly built naturalistic ones of Courbet, not to speak of the numerous painters who tended more or less toward the one or the other extreme. All agreed, however, on the fundamentals of painting. They interpreted nature as a network of *valeurs,* of subtly graded hues.

Central Park in New York, this monumental project in landscaping, had been hailed by Jarves as the coming of a new era in American art—a view that the era of geo-architecture with its power dams and scenic highways was to corroborate three generations later.[7] In the light of the new movement in landscape design, the vogue in landscape painting which developed after the panoramic school had reached its apogee attained a new symbolic significance. The English garden as conceived by its American protagonist Olmsted was to bring the man of the city into close and intimate contact with nature.

The painters of the era of expansion captured the thrill of the moment when a new peak or a new canyon appeared before the eye of the westbound traveler. The more general and simplified was his representation the greater was its appeal.

The era of expansion was followed by an era of integration. The painter of the new era was less concerned with the assimilation of new experiences than with the intensification of his sensibility.

The old painters of the "sentiment of nature" who might have served as teachers for the new generation did not speak the language of the young men who felt the urge to express their own reaction to the landscape. The Biedermeier attitude in which they were wrapped prevented them from absorbing the new ideas that had developed in France during the second third of the century—since Theodore Rousseau set up his easel in the woods of Fontainebleau. The panoramic painters were most antagonistic to the new trend, and thus were not chosen as teachers. But more and more of these small alluring canvases from France appeared in the exhibitions of New York: simple motifs taken from nature, painted with broad strokes in warm, blended tints, and vibrant with life. Unlike the panoramic pictures they did not intrude themselves upon the spectator with the didactic oratory of a travel lecturer. New names were to be read on the little gold labels which were fixed to the broad and highly ornate frames: Troyon, Dupré, Daubigny. In the 'seventies and early 'eighties the growing interest in the Barbizon school excited the members of the old school of American painters, driving them either into violent opposition or into attempting to digest the new style, an attempt that in most cases led only to confusion and to the loss of an earlier acquired proficiency. There was only one authentic representative of the new style—and this was Hunt in Boston. But Hunt's classes were swarming with young Bostonian ladies of a not too professional standard, and even

if you were a student of Hunt, he inevitably advised you to make your pilgrimage to Mecca personally. Thus he sent his best pupil, John La Farge [8] (1835–1910), to Paris. As a matter of fact most people who could afford it went abroad and, in increasing ratio, to Paris. Those who stayed home could not escape the subtle influence that indirectly transformed the artistic atmosphere. After all, it was not necessarily French influence that made the young painters discover *la peinture à valeurs.* For these discoveries were in keeping with the general trend of the time. A sensitive young American would go instinctively in the direction which the main stream of artistic evolution had taken in Europe.

Since La Farge came from French stock, he had no difficulty in absorbing the ways of the French. In the first works done after his return, flower pieces, he came as close to French standards as any painter of his time, his style being midway between Courbet and Fantin-Latour. But the work in which his French teachings manifested themselves most impressively was the landscape, *Paradise Valley, Newport,* of 1868 (Fig. 101). The painting shows a practically treeless plain with slight elevations of soil on each side between which the open sea is visible in the background. A few sheep are grazing in the lonesome valley. The whole is bathed in diffused light. The painter could say about his work: "I undertook a combination of a large variety of problems which were not in the line of my fellow artists here, nor did I know of anyone in Europe who at that time undertook them."

Above all, there "is light in it," as William Morris Hunt used to say, and light was to become the goal of the artists who went through the school of peinture à valeurs. La Farge's *Paradise Valley* is one of the works of art which are pregnant with future developments. The man who in the first years after his return from Paris created so momentous a painting was, however, not to follow up the course he had outlined for himself. Decorative tasks sidetracked him, first in the realm of religious murals and later in the designing of stained glass. In these fields his genuine gift of direct pictorial expression had no outlet and withered away, whereas he lacked the breadth, the simplicity, and the technical tradition necessary to paint monumental frescoes and to work in a medium demanding the skill of a medieval craftsman. La Farge died long after he had made his real contribution to American art.

It is a truism to say that the public makes the artist. Nobody can paint in a vacuum. The break in tradition which followed the Civil War deprived the American artist of a society sympathetic with his aims. The cities began to lose their charm and the countryside its idyllic character. It needed a very strong sense of direction to swim against the stream, and the fact that art dealers and museums began to operate on a larger scale did not make up for the lack of an organically developed art life. Few artists succeeded in developing their talents in this antagonistic milieu. They could, of course, settle in Europe if they were sufficiently successful there or could afford to live abroad, but few succeeded in expatriating themselves without a break in their development. Mary Cassatt (1853–1926) was one of the most successful among the American expatriates whose work shows a complete integration with European culture, in this case that of France. But she was a portrait painter.

James McNeill Whistler,[9] who is con-

FIGURE 101
JOHN LA FARGE
Paradise Valley, Newport
Mr. Francis B. Lothrop, Boston, Mass.

sidered the second great expatriate, was both a figure and a landscape painter. Born in Massachusetts in 1834, he spent his boyhood in Russia where his father built railroads for the Tsar. After the death of his father he moved with his mother to America. He was then fifteen. A stay at the Military Academy of West Point proved a failure and Whistler soon after went to Paris. The extremely gifted and intelligent young foreigner won the acclaim of Courbet and became his follower. Unlike Hunt, however, he later on regretted the choice of a colorist as a model and would have preferred Ingres, the master of pure line.[10] Whistler's later work does not seem to justify entirely the inner voice that led him away from tone and color into the austere realm of line, although he made the linear style of the classicists palatable to his esoteric taste by interpreting it in Japanese terms.

The vitality and soundness of *The Thames in Ice* [11] painted in 1860 before his conversion to the doctrine of line is superior to his later vaporous "arrangements" in blue, silver, and gray (Fig. 102). It recalls Sisley's concise impressionism. Only the famous set of etchings of the Thames that originated in the same period reaches or perhaps even surpasses in quality Whistler's nonfigural paintings of these years

Except for a trip to Valparaiso in 1869, Whistler never came close to the New World after he left America, and his work practically belongs to England as does that of Mary Cassatt to France. He died in 1903.

Whereas Whistler chose escape as a solution to the problem that faced the artist in the America of the second half of the nineteenth century, Thomas Eakins (1844–1916) remained at home upon his return from a period of study in Europe.

It is questionable whether his solution was much better than was that of his expatriate colleague. He was slow, conservative, and restrained in contrast to the flashing, experimental, and expansive Whistler. His more subtle opposition to the world around him made his art tight, obstinate, and strangely subdued. Neither of the two painters reached the healthy maturity of their French contemporaries Degas and Manet, although they had enormous artistic possibilities. In the landscape backgrounds of his figural paintings—only one pure landscape of his has come to my knowledge— Eakins materializes what Whistler might have had in mind when he regretted not having studied under Ingres, for in Eakins there is something of Courbet's tonal finesse modified by a linear exactitude that gives it a fascinating austerity.

More problematical than the cases of Whistler and Eakins who, after all, developed according to an artistic program of their own choice, are the two most widely acclaimed American landscape painters, George Innes and Winslow Homer.

Innes [12] (1825–94) was trained as a map engraver and was for a short time a pupil of Gignoux. He painted in his youth, like La Farge, a revolutionary picture anticipating a development that was completed by others than he. And like La Farge's *Paradise Valley*, this picture, *The Lackawanna Valley*, stands out by its quality from all his later work (Fig. 103). The painting was the product of a commission given to the painter in 1854 by a railroad company and grumblingly carried out; for the task of depicting things as devoid of pictorial charm as a roundhouse and repair shop disgusted the young artist who aspired to the rank of a lyric poet among painters. Evidently the discipline of the task was salutary to

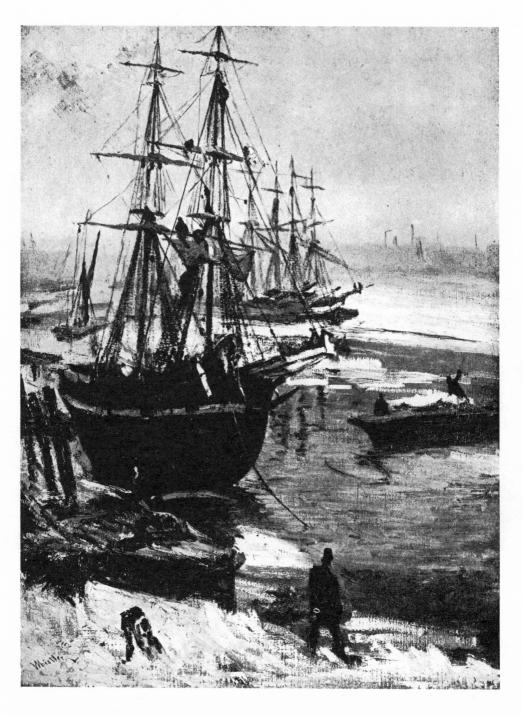

FIGURE 102
JAMES MCNEILL WHISTLER
The Thames in Ice
Freer Gallery of Art, Washington, D.C.

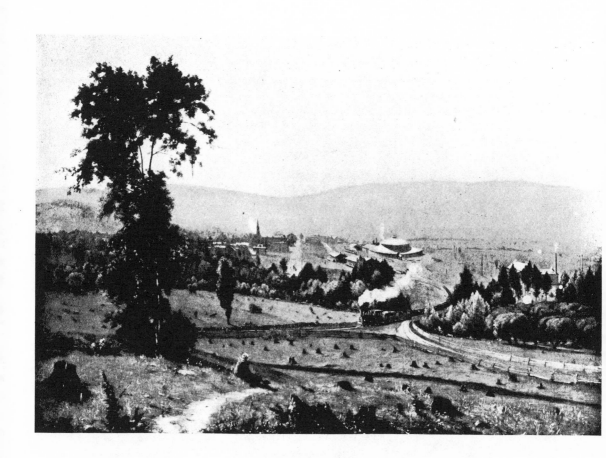

FIGURE 103
GEORGE INNES
The Lackawanna Valley
National Gallery of Art, Washington, D.C.

his talent, which contained the germ of disintegration. For under the compulsion of solving an almost scientific problem he unfolded all his latent capacity for observation. The first stages of industrialization which threatened the purity of the American landscape stimulated an escapism among the American landscape painters that was bound to render their work bloodless. Forced to undertake a landscape that represented the first stage of industrialization, Innes, in spite of himself, discovered the possibilities of the new subject matter. It demanded a factual attitude—and a new color gamut fit to record machinery and plants clearly and soberly, as well as to clarify a topographical situation. The picture is laid on in parallel planes so that the spectator grasps at a glance the spacial relationships of the composition. Innes lighted his palette to a degree unheard of at that time, and that was not reached, even in Paris, until ten years later. The most astounding thing is that the tonal harmony of the painting did not suffer from this luminosity. The examples of the Barbizon school that came to his knowledge were wrapped in an impenetrable layer of romanticism that did not allow the threatening machine age to interfere with their mute dialogues with nature. Thus Innes took what appears to be a logical step: he applied the teachings of Barbizon to the form of landscape that was current among the American painters of his time, namely the modified panoramic style of the Hudson River men. The most satisfactory product of this synthesis is the *Delaware Water Gap* of 1861 (Fig. 104). Mountains and water are viewed with an eye to the grandeur of the scenery, and at the same time a subtle veil of tonality seems to transfigure the landscape in striking contrast to the geographical tableau naïvely adopted by Bierstadt and Church.

Evidently the slight lyricism which characterized the *Delaware Water Gap* did not satisfy Innes' urge for poetry, for in his most ambitious work, *Peace and Plenty*, emphasis is laid on the poetic content rather than on artistic form, to the detriment of the picture. The composition lacks unity and the color is oversweet. Innes, obviously inspired by Corot, spent years in Italy where a classic soil, tilled for untold centuries and transformed into what almost amounts to a huge formal garden, saved him for a while from disintegration. His Italian paintings are of a cosmopolitan character, charming, well organized and filled with an attractive melancholy (Fig. 105). Indeed Corot himself did not quite escape the danger of overemphasizing lyricism, and his late period, readily acclaimed by the buying public, tended toward a vaporous, conventional parlor ideal. Innes, spellbound by Corot, exaggerated Corot's weaknesses as Thomas Moran did Turner's, and with the same results. Whereas the pictorial quality of his work decreased, its market value increased, and this fact stimulated overproduction. Eventually the painter succumbed to the visionary mysticism of Swedenborg, under whose spell he developed a vague theosophical nature worship. This influenced his work. His painting lost its strength and ended in mannerism, dissolving in a cloying haze.

Winslow Homer, who was eleven years younger than Innes and survived him by sixteen years, began his career as a pictorial reporter for illustrated magazines. Gifted with a versatile talent, and not too discriminating in his methods, he made a good newspaperman. If his drawings from the Civil War lacked the stirring

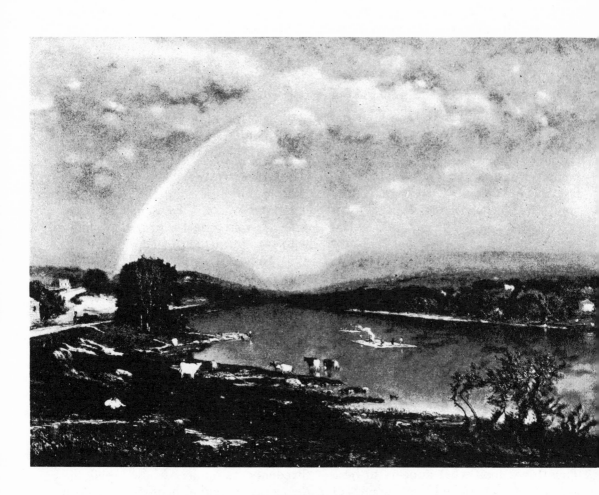

FIGURE 104
GEORGE INNES
Delaware Water Gap
Metropolitan Museum of Art, New York City

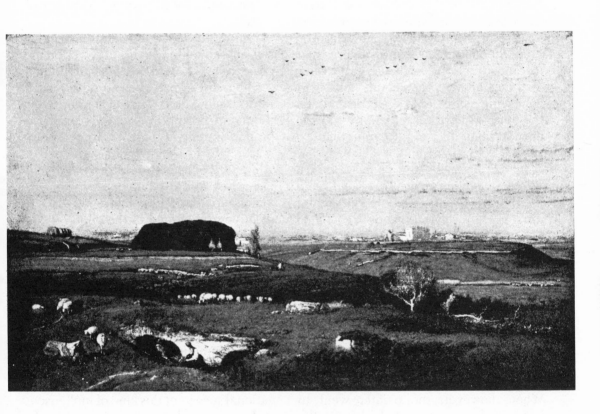

FIGURE 105

GEORGE INNES

The Roman Campagna

City Art Museum of St. Louis, Mo.

and uncompromising effect of the photographs of Brady, who covered the conflict with his camera, they had to their credit a robust popular appeal.

In his paintings his training as an illustrator interfered with his artistic claims. He evidently could not free himself from the journalistic habit of overdramatizing or "prettifying" what he had seen. Too often the pantomimes of his figures mar a landscape. Nevertheless, Winslow Homer painted a considerable number of handsome pictures as long as he retained the tonal scale of the preimpressionistic era and limited himself to unpretentious subjects (Figs. 106, 107). The *Morning Bell*, a country girl walking across a wooden overpass under trees, and *Snap the Whip*, a group of boys playing before a background of sunny hills, belong to this group.

The most impressive of his pictures are studies of the Negroes of the South. These are done with remarkable objectivity and are full of pictorial charm. There is, in some of his early genre scenes from the beach, a quality of pure painting that makes us forget the unfortunate female characters who seem to have stepped out of *Godey's Lady's Book*. When, however, the painter went to England for a protracted visit in the 'eighties, his style lost much of its authenticity. He adopted the light key of the impressionists but not its complement, the broken color that produces the effect of plein-air. For this reason the seascapes in which he specialized in his later years are static, even though they portray storm and waves (Fig. 108). Moreover Homer, like so many of his contemporaries, was influenced by instantaneous photography, then a new and startling invention. This influence was detrimental, for the split-second picture of the camera does not correspond to the picture we unconsciously form from a multitude of impressions. Thus the influence of photography further increased the static character of his style. At the same time his sensitiveness to texture decreased, as is illustrated by his glassy treatment of water.

During his last years he sat idly in his self-chosen solitude at Prouts Neck on the coast of Maine, where he had built a studio, staring at the familiar ocean rather than adding more examples to his numerous portrayals of it. According to his own statement [13] he no longer saw any reason why he should paint—a revealing admission. Evidently the pleasure of using his skill in painting had been his main impulse. This impulse was not a creative urge rooted in the depth of the mind, and thus it eventually spent its force. All that was left was frustration.

It cannot be said that Winslow Homer, for all his refusal to leave America during the last twenty-six years of his life, developed an artistic idiom characteristic of America, for realistic painting in a high key was practiced all over the world at the turn of the century.

The man who made the greatest international success of this kind of inoffensive realism was John Singer Sargent.[14] He was born in Florence in 1857 of American parents, received most of his training in Paris, had his permanent residence in London and his spiritual home in the cosmopolitan sphere of the society column. He visited America occasionally to carry out lucrative commissions for portraits and murals. Sargent wasted on fashionable showpieces a most promising talent —a talent that had produced the fascinating plein-air study of the *Luxembourg Gardens* at twilight (Fig. 109). The inevitable result, as in the case of Homer,

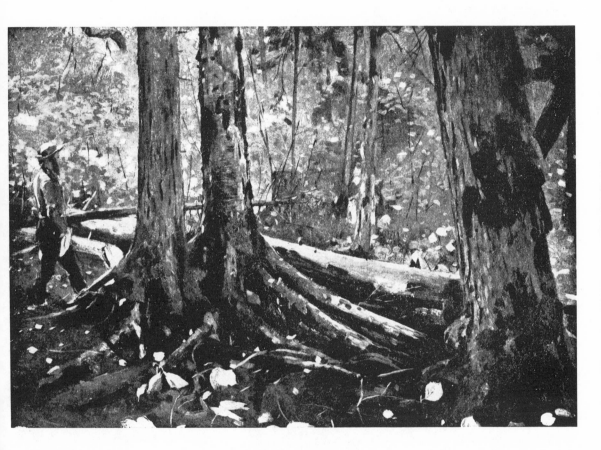

FIGURE 106
WINSLOW HOMER
The Woodchopper
Wildenstein & Co., Inc., New York City

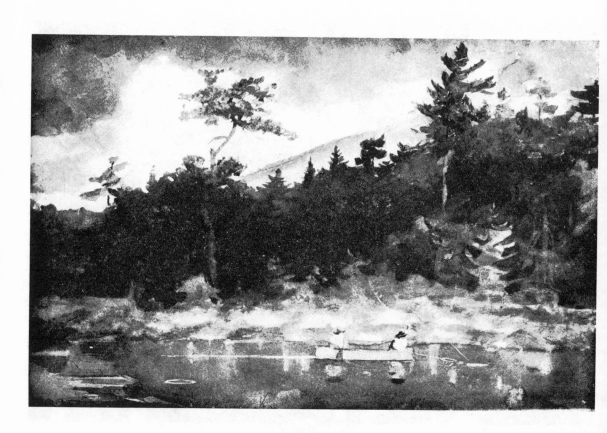

FIGURE 107
Winslow Homer
A Fisherman's Day
Freer Gallery of Art, Washington, D.C.

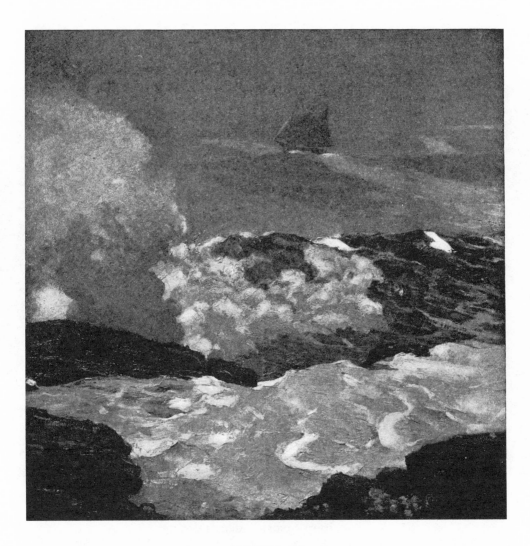

FIGURE 108

WINSLOW HOMER

On the Lee Shore

Museum of Art, Providence, R.I.

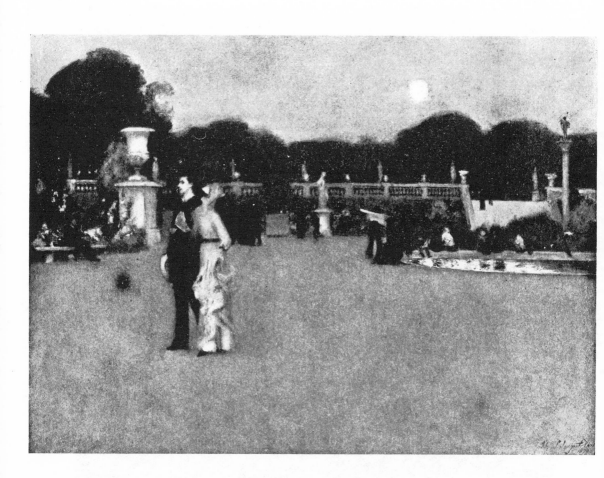

FIGURE 109
JOHN SINGER SARGENT
In the Luxembourg Gardens
Johnson Collection, Philadelphia, Pa.

was boredom. He tried in vain to find release from it by turning to nature. It was too late. His water colors of Italian and Canadian landscapes painted in his declining years are technically brilliant but fail to convey more than the external characteristics of their motifs. Sargent died, world famous but actually *passé,* in 1925.

Another group of American landscape painters that belonged neither to the expatriates nor to the stay-at-home-at-any-price type strove to assimilate in Europe what they thought worth studying and applied it afterward to the American scene. The most renowned of these was Homer D. Martin [15] (1836–97). He had developed a realistic and at the same time lyrical style of his own, before he went to France to make his home in Normandy for several years. In some of his French landscapes, such as the *Harp of the Winds* (a view of the river Seine bordered by poplars), he toyed with impressionistic methods—just enough to put his art into disfavor with the American public of his day, which was more attracted to the older innovations of the Barbizon painters than to the "radicals" around Manet.

Martin's paintings are filled with a brooding quality that defied national boundaries. The only specifically American feature of his paintings is their narrow form, a carry-over from the panoramic school (Fig. 110).

Alexander H. Wyant [16] (1838–1902) was trained in Germany but developed a manner similar to Martin's. Today his early, precisely drawn foreground studies appear more convincing than the moody and formless landscapes of his later years —brownish, somewhat monotonous canvases that lent themselves well to the plushy rooms of the period (Fig. 111).

One of the last Americans who in quest of instruction turned to the masters of Barbizon instead of the impressionists was Henry Ward Ranger [17] (1858–1916), an enlightened conservative who more than anybody else made the peinture à valeurs a test of pictorial quality. The memories of his sojourn in France which he communicated to the writer Ralph Husted Bell form the main part of the latter's *Art Talks with Ranger.* This book tells us all about Ranger's theory of tonalism and its origin in the French peinture à valeurs. It is interesting to hear that he learned most from a series of unfinished paintings left by Monticelli. Here he saw how the French masters built up their paintings systematically from patches of carefully graded tone values. Ranger's own paintings, however, show more the influence of Diaz de la Peña and Corot. Diaz, who was surpassed by a few in his rendering of sunlight filtering through the foliage of the woods, evidently was the model for such paintings by Ranger as the *Connecticut Woods* of 1899 (Fig. 112), but his American disciple heightened the subdued color harmony of the Hispano-French master in keeping with the glowing hues characteristic of an American autumn.

Six years after the *Connecticut Woods,* Ranger painted the *High Bridge,* a New York structure recalling by its function and design ancient Roman aqueducts (Fig. 113). The painter chose the time between day and night, the *heure bleue* of the French, for his work. The picture is distinguished by a soft luminosity and broken colors that transcend his Barbizon period. Ranger seemed at the threshold of impressionism, but there he stopped. In his declining years his conservatism got the better

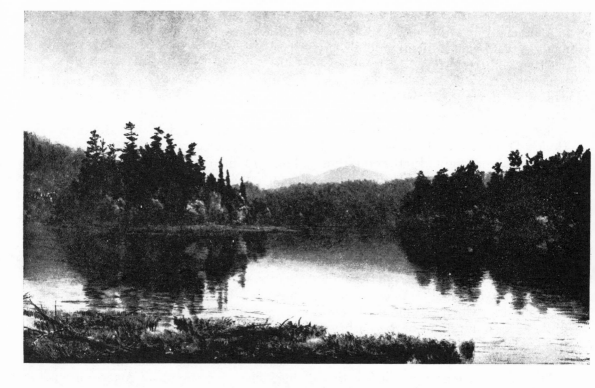

FIGURE 110
HOMER D. MARTIN
Preston Ponds, Adirondacks
Minneapolis Institute of Arts, Minneapolis, Minn.

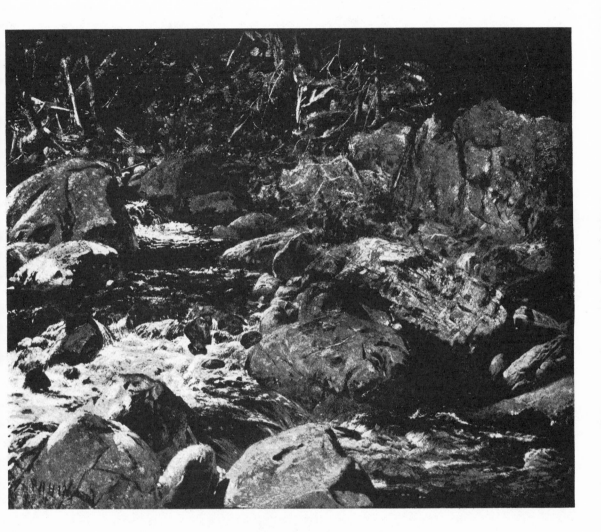

FIGURE 111

ALEXANDER H. WYANT

Forest Stream, a Study from Nature

Minneapolis Institute of Arts, Minneapolis, Minn.

FIGURE 112
HENRY WARD RANGER
Connecticut Woods
National Collection of Fine Arts, Washington, D.C.

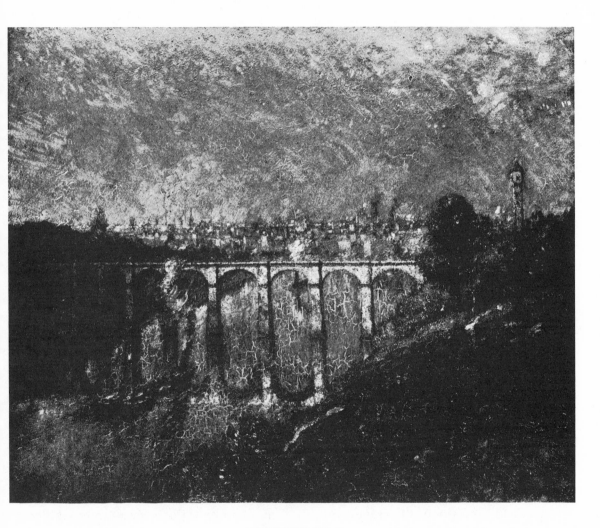

FIGURE 113
HENRY WARD RANGER
High Bridge
Metropolitan Museum of Art, New York City

of him. He developed toward a conventional naturalism, and it is characteristic of his ultimate attitude toward life that he bequeathed his fortune—his paintings had sold extremely well—to the conservative National Academy of Design, with the stipulation that from the interest paintings by American artists over 45 should be bought and distributed to American museums.

Among a list of painters whom he considered as "tonalists," e.g., acceptable to his own doctrinal views about the right style of painting, were Albert Pinkham Ryder [18] (1847–1917) and Ralph Albert Blakelock [19] (1847–1919), the two representatives of imaginative landscape painting usually considered as "independent" painters. The broad treatment and deep tone of Ryder's small seascapes and vaguely symbolic compositions which sometimes were stimulated by literature or music distinguish his work from other postromanticists. Self-centered and unconcerned with even the most primitive demands of decent living, he evidently was a psychiatric border case, a man whose thinking was "autistic," separated from the outside world as is the dream world. Ryder produced slowly, without method, small pictures of a fragmentary and haunting character (Fig. 114). Seen in historic perspective, he stems from such poetic painters as Monticelli, save for his duller treatment of color.

Monticelli, evidently, also inspired Blakelock, who studied art in Europe. While a slight psychotic touch can be traced in Ryder's eccentric personality, Blakelock developed insanity. The abject poverty in which he spent his life certainly contributed to his mental derangement but cannot have been its cause— any more than in the case of Monticelli,

whose struggle against economic difficulties was also overcast by the shadow of mental disease. Blakelock's talent was considerable but of slender scope, and like most of the borderline cases, repetitious. Artists of a more or less autistic type (and Blakelock probably belonged to them) are not easily reached, after their ideas have once been formed, by new experiences from the outside world. It is no accident that Ryder and Blakelock preferred the evening and the night to the morning and the day. It seems as if they shrank from the light. Ryder, whose childhood was spent at the seacoast, was obsessed with dark sailboats set against a moonlit night, Blakelock by the equally black silhouette of trees set against similar moonlit skies (Fig. 115). Ryder's nocturnal scene is sometimes enlivened by lonesome figures of outlaws, smugglers, and pirates, additions probably inspired by juvenile books. In Blakelock's paintings tiny Indians perform ritual dances, equally close to the literary taste of boyhood. It is as if both painters are haunted by the fantasies, anxieties, and joys of their early years. Blakelock's style resembled that of Monticelli in its mosaic-like texture: the whole picture is put together with dots of color applied with the palette knife so that the surface of the painting recalls cobblestones. Both Monticelli and Blakelock adopted this technique in their quest for a representation of their concepts of light—and this light in both cases is the unreal light of an imaginary world, seen with the inner eye. In their colors, however, Monticelli and Blakelock differ fundamentally. Monticelli sparkles with jewel-like, fiery hues, whereas Blakelock is almost monochromatic. This helped him to convey the impression of well-ordered space, even in his night pieces, in contrast to Monticelli,

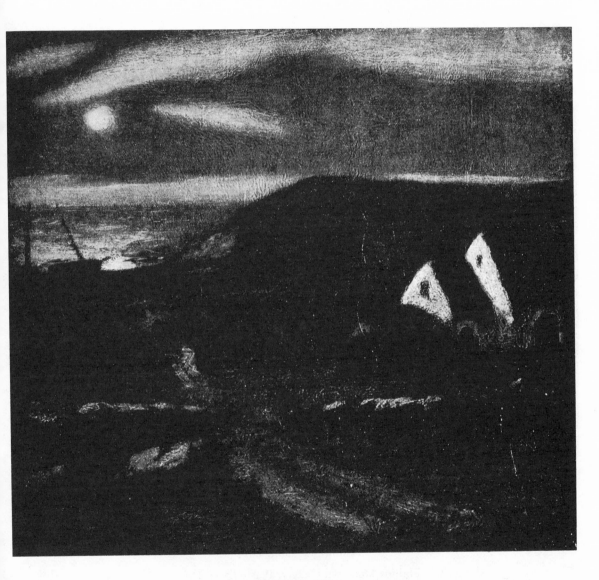

FIGURE 114
ALBERT PINKHAM RYDER
Fishermen's Huts
Phillips Memorial Gallery, Washington, D.C.

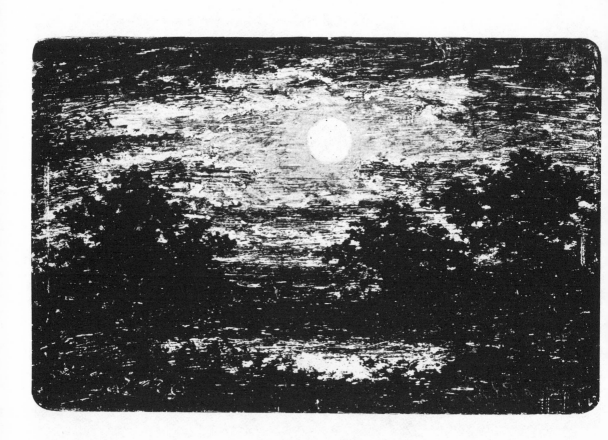

FIGURE 115
RALPH ALBERT BLAKELOCK
Moonlight Landscape
Phillips Memorial Gallery, Washington, D.C.

whose paintings finally disintegrated into a pyrotechnical display.

Two Americans, Worthington Whittredge [20] (1820–1910) and Eastman Johnson [21] (1824–1906), groped their way from a naturalism with romantic overtones to the stylistic level of early impressionism. By a methodical development of previous studies in Europe they arrived in America at about the same time at results similar to those of progressive Europeans. Whittredge lived in Düsseldorf and Paris from 1849 to 1854 and in Rome from 1854 to 1859. He seems to have picked up trends that agreed with him wherever he found them, including the type of romanticism that flourished in Munich, although he never visited the Bavarian capital (Fig. 116). Very soon he developed a comparatively luminous color scale with which he depicted the familiar motifs of the landscape of mood: the woods, the seacoast, fields and meadows in a new and fresh manner that was the more convincing since the painter never stooped to literary associations (Fig. 117).

Like Whittredge, the genre and portrait painter Eastman Johnson studied in Düsseldorf, but he offset the influence of this city by a subsequent stay in The Hague from 1851 to 1855, where he absorbed the teachings of the great Dutch masters of the seventeenth century. In the landscape backgrounds of his genre paintings he is closer to Whittredge than to any other painter, and we can follow his development from a rather detailed and minute to a broad and fluid interpretation of nature.

Two painters of a later generation, Frank Duveneck (1848–1919) and William Merrit Chase [22] (1849–1916), went to Munich where, after 1870, there flourished a realistic school derived from Courbet. Duveneck's work definitely belonged to the Munich school as long as it kept free from compromise, but unfortunately he succumbed to the influence of the taste of the time and relinquished the strictly tonal landscapes of his early period in favor of sugary genre paintings (Fig. 118). As a teacher, Duveneck spread the technique of Courbet, though with German modifications, among American art students. Chase, who from a similar beginning developed a different style, a somewhat diluted and all too smooth impressionism, was an equally famous teacher. Both men directed the attention of American art students toward technical problems teaching the *à la prima* technique—the direct and free application of paint with quick brush strokes, and the use of a strictly tonal color scale, with brown as the basis.

Chase was prominently engaged not only in art instruction but also as a promoter of exhibitions. In this capacity he paved the way for the appreciation of the modern art of his day in America.[23] In 1877 the Society of American Artists was founded with Chase as one of its driving powers, and the society not only served the purpose of giving the young progressive artists an opportunity to show their works but also sponsored the exhibition of foreign art, especially that of contemporary French painters. Bastien-Lepage's *Joan of Arc* was shown there in 1881. This painting, which was to remain in America as the possession of the Metropolitan Museum, excited the public and evidently was influential in making familiar to it the high key, the broken colors, and the objective representation of reality which Bastien-Lepage had in common with the impressionists. The narrative character and the sentimentality which have since rendered this work

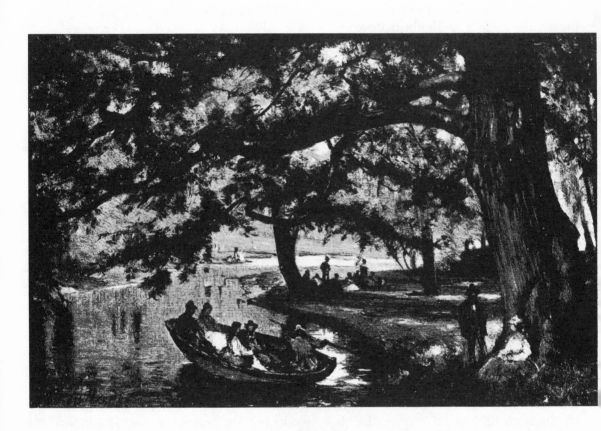

FIGURE 116
WORTHINGTON WHITTREDGE
A Boating Party in Central Park
Mr. Paul Lane, New York City

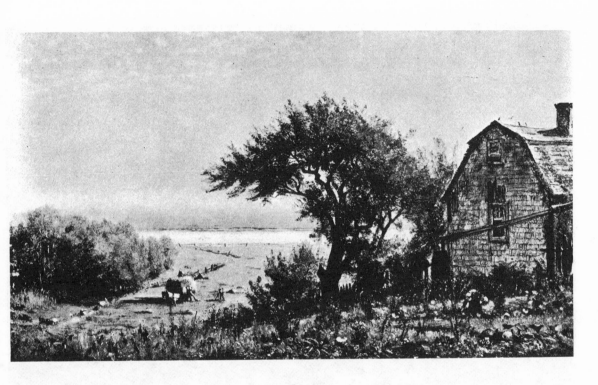

FIGURE 117
WORTHINGTON WHITTREDGE
The House on the Sea
Los Angeles County Museum, Los Angeles, Cal.

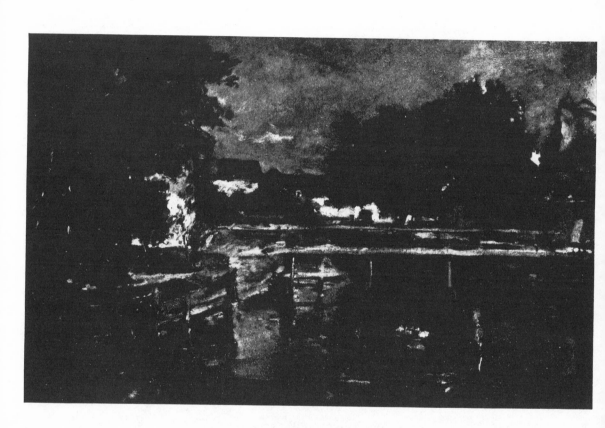

FIGURE 118
FRANK DUVENECK
Old Town Brook, Polling, Bavaria
Cincinnati Art Museum, Cincinnati, Ohio

obsolete made it at that time more acceptable than were the uncompromising masters around Manet.

In 1884 Chase, assisted by his friend Carrol Beckwith, organized an exhibition of French paintings to help raise funds for a pedestal for the Statue of Liberty. This exhibition placed the great French impressionists and their forerunners for the first time fully in the limelight.

These were the decisive years. In 1883 John H. Twachtman (1853–1902), a pupil of Duveneck, and John Alden Weir (1852–1919), a painter who had reached distinction with dark but realistic and broadly painted pictures, became impressionists while in Paris. Childe Hassam (1859–1935), a younger man, soon followed. And Theodore Robinson (1852–96), who only by his untimely death was prevented from becoming a leading figure in American art, was living with his master, Claude Monet, in Givernais. These painters formed the nucleus of the group of American impressionists [24] which, although never organized into a society, stands out as a definite "school." Ernest Lawson (1873–1939), William Glackens (1870–1938), and Willard L. Metcalf (1858–1925) were also connected with this "school."

Robinson [25] probably was the first American to paint true impressionistic landscapes. It cannot, however, be denied that his best works depend on Monet almost to the point of self-identification, and that his subsequent American pictures suffered from uncertainty (Fig. 119). This uncertainty was caused by the difficulty of adapting a style developed in a mellower nature and civilization to the brisker and more prosaic American scene. He evidently had not enough time to clarify his approach, and when he died his style was still incomplete. Robinson's weaknesses, however, only testify to his sensitivity.

Childe Hassam,[26] who was less meticulous, probably was never haunted by doubts when he looked at the coast of Maine or the squares of New York with the eyes of a Parisian on vacation. Hassam's French impressionism was so deeply rooted that he forced the obstinate sun of America to yield the chromatic effect he wanted to see, and he projected a leisurely style of life into the young ladies who enliven his seascapes—figures reminiscent of a sidewalk café in Montparnasse rather than a cafeteria in Manhattan (Fig. 120).

Weir,[27] on the other hand, was of a somewhat heavy fabric, and his impressionist conviction seems a matter of intellectual insight rather than of organically developed feeling. Impressionism does not seem to have helped him greatly: his color scheme was set before he was converted to the doctrine of plein-air and so was his taste in composition. The result was an art that was hesitating and even somewhat lame. Landscape, it is true, played only a secondary part in his work, and it never fully released his energies (Fig. 121).

Twachtman [28] was a genuine landscape painter and he repeated in his development the historic evolution of painting from Courbet to Manet. His early landscapes, inspired by Duveneck, are warm, sober, and strongly built from broad patches of color (Fig. 122). Under the influence of the French plein-air his color gradually brightened and his broad and slow brush strokes split into quick dashes. Monet's late period evidently swept him off his feet, for like his French model he eventually suppressed depth almost entirely in favor of a scintillating surface effect. His eye responded to the

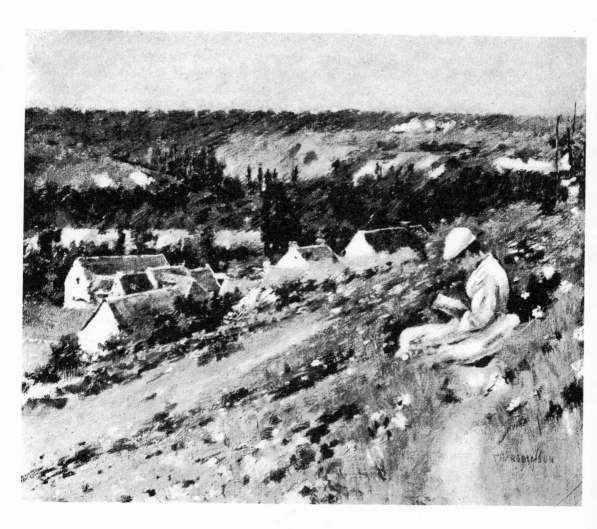

FIGURE 119
THEODORE ROBINSON
Val d'Arconville
Art Institute of Chicago, Chicago, Ill.

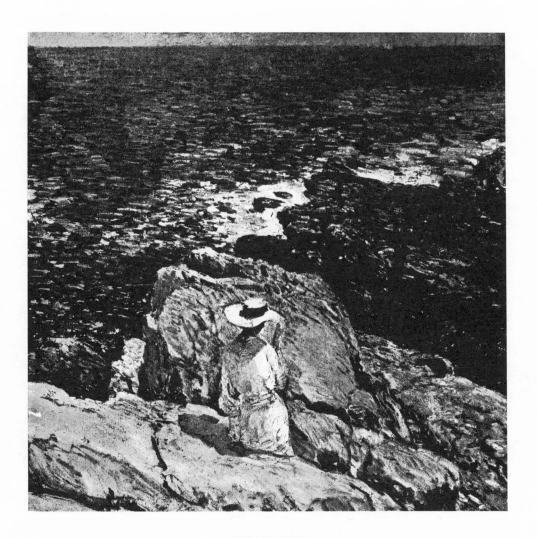

FIGURE 120

CHILDE HASSAM

Sunny Blue Sea

National Collection of Fine Arts, Washington, D.C.

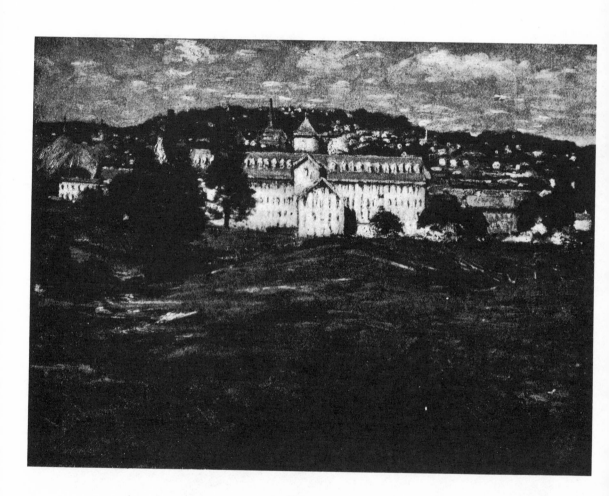

FIGURE 121
JOHN ALDEN WEIR
Willimantic Thread Mill
Brooklyn Museum, Brooklyn, N.Y.

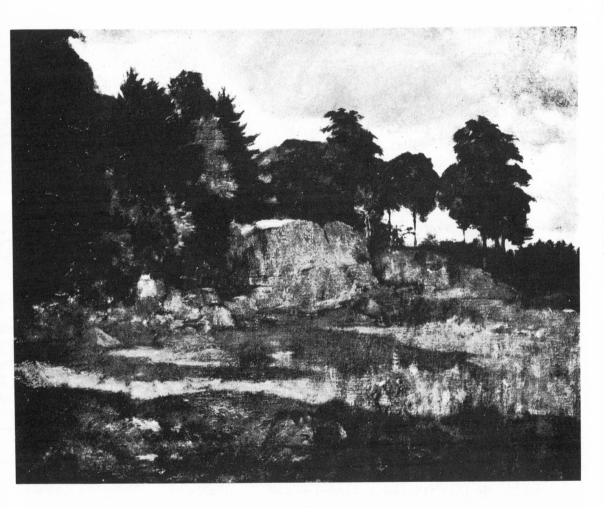

FIGURE 122
JOHN H. TWACHTMAN
Landscape
Whitney Museum of American Art, New York City

slightest stimulus, and it was the delicate aspect of nature that attracted him: the pale winter sun casting spiderwebs of bluish shadows from barren trees onto the soil with its white patches of snow, or the glittering of a waterfall between mossy stones and underbrush veiled in autumnal mist (Fig. 123). More and more the motif lost its interest for him, and more and more he became concerned with atmosphere. The structure of his paintings became thinner and thinner. The final stage of his development was the portrayal of effects rarely to be found in America—effects, indeed, that are seldom found even in the silvery air of France—and that he "read" into the landscape rather than actually observed.

What Monet was to Twachtman, Renoir was to Glackens.[29] Renoir's mastery fascinated his American admirer, who with all his energy strove to capture the same charm. Glackens had been an excellent illustrator. When he painted, he wanted to get away from the bustle of the crowds which he knew how to represent so well in nervous lines. It was just this background that excluded him from the serene world of Renoir. The most French of all Frenchmen did not yield his secret to him. Where Renoir saw a chromatic fabric of liquid hues, Glackens saw forms, good, solid forms which you could touch, and all that he could master was an arresting treatment of the surface in which the liquid color of Renoir solidified (Fig. 124).

Ernest Lawson,[30] an American of Canadian extraction, and Willard Leroy Metcalf tended to a more academic practice of impressionism which in America, as in Europe, became popular around 1900 and reached a general level that ought not to be underrated—although it eventually became superficial.

Lawson drew his motifs from the suburbs of New York, especially from Washington Heights, which at that time had not yet lost its semirural character (Fig. 125). Metcalf interpreted the charm of the New England countryside with its white Georgian churches and tree-flanked village streets in an attractive, slightly decorative manner (Fig. 126).

As a whole the production of American impressionism was not too extensive. Most of the younger American painters around 1900 were too engrossed in subject matter to follow the French masters the entire way. The groups of artists formed in the 'nineties as a protection against academic organizations did not sponsor impressionism, but rather realism. The societies of The Ten and The Eight—of which the second was dubbed the Ash Can School—included some of the impressionists, but the latter especially was less concerned with purely aesthetic problems than with making art a vehicle of social criticism, or at least a mirror of everyday life. The suburban slums began to invade American landscape painting. The form in which these motifs were treated was a simplified variety of impressionism. Research into color problems was abandoned, but the sketchy technique of the impressionists was retained.

The most gifted man among the realists, and the only one who showed a marked interest in landscape, was George F. Bellows[31] (1882–1925). A robust painter, given to the use of shrill color, Bellows never was attracted by pure nature. A landscape without some product of man failed to arouse his interest. He liked modern bridges, built of concrete and steel, and his rivers carried steamboats or freight barges. There is

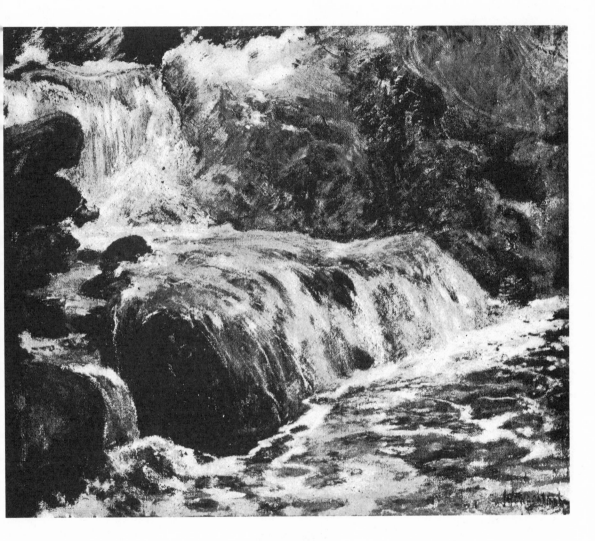

FIGURE 123

JOHN H. TWACHTMAN

Blue Brook Water Fall

Cincinnati Art Museum, Cincinnati, Ohio

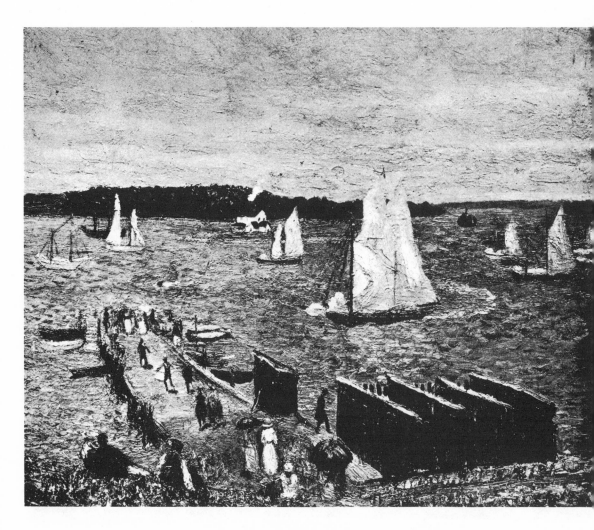

FIGURE 124
WILLIAM GLACKENS
Mahone Bay
Hall Collection, University of Nebraska Art Galleries, Lincoln, Neb.

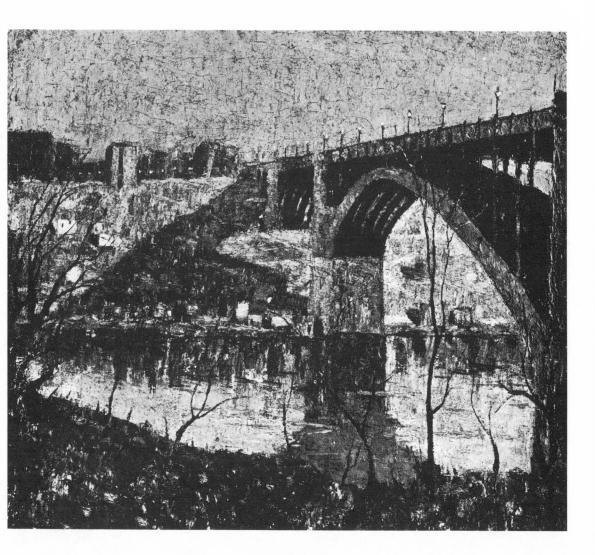

FIGURE 125
ERNEST LAWSON
Spring Night, Harlem River
Phillips Memorial Gallery, Washington, D.C.

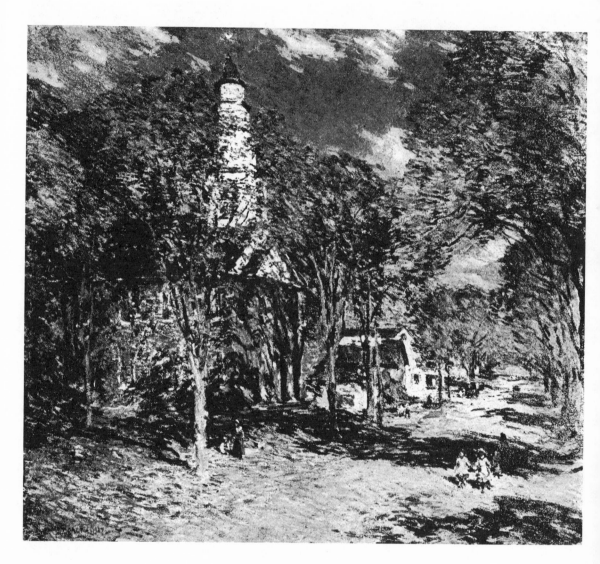

FIGURE 126

WILLARD LEROY METCALF

October Morning—Deerfield, Mass.

Freer Gallery of Art, Washington, D.C.

always noise being made in his pictures. In this he is in keeping with the popular taste of the modern city dweller, who carries his radio to the seashore in preference to listening to the song of the waves. But sometimes, in rare moments, such as the mood of his arresting landscape, *The White Horse,* nature begins to speak to him, and he records this unusual experience with his customary competence (Fig. 127). Then, and only then, his colors begin to harmonize and to resound.

Unadulterated impressionism was carried on in America during the twentieth century by outsiders rather than by professional artists—outsiders who were not primitives and who sometimes attained a high artistic level.

Dr. William Henry Holmes [32] (1846–1933) belongs to this group of which very little has been recorded. During his lifetime he had a reputation as a semiprofessional artist. Eventually he became the director of the National Collection of Art in Washington, a branch of the Smithsonian Institute with which he had been connected as a scientist. His output was uneven—a fact that is only partly explained by the comparatively small role painting played among his activities, which were chiefly connected with geological and anthropological research. It is more likely that he adopted a smooth and conventional style for his finished "exhibition" pictures, whereas the rugged and vigorous paintings which attract the modern spectator originated spontaneously, more or less as studies for their own sake. Holmes received his only instruction in painting in Germany as early as 1879–80. His impressionism was less "studied" than that of the better-known American impressionists who often, to their disadvantage, developed fixations on certain masters of their choice. If one

looks for painters to whom Holmes shows an affinity, one has to go back to the earliest stage of the impressionist movement in France. The most striking plein-air painting of Holmes that has been accessible to me is a coast scene: a sunny bay in Jamaica with a fishing boat and a group of Negroes (Fig. 128). It is painted with unusually broad brush strokes. Its colors, although comparatively bright, retain a great deal of the tonal harmony of the preimpressionist period. As a whole it recalls Émile Boudin, the immediate forerunner of the great French plein-air painters. Boudin's unobtrusive art was little known in America when Dr. Holmes painted, around the turn of the century. Another of the spontaneous works by Holmes, *A Maryland Landscape,* is less subdued than the seascape (Fig. 129). The painter turns here from a blond tonality to sonorous colors, including a deep green and blue, colors that recall the early Monet.

Arthur Clifton Goodwin [33] (1863–1929), perhaps the most authentic impressionist of America, was another artist of this type. He had been a clerk before he took up painting as a profession, and his career as an artist was thwarted by alcoholism, which eventually became fatal to him. During his later years he enjoyed a limited success in Boston. After his death he was remembered only by a few friends and collectors, until in 1945 his works were exhibited in New York in a one-man show which disclosed the scope of his talent.

Goodwin was more interested in city motifs than in pure landscape. He loved the appearance of buildings in rain or under a cloudy sky—their warm grays and reds as contrasted with the fresh green of the trees. His was an intuitive impressionism, trained by the continuous

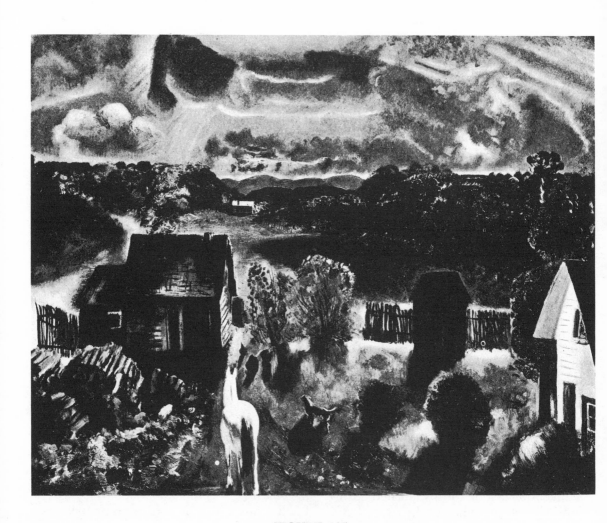

FIGURE 127
GEORGE F. BELLOWS
The White Horse
Worcester Art Museum, Worcester, Mass.

FIGURE 128

WILLIAM H. HOLMES

By the Sea

Mr. Glenn T. Martin, Washington, D.C.

FIGURE 129

WILLIAM H. HOLMES

A Maryland Landscape

Mr. Glenn T. Martin, Washington, D.C.

practice of open-air painting (Fig. 130). The texture of his paintings is rich and interesting. His sense of composition is less developed than his sense of color, but he manages to arrange his motifs in an improvised manner that is disarmingly ingenuous. His painting of the *High Bridge* is a good example of his happy-go-lucky composition (Fig. 131). The bridge is cut off by the frame only because the canvas just comes to an end there, and the painter glosses over this deficiency with a brilliant display of technique that makes every square inch of paint fascinating. It is interesting to compare Goodwin's version of the motif with that of Ranger who dutifully por-trays every arch of the structure but with all his correctness does not reach the persuasive effect of Goodwin's spontaneous solution.

The rôle played by impressionism was decidedly more limited in America than in France. For in France, where it originated, it expressed the very spirit of the country. It was, nevertheless, of great importance to America that the tenets of impressionism were assimilated by her artists. For only by joining the creative movements of the western world could American art attain the freedom necessary to express itself without the impediments of an antiquated vocabulary.

FIGURE 130

ARTHUR CLIFTON GOODWIN

Landscape with Brook

Wildenstein & Co., Inc., New York City

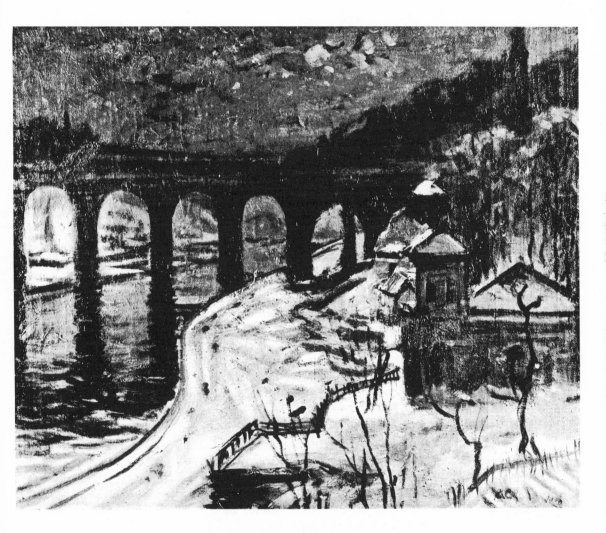

FIGURE 131
ARTHUR CLIFTON GOODWIN
High Bridge, New York
Wildenstein & Co., Inc., New York City

TOWARD A TECHNOCRATIC LANDSCAPE

THE decisive turn heralded by the works of Cézanne, Van Gogh, and Gauguin took considerable time to influence the development of painting outside France. The earliest visible effect came from symbolism which was a somewhat problematical outgrowth of Gauguin's legacy, a hybrid between a pictorial sign language and decorative impressionism. Symbolism sailed in the wake of the *art nouveau* movement which had in Tiffany its American high priest. Art nouveau was an ill-defined style which mixed Japanese inspired patterns with pictorial motifs. For a short time America, as well as Europe, was impressed by it.

The outstanding representative of symbolist painting in America was Arthur B. Davies [1] (1862–1928), an artist of delicate perception, cultured, intelligent, and discriminating. Unfortunately in his desire to absorb the new trends in world art he overtaxed his creative capacity and ended in confusion. His approach to art was eclectic. He saw the world through the eyes of old and modern masters. From a violent reality he fled into an idealized landscape that, for all its modernism, could not conceal its derivation from the world of Poussin and Claude Lorrain. In his best paintings which were created before cubist influence began to disintegrate his esoteric, frail, and musical style, he was an American counterpart of men

like Maurice Denis, the Frenchman who found in symbolism a new pictorial garb for religious themes. Davies was no religious painter, but he infused a mystic depth in his evening scenes with unicorns and maidens solemnly walking by dark lakes. The overtone of art nouveau which these compositions display has caused them to date earlier than the less pretentious pictures, in which a piece of nature with people in modern attire is poetically represented.

As early as 1890 Davies painted his moody *Along the Erie Canal*, a landscape which in its composition recalls the Pre-Raphaelites and thus seems to resume the trend of Moore's landscapes from the 'sixties (Fig. 132). Its narrow shape, on the other hand, is the favorite one of Martin and Wyant—a last echo of the panoramic school. Under a tree, in the center of the picture, is a little girl engrossed in the view, a device used previously by the romanticists.

Sixteen years later Davies resumed the early trend of the *Erie Canal* landscape in a painting, *Spring Time of Delight* (Fig. 133). A party of boys and girls is roaming happily in the clearing of a forest. A mass of golden sunlight streams on the foliage. White dresses stand out from the green half-light of the forest. In the center a girl is sleeping on the ground. A boy with a butterfly net is stepping

FIGURE 132
ARTHUR B. DAVIES
Along the Erie Canal
Phillips Memorial Gallery, Washington, D.C.

FIGURE 133
ARTHUR B. DAVIES
Spring Time of Delight
Phillips Memorial Gallery, Washington, D.C.

toward the back, leading the eye of the spectator subtly into the flickering depth of the woods. Davies displays the variegated activities of his youthful characters by using a panoramic picture form similar to that of the *Erie Canal*.

In the development of modern American art Davies forms a connecting link between impressionism and postimpressionism. Being a symbolist, he had no immediate successors. Symbolism, for all its magnetic quality, had as short a life span as art nouveau.

It was Cézanne, and not Gauguin, who stimulated a new development of a wider range. This is as true of America as Europe. A young New Englander, Maurice Prendergast [2] (1889–1924), discovered for himself the greatness of Cézanne when he stayed in Paris during the last years of the nineteenth century. As a matter of fact, this was not Prendergast's first visit to Paris—but it took him, for all his searching, a considerable time to see the light. It is true, Cézanne's fame was then limited to a circle of real connoisseurs, and even among the French only a handful of younger men understood his message. To Prendergast the teachings of Cézanne came as a revelation. Intoxicated with this new, mysterious draught, he hurried to testify for his master. He went to Venice and there, in a few weeks, he developed his own style: a mosaic-like, flat, and decorative pattern of pure colors, which reminds us of an enlarged and simplified pointillism. After his return to Boston Prendergast, struggling against poverty, isolation, and illness, developed his new style into a highly personal language of color. In his mature paintings human figures are integrated in the landscape to such a degree that they seem to be inconspicuous elements in a nervous all-over pattern (Fig.

134). Gradually a strong linear element makes itself felt in the outlines which begin to develop into something very important—almost like an obsession. Sometimes, especially before Prendergast's style became too repetitious, his landscapes are timeless in their freshness.

After Prendergast had pioneered for Cézanne, the teachings of the French master were accepted more readily in America and provided a most welcome leavening in the stirring mass of twentieth-century American painting. The Armory Show organized in 1913 by Arthur Davies and other artists of discrimination introduced postimpressionism to the reluctant public of New York. The younger men of Paris, especially Henri Matisse, had already begun to be emulated by advanced young American artists, among whom the most promising was agile John Marin [3] (1870–). He passionately sought an art form which expressed his reactions as succinctly as possible, for he was, and is, a man of instantaneous response in painting, and a high-strung sensitivity that responds intuitively to every stimulus. And there was no end of stimuli for this quick man with the slim body and the searching eyes. Cézanne showed him how to distil the essential forms and colors out of the confusing, restless universe, and Matisse taught him how to develop a shorthand technique of painting. Marin went to the extreme in speed and simplification. In hundreds of water colors and an ever-increasing number of oil paintings he put down the chronicle of his visual experiences. His whole work is an enormous pictorial diary in which the seasons are the leading characters, with wind and rain, sun and clouds as supporting cast (Fig. 135). Marin is an unorthodox personality, aloof and introspective to the

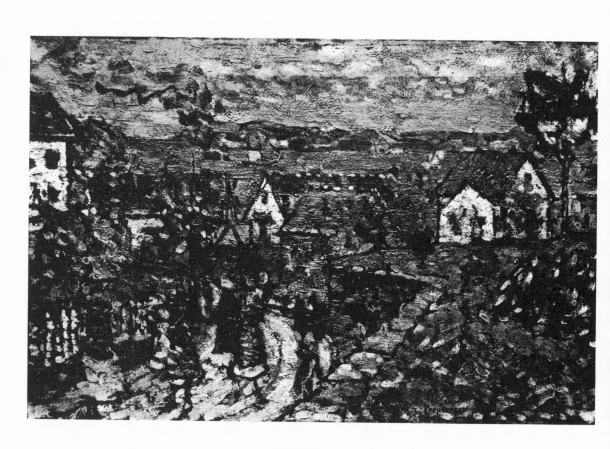

FIGURE 134

MAURICE PRENDERGAST

Gloucester

Barnes Foundation, Merion, Pa.

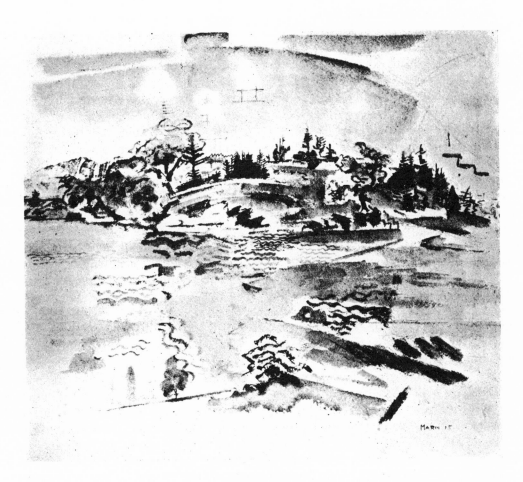

FIGURE 135

JOHN MARIN

Island, Small Point, Maine

Albert E. Gallatin Collection, Philadelphia Museum of Art, Philadelphia, Pa.

point of eccentricity. His written statements indulge, with stubborn gusto, in bizarre linguistic expression. He likes to solidify his intuitive brush strokes in semiabstract scrolls and geometric shavings, and he plays with these formal elements, using them as a kind of esoteric sign language. Sometimes waves of the seascapes seem to shade into hieroglyphics, and out of trees and clouds a jerry-built stage appears inside of which a sunrise over mountains unfolds like an apotheosis. Marin's type of fauvism is clearly distinguished from European examples. It manifests a reaction to nature which only the nation of the mass-produced automobile could display. Marin is the born protagonist of an automobilist's attitude toward nature. It is no accident that his activity as a painter coincided historically with the construction of the superhighways which, according to Sigfried Giedion's penetrating analysis, has engendered a new American aesthetics: the aesthetics of a space that, like Einstein's mathematical space, is a function of time.

The third of the great French postimpressionists, Van Gogh, found his posthumous American disciple in Marsden Hartley [4] (1877–1943). It is true Hartley, who stayed in Germany shortly before World War I, may have received the message of Van Gogh through the medium of the German expressionists, especially the painters of the Brücke, such as Pechstein, Kirchner, and Schmidt-Rottluff. He is the opposite of Marin in temperament. For him America has remained what it was to the Hudson River men, an inexhaustible reservoir of untamed nature. Sitting by the shore of the Atlantic, he ignored the superhighways and skyscrapers; and he ignored this world even when in a Manhattan studio. His landscapes are heavily built, almost like masonry, and his mountains have thick black outlines (Fig. 136). In all this tense and uneven struggle he occasionally comes close to Edvard Munch, the great Norwegian painter of epic vistas. Hartley was much less typical than Marin of the modern American mind. His attitude toward nature belongs to a period rather than to a country, although it is inspired by certain localities emotionally significant to the painter.

Among the trained painters of America there was a younger contemporary of the Douanier Rousseau whose work shows a marked psychological if not stylistical affinity to the great French primitive: Louis M. Eilshemius [5] (1864–1941). Eilshemius' imagination was pregnant with quaint characters dwelling in the familiar scenery of hills and woods. He was ill adapted to modern America but was economically independent and thus at least survived the general neglect that was his lot. Indeed, survival would have been difficult even to Rousseau if he had not stuck to his little job as customhouse official. Up to 1921 Eilshemius painted countless little pictures—it is said that his oeuvre would form a list of about 3,500 numbers. Then he gave up and developed into an eccentric. There can be no doubt that genuine cases of primitivism among the educated stratum of a modern society are borderline phenomena: the startling innocence and naïveté that fascinate us like a glance into the lost paradise of childhood are bought at the price of a mental instability which at any moment can develop into a manifest derangement. Eilshemius, embittered and querulous during the last quarter of his life, filled his idle days with writing crank letters to the newspapers, publishing odd little poems and deriding practically

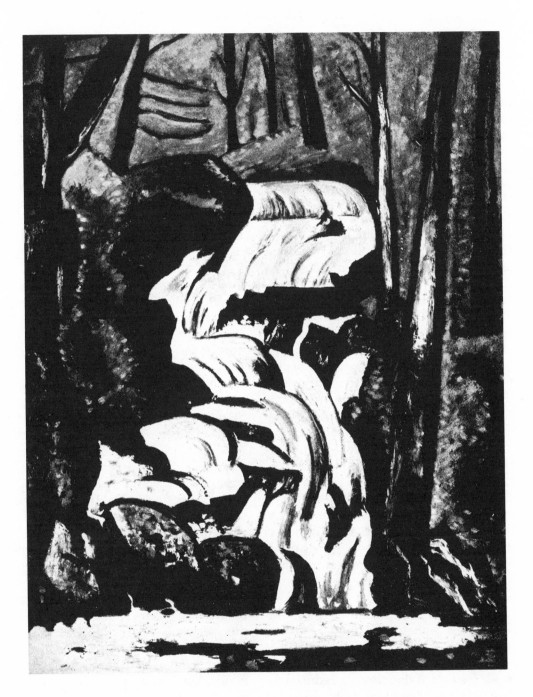

FIGURE 136
MARSDEN HARTLEY
Smelt Brook Falls
City Art Museum, St. Louis, Mo.

everything in art—quite contrary to the unruffled optimism of Rousseau.

Eilshemius' artistic production was extremely unequal. One has to eliminate much that is embarrassingly inept to unearth some works of value. There are numerous pictures in which the childlike and truly charming effect of a landscape is marred by clumsy figures which can in no way be justified. But, if we deduct all this, the remainder is worth saving. For Eilshemius was a genuine painter. Given a motif that inspired him, he could capture with paint and brush the fragrance of a happy hour spent sauntering by a silvery creek or a blue range of hills overlooking a meadow. His naïveté is less obvious than that of his great French predecessor. The rigidity and tenseness of Rousseau—a genuine primitive trait as illustrated by the Italian painters of the trecento and other historic eras of primitivism—are totally missing. On the contrary Eilshemius' way of handling color is fluid. He brushes it on the canvas thinly, accentuating a form here and there with a more "graphic" stroke. But the effect is as close to the "innocence of the eye" as is Rousseau's. When Eilshemius paints *Bridge for Fishing*, the bridge seems to be more a living being than the children whom he places on it (Fig. 137). One step more and it would be transformed into a snake like the props in Walt Disney's animated cartoons. For in Disney's world, reminiscent of old Rodolphe Toepffer, tree stumps or tools sprout limbs and begin to mix with the acting characters, only to be, on the magic formula of their master, reduced to their humble rank as inanimate objects.

It was providential for the young American artists who, following the lead of France, moved against the stream of American public opinion, that they found an unselfish and faithful friend in the photographer Alfred Stieglitz.[6] This unforgettable man was a pioneer of the spirit as were few others. In his studio and exhibition room, called "291" after the house number on Fifth Avenue where he had established himself, Stieglitz opened a haven for unorthodox young Americans, among them Marin, whose eloquent apostle he remained to his last breath. Stieglitz' magazine *Camera Work* became the most discriminating art magazine in America, and it is no accident that it was a photographer and not a painter or a critic who introduced postimpressionism to America. To an art historian of the future a photographer of the rank of Brady will seem as significant as the best painters of his epoch, for his approach to the visible world was so free from convention that it was equaled by very few of his painter contemporaries. The role played by Stieglitz in the birth of a new photography and in the development of modern American art has been enthusiastically appraised. There is no doubt that the freshness and clarity of his photographic concept were stimulating factors, and that he was at the same time a man of unshakable faith in modern art and a promoter of rare disinterestedness. But there is more involved than this.

Photography, it might be remembered, was the invention of a French panorama painter, Daguerre. In the same way that the panorama had caught the fancy of America, photography became acclimatized and developed into a means of communication more powerful than any other, including, perhaps, the written word. It is not difficult to show why this happened. American civilization, from the time of Jefferson, had adopted technology as a means of progress and

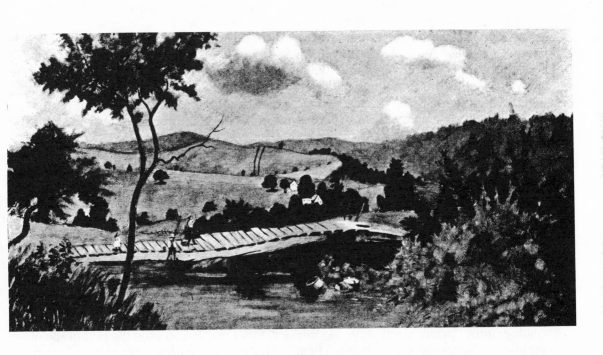

FIGURE 137

Louis M. Eilshemius

Bridge for Fishing

Phillips Memorial Gallery, Washington, D.C.

embarked on the development of a technocratic society. In an economic and social structure based on technological thinking, the exactitude of photography must have recommended itself as a perfect satisfaction of the "thirst for pictures" innate in man and increased in a period of heightened intellectual curiosity. Thus it happened that photography began to inspire painters. Photography showed that it was capable of producing true visual documents of the industrialized world. In spite of the disadvantage of a mechanical reproduction that cannot, save by synthetic devices, eliminate the unessential elements, the new aspect of the world was captured with an authenticity rarely before achieved. There was no escape. The photographic eye focused the hard, nonpicturesque structures of engineering architecture with the same objectivity as the trees and the water next to it. Only there were less and less trees and more and more industrial architecture.

The new wave of influence which photography exerted on painting was unlike that which, after the invention of photography, made itself felt in the middle of the nineteenth century. Then photography was considered a "truthful" means of "imitating nature" and it confused the painters who tried to compete with its alleged truthfulness—a naïve misunderstanding caused by a lack of discrimination. For artistic truth has nothing to do with mere optical correctness.

There was enough confusion in the camp of the photographers too, especially around 1900 when the doctrine of pictorial photography originated—a doctrine that looked for redemption to technical devices which were to make photography similar to painting and

etching. Stieglitz was instrumental in clearing the atmosphere and in paving the way for a distinctly photographic style. It was this "objective" style of photography that formed the starting point for the development of a style in American painting that eventually was able to cope successfully with the tasks that confronted the painter of the new American reality.

The first of these painters was Charles Demuth [7] (1883–1935). This descendant of a Pennsylvania German family, a man of refined taste but broken health, absorbed in Paris those elements of postimpressionist painting which eventually enabled him to interpret his own country. Demuth stayed in Paris during the halcyon but sometimes tense years before the first World War in which the faint grumbling of a political earthquake occasionally was sensed by those engrossed in pursuits seemingly far removed from reality. When Demuth studied the experiments of the cubists and, in the coming years, assimilated their theory to his own way of seeing, he paved the way to what soon was termed precisionism, an art that was to combine the exactitude of photography with the geometrical interpretation of space introduced by cubism. Demuth experimented with the latter. Since the line was to him a natural way of expressing himself, he interpreted the elements of solid geometry that form the essence of cubism in a way quite different from that of Picasso and Braque who painted the plane as such, and gave it its distinguishing character by means of an almost traditional illusionistic color treatment. Demuth indicated geometric relations by inserting ruler-drawn lines into his compositions, lines that forced the rigidity of a geometrical diagram upon the scene, whether it was a steeple of a

colonial church, the gable of a farm-house, or the smokestack of a factory (Fig. 138). When he gave the name of *My Egypt* to a cubistic picture of a factory done in his favorite technique, water color, he indicated that Egyptian temples and American industrial archi-tecture have in common the monumen-tal application of cubic forms. This coincidence suggests a relationship on a deeper level. According to Wilhelm Worringer the collective structure of the Egyptian society and the mass civiliza-tion of America actually show interesting points of contact, and the enormous building projects into which both civili-zations poured gigantic energies doubt-less suggest a comparison.

Demuth did not go all the way toward a geometric interpretation of the Ameri-can scene: his love of organic nature deterred him from the abstract. In the studies of flowers which form the most accomplished part of his work, possibili-ties of landscape painting can be felt which the painter had no time to realize.

Not quite ten years younger than Demuth, Preston Dickinson [8] (1891–1930) developed in a similar direction, and death cut short his career even earlier than it did that of Demuth. Dickinson was endowed with a gift for spatial ar-rangement that did not need the artificial means of diagrams in order to interpret nature in terms of geometry. It is true, he made use of the cubistic idiom, some-times in a more, sometimes in a less ob-vious way, but he never allowed it to distort reality fundamentally. He spent five years studying the old masters at the Louvre, and finally went to Spain like other young men of his generation, lured across the Pyrenees by the magic appari-tion of El Greco. And in Spain he devel-oped his detached and refined style to a

height that promised to carry him to mastery—when his career was termi-nated by an untimely death.

Preston Dickinson, like Demuth, avoided the pure landscape, but the two "precisionists" did this for reasons fun-damentally different from those of noise-loving Bellows. There is a calmness, a silence in their pictures that their objects, mostly industrial suburbs, do not have at all. Dickinson painted the *Harlem River, New York*, because the view offered the elements of a geometric composition with the lofty bridge and the cubes of tenement houses and sheds; and in order not to be diverted by the confusing antics of organic nature, he chose a winter day for his painting (Fig. 139). The trees with blackish branches form their own geometric pattern, and patches of snow provide further elements of geometric planes. What Egypt and the colonial architecture were for Demuth, Quebec was to Dickinson: a paradigm for the grammar of his artistic language, an his-toric body of cubic architecture which did not need to be distorted to yield an essentially cubist motif (Fig. 140). Whereas the world of Demuth is static, that of Dickinson is filled with a spiritual dynamism that causes him to emphasize the effects of foreshortening in a dra-matic way, or to exaggerate slightly the proportions of the objects of his still lifes. It is evident that he sought a confirmation of this when he studied El Greco, and in fact something of El Greco's conscious austerity and arresting spatiality can be felt in Dickinson's work. It is not by chance that Dickinson felt most at ease with pastel, for this technique was in ac-cordance with his perception of the world as a problem in applied geometry.

A third painter, Charles Sheeler (1883–),[9] by affinity rather than by per-

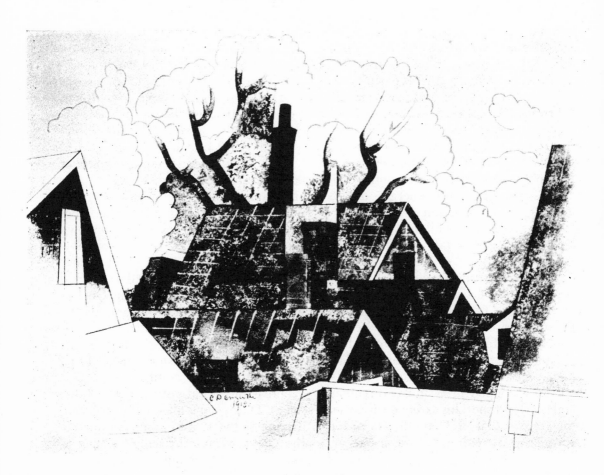

FIGURE 138
CHARLES DEMUTH
Red Chimneys
Phillips Memorial Gallery, Washington, D.C.

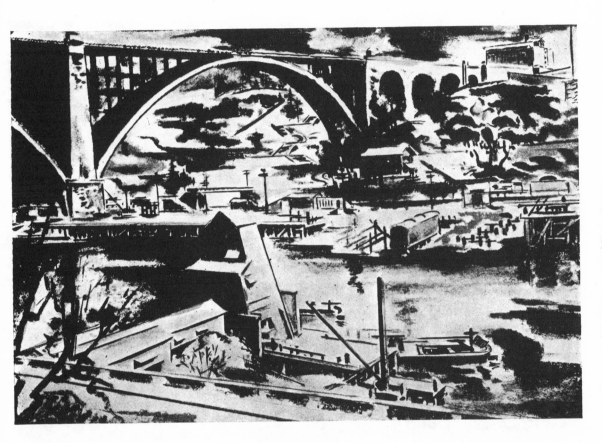

FIGURE 139
PRESTON DICKINSON
Harlem River
Whitney Museum of American Art, New York City

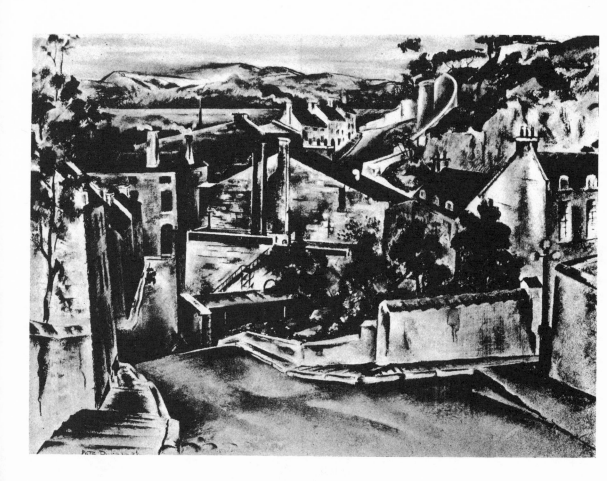

FIGURE 140

PRESTON DICKINSON

Quebec

Cincinnati Art Museum, Cincinnati, Ohio

sonal contact belong near Dickinson and Demuth. He led precisionism to its ultimate realization. This Philadelphian was trained by Chase as a painter. All through his life he has practiced photography as well as painting, and his photographs have raised industrial photography to a level of uncompromising artistic purity. It is this purity of concept that has led Sheeler out of the uncertainties of modern experimentation to a true and perfect style. It is important to know that the artist studied and collected the austere furniture which the Shakers produced early in the nineteenth century. The zeal that caused them to eliminate all decorative accessories from the things they made for their monastic quarters was motivated by an uncompromising religion, but its aesthetic product was a functionalism that is accepted without reservation by the modern industrial designer. Sheeler's attitude is the result of an intellectual approach. The rigidly geometrical forms of Shaker furniture helped him to work out his own style as a painter. The process was complicated by his relation to the aesthetics of photography, "My interest in photography," says Sheeler, "paralleling that in painting has been based on admiration for its possibility of accounting for the visual world with an exactitude not equalled in any other medium. Yet photography by its limitations is confined to presentation of an image of nature without the arbitrary redisposal of elements within the total image." [10]

Out of an integration of the photographic attitude with the requirements of a cubism that was, in the last analysis, more influenced by Shaker design than by French art, Sheeler developed a new art form appropriate to what I should like to call the technocratic landscape. He always had an eye for the functional, and he found it where less uncompromising artists found only the picturesque: in the folk architecture of the Pennsylvania Germans. The bare cubes of barns offered him an opportunity to exercise his sense of form (Fig. 141). By photographing and painting them he sharpened his sense of structure, simplifying both buildings and nature until a solidly built spacial construction developed (Frontispiece). The picture space became a stage for the display of geometrical bodies, manifested in industrial or rural architecture.

What painters of a less forceful mentality could not master—the new American scene—unfolded its aesthetic possibilities under his disciplined hand. There is no complaint about industrial ugliness to be traced in Sheeler's world, but neither does he try to glorify and to romanticize a chaos of steel and brick, smoke and refuse. He rather analyzes the technocratic landscape, this synthetic world in which concrete blocks are the mountains and smokestacks the trees, and he strips it to its essential elements (Fig. 142). He does not drive himself to create something specifically "American," but just because of his unbiased outlook he succeeds in capturing without effort those qualities which are peculiar to America. Sheeler's artistic language is, however, understandable not merely to Americans but everywhere in the world, for it is the language of truly contemporary art. In his work the time lag between the European and the American development has been finally overcome.

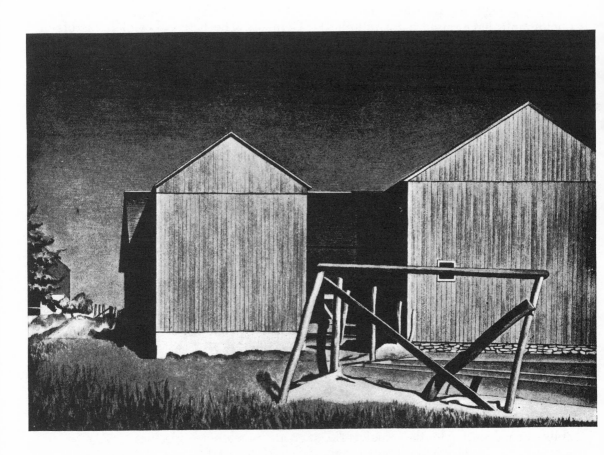

FIGURE 141
CHARLES SHEELER
Connecticut Farm Buildings
Newark Museum, Newark, N.J.

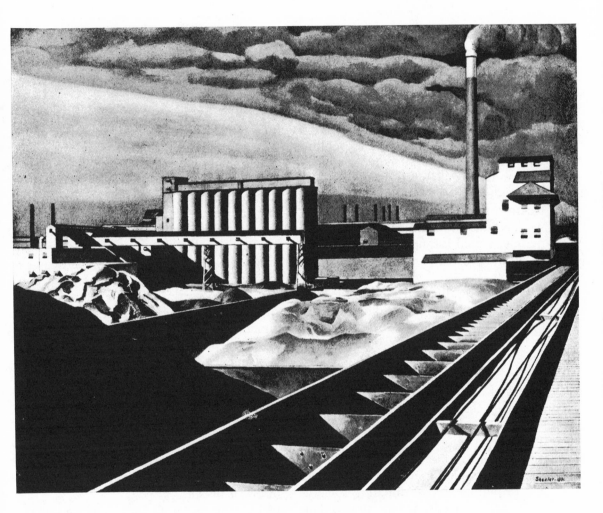

FIGURE 142

CHARLES SHEELER

Classic Landscape

Mrs. Edsel B. Ford, Grosse Isle, Mich.

IN CONCLUSION

IT would be arbitrary to conclude a discussion of American landscape painting with Charles Sheeler, if he were not the outstanding exponent of a style in which the modern aspect of America found its clearest form: precisionism. Thus his work attains an historic character which permits a final estimation more difficult to apply to other by no means lesser artists.

If we recapitulate the development that led from the topographical view to the landscape of mood, the panoramic style, naturalism, impressionism, and precisionism, two observations force themselves upon us: first, that the contribution of "little masters" is often more significant than that of the great personalities; secondly, that the demand for literal description is a basic factor in American art.

Great personalities require the support of a responsive and stimulating society. Such a society needs time to develop. The second quarter of the nineteenth century actually produced a rudiment of a society of this type, enabling a Thomas Cole to develop freely; but the break in American culture that followed the Civil War resulted in the increasing isolation of the American artist whose following was limited even in the best years. The most promising artists dried up like Eakins, or left the country like Whistler, whereas the more modest talent had a better chance. It always had flourished in a regional or peripheric sphere. For this reason the provincial artists, primitives, and panorama painters did not suffer from the frustration that beset many of the outstanding artists. In fact, the influence on legitimate painting of such a peripheral art form as the panorama stimulated the development of the most original school of American landscape painters. The panoramic school represented the descriptive trend in American art most strikingly, but even the earlier romanticists indulged in an exactitude unusual for a fundamentally emotional movement. This American approach, genuine though it was, threatened to create artistic isolationism. The danger of such a development was avoided by the assimilation of European innovations, especially impressionism. After this was accomplished America reverted to its basic aesthetic problem on the new level of precisionism.

The sudden appearance of an outstanding primitive such as Anna Mary Robertson implies a warning: we ought not to think that we know of all contemporary men and women who create true artistic values. America is too vast and its social structure still too fluctuating to permit a comprehensive survey which has proved to be practically unattainable even in Europe where the field is smaller. A new wave of immigration has swept artists of various origins to the shores of America, of whom few rose to promi-

nence but many are working quietly and unobtrusively, recording the unfamiliar surroundings with new sensibility.[1]

Numerous American painters are haunted by the destructive aspects of industrialization and have discovered what I should like to call the slum landscape for modern art. Their approach ranges from social criticism to poetic interpretation. All styles from unabashed naturalism to esoteric abstraction are being tried out. Whether the fascination with this world of refuse and waste will yield results of a more than temporary interest depends upon the creative energy available for the difficult task of bringing order out of chaos. After all, not all of America is a slum, and even the slums will one day be cleared by human hands or swallowed by nature.

America formed its concept of beauty in nature during the period of romanti-cism when the vogue of the picturesque was at its height. The English countryside, however, which was considered the model of a picturesque landscape, was developed artificially in the eighteenth century by aristocratic landowners after the model of Claude Lorrain and other great landscape painters. America has very little "garden landscape," for the class that created it in Europe practically did not exist in America. For this reason her nature is either primeval or developed in a rigidly utilitarian manner. Precisionism is capable of coping with the latter.

There is, however, enough of the timeless America left that delighted the Hudson River men and the painters of the American expansion. It patiently waits for the truly modern American landscape painter to approach it in a spirit that is authentic and at the same time universal.

NOTES

I. THE EUROPEAN HERITAGE

1. Hind, C. Lewis, *Landscape Painting, Giotto to the Present Day* (London, 1924).

2. R. Oldenbourg, *Die Flämische Malerei des XVII Jahrhunderts* (Berlin, 1918), pp. 14–25. For topographical views which anticipate the panoramic style of landscape painting cf. Vte Ch. Terlinden, "Un panorama de Rome à la fin du XV siècle," *Annuaire des Musées Royaux des Beaux-Arts de Belgique*, III (1941–43), 29–40, and Edward S. King, "A New Heemskerck," *The Journal of the Walters Art Gallery*, VII–VIII (1944–45), 61–73.

3. Manwaring, Elizabeth Wheeler, *Italian and English Landscape in Eighteenth Century England* (New York, 1925). Hussey, Christopher, *The Picturesque* (London, 1927).

4. Manwaring, *op. cit.*, p. 182.

5. A circular panorama painted by Johann Michael Sattler in 1829 is preserved in Salzburg, Austria. See *Salzburgs Panorama. Ein Wegweiser . . .* (Linz, 1829); *Österreichische Kunsttopographie*, XIII, 211. J.-J. Hittorff, *Description de la Rotonde des Panoramas . . . précédés d'un aperçu historique sur l'origine des panoramas . . .* (Paris, 1842), contains an interesting anecdote (p. 7): J.-L. David, visiting a panorama with his pupils, exclaimed: "Truly, one has to come here to study nature." "On Cosmoramas, Dioramas, and Panoramas," *The Penny Magazine*, N. S., XI (1842), 363–364. Bapst, G., *Essai sur l'histoire des panoramas et dioramas* (Paris, 1891). Telbin, W., "The Painting of Panoramas," *The Magazine of Art*, XXIV (1900), 535–538. Stanton, Theodore, "The Paris Panorama of the Nineteenth Century," *The Century*, XXXIX (1889), 256–269. Hausmann, S., "Die Erfindung der Panoramen," *Die Kunst für Alle*, IV (1889), 199–202; "Die neueste Entwicklung der deutschen Panoramamalerei," *idem*, V (1890), 251–263. Feldhaus, Franz Maria, *Die Technik der Vorzeit, der geschichtlichen Zeit und der Naturvölker* (Leipzig, 1914), p. 765. Coke, D., *Confessions of an Incurable Collector* (London, 1928), Chap. v, "Panoramas." On the influence of the panorama on wallpaper ("scenic papers") see *Tableaux-Teintures de Dufour et Leroy*, intro. by Clouzot, Henri (Paris, c. 1930).

6. Dickinson, H. W., *Robert Fulton, Engineer and Artist, His Life and Works* (London, 1913), pp. 95–96.

7. Hussey, *op. cit.*, pp. 239–240.

8. *Idem*, pp. 239–240.

9. Feldhaus, *op. cit.*, see under the heading "Panorama."

10. A painting by this artist dated 1821 that is influenced by his panoramas if it is not a study for a panorama is *Rugard auf Rügen*, illustrated in Tschudi, Hugo von, *Ausstellung Deutscher Kunst aus der Zeit von 1775–1875 in der Königlichen Nationalgalerie, Auswahl der hervorragendsten Bilder* (Munich, 1906), p. 113.

II. SENTIMENT OF NATURE

1. George Beck, born 1749, came to America in 1795, died there in 1812; William Groombridge, born in 1760, came to America in 1794, died there in 1811. William Winstanley, born at an unknown date, stayed in America from c. 1790 to c. 1801. Died at an unknown date, probably in England. See Pleasants, J. Hall, *Four Late Eighteenth Century Anglo-American Landscape Painters* (Worcester, Mass., 1943).

2. Harley, R. L., "An Eighteenth Century Connecticut Artist Comes into His Own," *American Collector*, XIV (1945), 10–13.

3. Hussey, *op. cit.*, pp. 57–60.

4. Little, Nina Fletcher, "Winthrop Chandler," *Art in America*, XXXV, No. 2 (1947), Fig. 33.

5. Weitenkampf, Frank, "Early American Landscape Prints," *Art Quarterly*, VIII, No. 1 (1945), 40–67.

6. Flexner, James Thomas, "American Colonial Paintings in General," *Magazine of Art*, XL (1947), 138–142.

7. Burroughs, Allen, *Limners and Likenesses* (Cambridge, Mass., 1936), pp. 142–144.

8. Soby, James Thrall, and Miller, Dorothy C., *Romantic Painting in America* (catalogue), The Museum of Modern Art, New York, 1943. Richardson, Edgar Preston, *American Romantic Painting* (New York, 1944), pp. 5–13. Sweet, Frederick A., *The Hudson River School and the Early Landscape Tradition* (catalogue) (New York, 1945), pp. 1–11.

9. Richardson, Edgar Preston, "Allston and the Development of Romantic Color," *Art Quarterly*, VII, No. 1 (1944), 33–57.

10. Coburn, Kathleen, "Notes on Washington Allston from an Unpublished Notebook of Samuel Taylor

Coleridge," *Gazette des Beaux-Arts*, Series 6, XXV (1944), 249–252.

11. Hellman, George S., *Washington Irving, Esquire* (New York, 1925), p. 138.

12. Born, Wolfgang, "Sources of American Romanticism," *Antiques*, XVLIII (1945), 274–277.

13. Sweet, *op. cit.*, illustrated p. 33.

14. McDowell, Tremaine, *William Cullen Bryant* (New York, 1935), pp. xxv–xxvi, xxxvi.

15. Dunbar, Seymour, *A History of Travel in America* (Indianapolis, 1915), II, passim.

16. Comstock, Helen, "Hudson River Portfolio after paintings by W. G. Wall," *Connoisseur*, CVII (1941), 120, 121. Shelley, Donald A., "William Guy Wall and His Watercolors for the Historic Hudson River Portfolio," *The New York Historical Society Quarterly*, XXXI, No. 1 (1947), 25–45.

17. Lanman, Charles, *Letters from a Landscape Painter* (Boston, 1844). Mather, F. J., Jr., "The Hudson River School," *American Magazine of Art*, XXVII (1934), 297–306. "Hudson River Men," *Bulletin, Minneapolis Institute of Art*, XXV (1936), 142–147. Kellner, Sidney, "The Beginnings of Landscape Painting in America," *Art in America*, XXVI (1938), 158–168. Isham, Samuel, *The History of American Painting* (new ed., New York, 1942), pp. 232–254. Cowdrey, Bartlett, "The Hudson River School and Its Place in American Art," *American Collector*, XIV (May, 1945), 10–11. "Knowns and Unknowns of the Hudson River School," *Antiques*, XLVII (1945), 140–144. Sweet, *op. cit.*, passim.

18. "In Nature's Wonderland" and "Landscape after Ruysdael, 1846," Sweet, *op. cit.*, illustrated pp. 37, 39.

19. Sweet, Frederick A., "Asher B. Durand, Pioneer American Landscape Painter," *Art Quarterly*, XVIII (1945), 140–160.

20. Einem, Herbert von, *Caspar David Friedrich* (Berlin, n.d.), "Chalk Cliffs in Rügen," illustrated Fig. 61.

21. Francis, H. S., "Thomas Cole, Painter of the Catskill Mountains," *Cleveland Museum Bulletin*, XXIV (1937), 98–101. Cumming, B., "Thomas Cole Exhibition," *Art in America*, XXX (1942), 68–69. Lesley, P., "Thomas Cole and the Romantic Sensibility," *The Art Quarterly*, V (1942), 199–211.

22. Tschudi, *op. cit.*, Caspar David Friedrich's "Cross in the Mountains," illustrated p. 150. Philipp Otto Runge's "The Morning," illustrated p. 45, *idem*.

23. Nathan, Walter L., "Thomas Cole and the Romantic Landscape," in Boas, George, ed., *Romanticism in America* (Baltimore, 1940), pp. 24–62.

24. Sweet, *op. cit.*, pp. 41–42, 48–53.

25. *Bulletin of the Minneapolis Institute of Arts*, XXIV (1935), 88–90.

26. Mumford, Lewis, *The Brown Decades. A Study of the Arts in America, 1865–1895* (New York, 1931), pp. 82–96.

27. Sweet, *op. cit.*, pp. 74–76, 93.

28. Decatur, Stephen, "Alfred Jacob Miller: His Early Indian Scenes and Portraits," *The American Collector*, VIII, No. 11 (1939), 6, 7. "West of the Rendezvous: Artist A. J. Miller Travels the Oregon Trail in 1837," *Fortune*, XXIX (1944), 11–21. Sweet, *op. cit.*, pp. 83–84. In the notes which Miller wrote to accompany each of the 200 water colors in the Walters collection, he has this to say about "Green River, Oregon":

"The source is near Fremont's Peak and runs southerly, making one of the tributaries of the great Colorado. As it is in close proximity to the Rocky Mountains, every bend almost produces fine views, the mountains forming a glorious background. Indians encamped 'en route' for the rendezvous were all about us, for this gathering at a fixed time brings them from far and near.

"A few days before reaching this spot we had the misfortune to lose one of our best men. He was driving his team in the train when the driver in the one before him, reaching back in his wagon, touched the lock of his rifle suspended at his side. The ball struck the man in the breast, passed through him and broke his squaw's arm, seated directly behind him. He was immediately laid on the grass but never spoke a word and died in less than ten minutes. The sun did not seem to shine so brightly for the balance of the day."

The following book appeared too late to be quoted: DeVoto, Bernard, *Across the Wide Missouri*. Illustrated with paintings by Alfred Jacob Miller, Charles Bodmer, and George Catlin. With an Account of the Discovery of the Miller Collection by Mrs. Clyde Porter (Boston, 1948).

29. *George Henry Durrie 1820–1863, Connecticut Painter of American Life* (exhibition catalogue), Cowdrey, Bartlett, intro., Wadsworth Atheneum (Hartford, Conn., 1947).

30. Sweet, *op. cit.*, p. 95.

31. Sweet, *op. cit.*, pp. 84–87. Cowdrey, Bartlett, "John Frederick Kensett, 1816–1872, Painter of Pure Landscape," *The American Collector*, XIV (Feb., 1945), 13.

32. Thieme-Becker, *Allgemeines Lexikon der bildenden Künstler*, XIX (Leipzig, 1926), 84. The Art Room of the New York Public Library keeps a considerable collection of reproductions after Johnson in its clipping file.

33. Rust, Fern Helen, *George Caleb Bingham. The Missouri Artist*, Jefferson City, Mo., 1917. Christ-Janer, Albert, *George Caleb Bingham of Missouri, the Story of an Artist* (New York, 1940).

34. Cowdrey, Bartlett, and Williams, Hermann Warner, Jr., *William Sidney Mount, 1807–1868, an American Painter* (New York, 1944).

35. Draper, Benjamin Poff, "Albert Bierstadt," *Art in America*, XXVIII (1940), 61–71.

36. Downes, William Howe, "American painters of Mountains," *Magazine of Art*, XXV (1932), 193–202.

37. McCausland, Elizabeth, "Martin Johnson Heade, 1819–1904," *Panorama*, L (1945), 1–7.

III. THE PANORAMIC STYLE

1. Flexner, James Thomas, *America's Old Masters; First Artists of the New World* (New York, 1939), "The Ingenious Mr. Peale," pp. 208–209.

2. Swan, Mabel M., and Karr, Louise, "Early Marine Painters of Salem," *Antiques*, XXXVIII (1940), 63–65.

3. A drop curtain in the old Providence Theater painted by J. Worroll c. 1809 shows a view of Providence in a style midway between stage design and panorama. It is illustrated in *Antiques*, XLIV (1943), 236.

4. Sweet, *op. cit.*, p. 26.

5. *Exhibition of the Work of John Vanderlyn, 1776–1852*, Kingston Senate House Museum, Kingston, N.Y., 1938.

6. Victor W. von Hagen, "F. Catherwood Archt 1799–1854," *The New York Historical Society Quarterly*, XXX (Jan., 1946), No. 1, 17–29; *idem*, "Mr. Catherwood's Panorama," *Magazine of Art*, XL (1947), 143–146.

7. Dunlap, William, *History of the Arts of Design of the United States* (new ed., Bayley, Frank W., and Goodspeed, Charles E., Boston, 1918). I, 133, 134.

8. Born, *op. cit.*, p. 277. Mr. Frederick A. Sweet directs my attention to a similarity between Cole's "An Architect's Dream" in the City Art Museum of St. Louis and Turner's "Conquest of Carthage."

9. "View from Mt. Holyoke," opposite p. 10 in N. T. Willis, *American Scenery* (London, c. 1840), I. This work contains engravings after W. H. Bartlett. Cf. Dintruff, Emma Jane, "The American Scene a Century Ago," *Antiques*, XXXVIII (1940), 279–281; Cowdrey, Bartlett, "William Henry Bartlett and the American Scene," reprinted from *New York History* (1941).

10. Voll, Karl, *Memling* (Stuttgart, 1909), illustrated, pp. 32–33.

11. Peters, Harry T., *Currier and Ives* (New York, 1926), pp. 274–277.

12. Born, Wolfgang, "St. Louis in the History of American Art. A Study in Regionalism," *Gazette des Beaux-Arts*, Series 6, XXX (1947), 301–318.

13. Coffin, Helen Lockwood, "Dioramas, Panoramas, Cycloramas," *The Mentor*, XII (1928–29), 33–35.

14. Odell, George C. D., *Annals of the New York Stage* (New York, 1928), III, 407. The names Jones, Gordon, Reinagle, and their assistants Haddock, White, and Leslie are quoted as those of the stage painters who created the dioramic scenery "from sketches made at the views portrayed." Coad, Oral Summer, *William Dunlap* (New York, 1917), pp. 107–108. The canvas area of the moving diorama was said to be 2,500 square feet.

15. *The Penny Magazine, op. cit.*, 363–364.

16. Whittier, John Greenleaf, "The Panorama," in *The Poetical Works*, VIII (Anti-Slavery Poems, Songs of Labor and Reform) (Boston, 1892), 193–210, describes a demonstration of a moving panorama in 1854. Bowerman, Sarah G., "John Banvard," in *Dictionary of American Biography*, Johnson, Allen, ed., I (1928), 582–583. Coburn, Frederick W., "John Rowson Smith," *idem*, XVII (1935), 306–307. Heilbron,

Bertha L., *Making a Motion Picture in 1848, Henry Lewis' Journal of a Canoe Voyage from the Falls of St. Louis* (St. Paul, 1936). McDermott, John Francis, "Newsreel—Old Style, or Four Miles of Canvas," *Antiques*, XLIV (1943), 10–13. Read, Georgia Willis, and Gaines, Ruth, *Gold Rush, The Journals, Drawings, and Other Papers of J. Goldsborough Bruff* . . . (New York, 1944), pp. 941, 1000, 1001, Fig. opposite p. 972. The history of the moving panorama is not yet written. On some early examples and panoramic maps see: Hegemann, Werner, *Das steinerne Berlin* (Berlin, 1930), Pl. 34, "Lindenpanorama" of 1825; *Descriptive Catalogue of the Padorama (sic!) of the Manchester and Liverpool Rail-Road* . . . (London, 1834); William Wade and Croome, *Panorama of the Hudson River from New York to Albany* (New York, 1846).

17. Mason, J. Alden, *Pennsylvania Archaeologist*, XII (Jan., 1942), 14–16.

18. Rathbone, Perry T., *Charles Wimar, 1828–62* (St. Louis, 1946) (exhibition catalogue).

19. Illustrated in Sweet, *op. cit.*, p. 41.

20. S. R. K., "George Loring Brown," *Zeitschrift für Bildende Kunst*, VI (1871), 61–68. Richardson, *op. cit.*, p. 27.

21. Hawthorne, Nathaniel, *Passages from the French and Italian Notebooks* (1871), pp. 169–170 (on Brown); p. 368 (on Cimabue and Giotto).

22. *Life in America* (New York, 1939) (exhibition catalogue), No. 93.

23. Draper, *op. cit.*, Spieler, Gerhard G., "A Noted Artist in Early Colorado. The Story of Albert Bierstadt," *American-German Review* (June, 1945), pp. 13–17.

24. Downes, *op. cit.*, p. 194. Richardson, *op. cit.*, p. 36.

25. Draper, Benjamin Poff, "Thomas Moran, Painter, Adventurer and Pioneer," *Art in America*, XXIX (1941), 82–87.

26. Gardner, A. T. E., "Scientific Sources of the Full Length Landscape: 1850," *Bulletin, Metropolitan Museum of Art*, N.S. 4 (1945), pp. 59–65.

27. Ford, James B., "Conrad Wise Chapman, Valley of Mexico," *Gazette des Beaux-Arts*, N.S. 6, XXII (1942), 53–56. Sweet, *op. cit.*, pp. 113–114.

28. Encina, Juan de la, *El Paisagista José María Velasco (1840–1912)* (Mexico City, 1943).

29. Born, Wolfgang, *Still-Life Painting in America* (New York, 1947), pp. 27–37. Miss Bartlett Cowdrey informed me of an interesting fact that had come to her attention after the book on the still life was completed. Church, who shared Heade's studio, painted the trompe l'oeil in Heade's "Gremlin in the Studio" (Fig. 73 in *Still-Life Painting in America*). His addition of the water dropping from the picture and the gremlin, were a practical joke; nevertheless it demonstrates the affinity between the panoramic style and the style of trompe l'oeil.

IV. WITH FRESH EYES

1. Lipman, Jean, *American Primitive Painting* (New York, 1942), p. 19.

2. The Museum of Modern Art, *American Folk Art, The Art of the Common Man in America, 1750–1900*, intro. by Cahill, Robert (New York, 1932) (exhibition catalogue), pp. 31–33.

3. Anastasi, A., and Foley, J., Jr., "The Study of

'Populistic Painters' as an Approach to the Psychology of Art," *The Journal of Social Psychology*, XI (1940), 353–368.

4. Born, Wolfgang, "American Primitives in Their Relation to Europe and the Orient," *Antiques*, LII (1947), 180–182.

5. H. S. (Heinrich Schwarz), "American Folk

Painting," *Museum Notes,* II (Providence, R.I., Jan., 1944), 2, 3.

6. *First American Modern* (exhibition catalogue), Macbeth Gallery (New York, 1942).

7. Lipman, Jean, "American Townscapes," *Antiques,* XLVI (1944), 340–341. MacFarlane, Janet R., "Hedley, Headley or Hidley, Painter," *New York History,* XXVIII, No. 1 (1947), 74–75.

8. Pleasants, *op. cit.,* pp. 55–116.

9. Director E. P. Richardson of the Detroit Institute of Arts believes the picture was probably based on an engraving by I. C. Armitage after Bartlett in Willis, *op. cit.,* II, opposite p. 71, "Schuylkill Waterworks at Philadelphia" (cf. Chap. III, note 9).

10. Parker, Barbara N., "George Harvey and His Atmospheric Landscapes," *Bulletin of the Museum of Fine Arts,* XLI (Boston, 1943), 7–9.

11. Sweet, *op. cit.,* p. 74.

12. Millard, Everett L., "Sign Painter Succeeds in Genre Field. Albertis D. O. Browere Left Valuable Records of Last Century," *The New York Sun* (Feb. 10, 1940) (Antiques—Art). Richardson, *op. cit.,* p. 27. Sweet, *op. cit.,* pp. 81–82.

13. I am indebted to Miss Ninfa Valvo, Associate Curator of Paintings at the M. H. de Young Memorial Museum, San Francisco, for information about Lee.

14. Museum of Modern Art, *op. cit.,* p. 33.

15. Kallir, Otto, ed., intro. by Bromfield, Louis, *Grandma Moses, American Primitive* (New York, 1946).

V. PAINTERS OF TONE AND LIGHT

1. Jarves, James Jackson, *The Art-idea: Sculpture, Painting and Architecture in America* (3d. ed., New York, 1866). Cf. Boas, George, "The Critical Practice of James Jackson Jarves," *Gazette des Beaux-Arts,* Series 6, XXIII (1943), 295–307.

2. Jarves, *op. cit.,* p. 254.

3. Dickeson, D. H., "The American Pre-Raphaelites," *Art in America,* XXX (1942), 157–165. Cary, Edward, "Some American Pre-Raphaelites: A Reminiscence," *The Scrip,* II, No. 1, (1906).

4. Pope, Arthur, *op. cit., Dictionary of American Biography,* XIII (1934), 116–117. Sweet, *op. cit.,* p. 113.

5. Letter on back of panel:

<div align="right">Catskill, N.Y.,
March 16, 1869</div>

Mr. S. Wilde
Dear Sir:

Herewith you have the picture which was commended so long ago for you—I hope you will find in it enough excellence to repay for the long waiting.

The bridge, in the middle ground, I think the most interesting thing of the kind in this country and it was on account of it that I chose the object.

<div align="right">Yours very truly,
C. H. Moore</div>

See: Newhouse Galleries, *The American Scene, 1820–1870, an Exhibition of the American Landscape by American Painters* (New York, n.d.), p. 40.

6. Shannon, Martha A. S., *Boston Days of William Morris Hunt* (Boston, 1923).

7. Jarves, *op. cit.,* 316–321. Born, Wolfgang, "Geo-Architecture, an American Contribution to the Art of the Future," *Magazine of Art,* XXXVII (1944), 16–21.

8. Cortissoz, Royal, *John La Farge: A Memory and a Study* (Boston, 1911).

9. Mellquist, Jerome, *The Emergence of an American Art* (New York, 1942), pp. 3–43.

10. Meier-Graefe, Julius, *Die Grossen Engländer* (Munich, 1908), p. 147.

11. *Idem,* p. 139.

12. McCausland, Elizabeth, *George Innes, An American Landscape Painter* (New York, 1946); "The Early Innes," *American Collector,* XV (1946), 6–8.

13. Beatty, John W., "Recollections of an Intimate Friendship," in Lloyd Goodrich, *Winslow Homer* (New York, 1944), p. 216.

14. Mellquist, *op. cit.,* pp. 44–59.

15. Martin, Elizabeth Gilbert, *Homer Martin, a Reminiscence* (New York, 1904). Mather, Frank Jewett, *Homer Martin: Poet in Landscape* (New York, 1912).

16. Clark, Eliot, *Alexander Wyant* (New York, 1916).

17. Bromhead, Harold W., "Henry W. Ranger," *The International Studio,* XXIX (1906), xxxiii–xliv. Ruge, Clara, "The Tonal School of America," *The International Studio,* XXVII (1906), lvii–lxvii. Bell, Raley Husted, *Art Talks with Ranger* (New York, 1914).

18. Sherman, Frederick Fairchild, *Albert Pinkham Ryder* (New York, 1920).

19. Daingerfield, Elliott, *Ralph Albert Blakelock* (New York, 1914). *Ralph Albert Blakelock Centenary Exhibition* (catalogue), intro. by Goodrich, Lloyd, Whitney Museum of American Art (New York, 1947).

20. "The Autobiography of Worthington Whittredge," Baur, John I. H., ed., in *Brooklyn Museum Journal* (1942), 3–68.

21. Baur, John I. H., *An American Genre Painter, Eastman Johnson, 1824–1906* (Brooklyn, 1940).

22. Mellquist, *op. cit.,* pp. 60–77.

23. Huth, Hans, "Impressionism Comes to America," *Gazette des Beaux-Arts,* Series 6, XXIX (1946), 225–252.

24. Baur, John I. H., *Leaders of American Impressionism* (Brooklyn, 1939).

25. Baur, John I. H., *Theodore Robinson, 1852–1896* (Brooklyn, 1946).

26. Adams, Adeline, *Childe Hassam* (New York, 1938).

27. Philipps, Duncan, and others, *Julian Alden Weir; An Appreciation of His Life and Works* (New York, 1922).

28. Tucker, Allen, *John H. Twachtman* (New York, 1931).

29. Pène du Bois, Guy, *William J. Glackens* (New York, 1931).

30. Pène du Bois, Guy, *Ernest Lawson* (New York, 1932).

31. Eggers, George W., *George Bellows* (New York, 1931).

32. "William Henry Holmes (1846–1933)," *Bulletin of the Addison Gallery of American Art, Phillips Academy*, Andover, Mass., XLII, No. 5, 19–21. Hough, Walter, "William Henry Holmes," *The American Anthropologist*, XXXV (1933), 752–764. Mechlin, Leila, "William H. Holmes," *Art and Progress*, VI,

No. 1 (1914), 11–14. I am indebted for additional information to Mr. Thomas M. Beggs, Assistant Director of the National Collection of Art, Washington, D.C.

33. Wildenstein (Galleries), *An Exhibition of Oils and Pastels by Arthur C. Goodwin* (New York, 1946), Text by Peterkin, L. Denis: "The Man," and Venturi, Lionello, "The Artist."

VI. TOWARD A TECHNOCRATIC LANDSCAPE

1. Cortissoz, Royal, *Arthur B. Davies* (New York, 1931). Mellquist, *op. cit.*, pp. 213–228.

2. Breuning, Margaret, *Maurice Prendergast* (New York, 1931). Mellquist, *op. cit.*, pp. 141–145.

3. Benson, E. M., *John Marin: The Man and His Work* (Washington, D.C., 1935). Mellquist, *op. cit.*, pp. 384–402.

4. Museum of Modern Art, *Lyonel Feininger; . . . Marsden Hartley*, with statements by the artist and a foreword by Monroe Wheeler (New York, 1944), pp. 356–361.

5. Schack, William, *And He Sat among the Ashes, Biography of Louis M. Eilshemius* (New York, 1939).

6. Frank, Waldo, and others, ed., *America and*

Alfred Stieglitz (New York, 1934). Mellquist, *op. cit.*, pp. 85–112.

7. Murell, William, *Charles Demuth* (New York, 1931). Lane, James M., "Charles Demuth," in *Masters in Modern Art* (Boston, 1936), pp. 83–92. Mellquist, *op. cit.*, pp. 336–340. Lee, Sherman E., "The Illustrative and Landscape Watercolors of Charles Demuth," *The Art Quarterly*, V (1942), 158–175.

8. Mellquist, *op. cit.*, pp. 320–321.

9. Rourke, Constance, *Charles Sheeler, Artist in the American Tradition* (New York, 1938).

10. "Sheeler—1946," *Art News*, XLV (1946), 30–31.

IN CONCLUSION

1. Born, Wolfgang, "The Panoramic Landscape as an American Art Form," *Art in America*, XXXVI (1948), No. 1, 3–10.

ADDENDA

One of the contemporaries of Kensett (see p. 59) undeservedly fallen into oblivion has been brought to light recently by J. Carson Webster. See "Junius R. Sloan (1827–1900), An Exhibition of Paintings Held in Connection with the Midwestern College Art Conference, 1946, Scott Hall, Northwestern University" (Evanston, Illinois) (catalogue).

The painting by W. H. Titcombe mentioned on p. 131 is listed in Arthur Everett Austin, Jr., ed., "Twenty-five American Paintings from the Revolution to the Civil War" (catalogue), Wadsworth Atheneum (Hartford, Conn., n.d.), as "No. 12, Winter Scene in Raymond, New Hampshire, 22 × 30." According to the catalogue Titcombe painted mostly in

New Hampshire. The Addison Gallery of American Art, Phillips Academy, Andover, Mass., owns another winter landscape by Titcombe. Austin points at the similarity between Titcombe and George Henry Durrie.

The Boston portrait painter Dennis Miller Bunker (1861–90) painted several handsome impressionistic landscapes at an early date. He deserves to be included in the group of American impressionists listed on p. 179. See "Dennis Miller Bunker, Exhibition of Paintings and Drawings, Museum of Fine Arts," Boston, 1943, Nos. 13–24, and "Dennis Miller Bunker, A Supplementary Group of Paintings and Water Colors Including Some Early Works, Museum of Fine Arts" (Boston, 1945) (catalogue), Nos. 5, 7–12.

INDEX

Achenbach, Andreas, 100
Adams, Adeline, 220
Agasse, Jacques Laurent, 50
Albany, 90, 219
Algeria, 56
Allegory, 32, 126
Allston, Washington, 30, 31, 80, 118, 217
Alps, 7
American Academy of Arts, 40
Anastasi, Anne, 219
Andersen, Hans Christian, 31
Angelico, Fra, 120
Armitage, I. C., 220
Armory Show, 199
Art nouveau, 196, 199
Athens, 78
Atlanta, Ga., 78
Atlantic, 80, 202
Audubon, John James, 50
Austin, Arthur Everett, Jr., 221
Austria, 3, 217

Baedeker, 103
Balmoral, 90
Baltimore, Md., 53, 56
Banvard, John, 90, 91, 96, 113, 219
Bapst, Germain, 217
Barbizon school, 12, 19, 150, 153, 159, 167
Barker, Henry, 11, 81
Barker, Robert, 10, 11
Barnstable, Mass., 135
Baroque, 4, 10, 11, 109
Bartlett, William Henry, 81, 135, 219, 220
Bassanos, the, 7
Bastien-Lepage, Jules, 175
Baur, John I. H., 220
Bayley, Frank W., 219
Beatty, John W., 220
Beck, George, 217
Beckwith, Carrol, 179
Beggs, Thomas M., 221
Belgique (Belgium), 217
Bell, Ralph Husted, 167, 220
Bellini, Giovanni, 126
Bellows, George F., 184, 207, 221
Benson, Emanuel Mervin, 221
Berlin, 12, 90, 219
Bethlehem, 86
Biedermeier, 12, 53, 56, 69, 103, 106, 109, 139, 143, 149, 153, 159, 218, 219
Bierstadt, Albert, 69, 103, 106, 109, 117, 149, 159, 218, 219
Bingham, George Caleb, 65, 89, 118, 218
Birch, Thomas, 26
Blakelock, Ralph Albert, 172, 220

Boas, George, 218, 220
Bodmer, Charles, 218
Bond, Frances. *See* Palmer
Born, Wolfgang, 218, 219, 220, 221
Boston, 31, 32, 75, 78, 90, 109, 150, 153, 189, 199, 220
Boucher, François, 53
Boudin, Émile, 189
Boulevard Montmartre, 11
Bouton, Charles Marie, 89
Bowerman, Sarah G., 219
Bradley, A. Wesley, 109
Brady, Matthew B., 162, 204
Braque, Georges, 19, 206
Brazil, 69
Breuning, Margaret, 221
Breysig, Johann Adam, 11
Brill, Paulus, 4
Bromfield, Louis, 220
Bromhead, Harold W., 220
Brooklyn, 131
Brooklyn Museum, 40
Browere, Albertis D. O., 139, 144, 220
Brown, George Loring, 100, 103, 219
Brücke, 19
Brueghel, Jan (Velvet), 4
Brueghel, Pieter the Elder, 4, 126, 131
Bruff, J. Goldsborough, 219
Bryant, William Cullen, 33, 36, 42, 218
Buffalo, New York, 103
Bunker, Dennis Miller, 221
Burford, Robert, 11, 78, 81
Burgundy, 3
Burke, Edmund, 26
Burroughs, Allen, 217

Cahill, Robert, 219
Calame, Alexander, 40
California, 139
Canaletto, 12
Caravaggio, 7
Carthage, 219
Cary, Edward, 220
Casilear, John W., 100
Cassatt, Mary, 154, 156
Catherwood, Frederick, 78, 219
Catlin, George, 218
Catskill, 139, 220
Catskills, 46, 50, 90, 113, 139, 150, 218
Central Park, New York City, 53, 153
Cézanne, Paul, 19, 196, 199
Chambers, Thomas, 122
Champs Élysées (Paris), 11
Chandler, Winthrop, 217
Chapman, Conrad Wise, 113, 219

Chase, William Merritt, 175, 179, 211
Chevreul, Michel-Eugène, 19
Chicago, 89
Chouteau's Pond (St. Louis), 131
Christ-Janer, Albert, 218
Church, Frederick Edwin, 109, 113, 149, 159, 219
Cimabue, 100, 210, 219
Cincinnati, 126
Clark, Eliot, 220
Clark, William, 80
Classicism, 12, 26, 78
Claude Lorrain, 7, 10, 32, 40, 46, 120, 196, 215
Claude glass, 10, 53
Cleveland, 109
Cleveland Museum of Art, 81
Clouzot, Henri, 90, 217
Coad, Oral Sumner, 219
Coburn, Frederick W., 219
Coburn, Kathleen, 217
Coffin, Helen Lockwood, 219
Coke, Desmond, 217
Cole, Thomas, 42, 46, 50, 80, 81, 86, 97, 100, 109, 214, 218, 219
Coleridge, Samuel Taylor, 31, 218
Colorado, 109, 218, 219
Comstock, Helen, 218
Concord, Mass., 32, 50
Concordia, Lake, 96
Coninxloo, Gillis von, 4, 7
Connecticut, 56, 81, 167, 217
Constable, John, 12, 139
Cooper, James Fenimore, 31, 38, 78, 80
Corné, Michele Felice, 75
Corot, Camille, 12, 153, 159, 167
Cortissoz, Royal, 220, 221
Cosmorama, 90, 217
Courbet, Gustave, 19, 150, 153, 154, 156, 175, 179
Couture, Thomas, 150
Cowdrey, Bartlett, 218, 219
Croome, William, 219
Cropsey, Jasper F., 56, 59, 100
Cubism, 206, 211
Cumming, George Burton, 56, 88, 219
Currier and Ives, 56, 88, 219
Cyclorama, 10, 78, 219

Daguerre, Jacques Mandé, 87, 204
Daingerfield, Elliott, 220
Danube Style, 3
Daubigny, Charles, 153
David, Jacques-Louis, 40, 217
Davies, Arthur B., 196, 199, 221
Decatur, Stephen, 218
Degas, Edgar, 156
Delacroix, Eugène, 56
Delaroche, Paul, 53
Delaware, 159
Demuth, Charles, 206, 207, 211, 221
Denis, Maurice, 196
Der Blaue, 65
De Soto, Hernando, 96
Detroit Institute of Arts, 220
De Voto, Bernard, 218
Diaz de la Peña, Narcisse, 167

Dickason, David Howard, 220
Dickens, Charles, 38, 119
Dickeson, Montroville Wilson, 91, 96, 119, 220
Dickinson, Henry Winram, 217
Dickinson, Preston, 207, 211
Dintruff, Emma Jane, 219
Diorama, 89, 90, 217, 219
Disney, Walt, 204
Doughty, Thomas, 38, 40, 42, 50, 97
Downes, William Howe, 218, 219
Draper, Benjamin Poff, 218, 219
Dresden, 32
Dufour, Joseph, 217
Dughet, Gaspard (Poussin), 7, 40
Dunbar, Seymour, 218
Dunlap, William, 90, 219
Dupré, Jules, 153
Durand, Asher B., 40, 42, 46, 50, 97, 122, 218
Dürer, Albrecht, 3, 4
Durrie, George H., 56, 218
Düsseldorf, 12, 65, 91, 97, 100, 103, 150, 175
Duveneck, Frank, 175, 179
Dyck, Anton van, 40

Eakins, Thomas, 156, 214
Earl, Ralph, 24
East (Coast), 26, 90
Eastman, Seth, 139
École des Beaux-Arts, 53
Edinburgh, 10
Egan, John J., 91, 96
Eggers, George W., 221
Egypt, 89, 207
Eidophusicon, 11, 75
Eight, the, 184
Eilshemius, Louis M., 202, 204, 221
Einem, Herbert von, 28, 218
Einstein, Albert, 202
El Greco, 20, 207
Elsheimer, Adam, 4, 7
Emerson, Ralph Waldo, 32, 50
Encina, Juan de la, 219
England, 11, 26, 30, 46, 91, 131, 135, 149, 162, 217
Erie Canal, 38, 90, 196, 199
Expatriates, 154, 156
Expressionism, 19

Fantin-Latour, Henri, 154
Fauvism, 202
Feininger, Lyonel, 221
Feldhaus, Franz Maria, 217
Fisher, Alvin, 50
Flexner, James Thomas, 217, 218
Florence, 3, 100, 126, 162
Florida, 69
Fogg Museum (Cambridge, Mass.), 150
Foley, John Porter, Jr., 219
Folk art, 86, 88, 118, 219
Fontainebleau, 153
Ford, James B., 219
France, 11, 19, 38, 53, 78, 100, 117, 126, 131, 149, 153, 154, 156, 167, 184, 189, 193, 196, 204
Francis, Henry Sales, 218
Frankenthal (Germany), 4

Fremont's Peak, Col., 218
Friedrich, Caspar David, 12, 32, 33, 36, 42, 218
Frontier, 19, 80, 117
Fuller, Margaret, 32
Fulton, Robert, 11, 75, 78, 217

Gaines, Ruth, 219
Gainsborough, 10, 36
Gardner, Albert Ten Eyck, 219
Gauguin, Paul, 19, 196, 199
Geneva, 78
Germany, 4, 11, 12, 33, 36, 46, 80, 97, 112, 113, 167, 189, 202
Giedion, Sigfried, 202
Gifford, Sanford Robinson, 100
Gignoux, Régis François, 53, 100, 156
Giorgione, 7
Giotto, 3, 100, 119, 217, 219
Girtin, Thomas, 12
Givernais, 179
Glackens, William, 179, 184, 220
Goethe, Johann Wolfgang von, 31
Gogh, Vincent van, 19, 196, 202
Goodrich, Lloyd, 81, 220
Goodspeed, Charles E., 219
Goodwin, Arthur Clifton, 189, 193, 221
Gordon (scene painter), 219
Gothic, 150
Gothic revival, 135
Goyen, Jan van, 7, 53
Grand Canyon, 109
Grand manner (grand style), 24, 31, 81
Green River, Ore., 218
Groombridge, William, 217
Guardi, Francesco, 12
Guercino, 7
Guy, Francis, 131

Haddock (scene painter), 219
Hagen, Victor W. von, 219
Hague, The, 175
Harding, Chester, 65
Harlem River (New York), 207
Harley, Robert L., 217
Harnett, William M., 117
Hart, James MacDougall, 53, 100
Hart, William M., 100
Hartford, Conn., 78
Hartley, Marsden, 202, 221
Harvard University, 30, 150
Harvey, George, 135, 139, 220
Hassam, Childe, 179, 220
Hausmann, Sebastian, 217
Havell, Robert, 50
Hawthorne, Nathaniel, 100, 103, 119, 219
Haymarket (London), 10, 11
Heade, Martin J., 69, 103, 139, 218, 219
Hedley, Joseph (Hidley), 126, 220
Heemskerck, Martin van, 217
Hegemann, Werner, 219
Heilborn, Bertha L., 219
Hellman, George S., 218
Herod, 131
Heroic landscape, 7, 12, 120

Hicks, Edward, 120
Hidley, Joseph. *See* Hedley
Hill, Thomas, 69, 109, 117
Hind, C. Lewis, 217
Historical Society of Pennsylvania, 26
Hittorf, Jacob Ignaz, 217
Hobbema, Meindert, 7
Holmes, William Henry, 189, 221
Homer, Winslow, 156, 159, 162, 220
Hudson (panorama painter), 91
Hudson River, 31, 36, 38, 46, 50, 59, 90, 97, 100, 113, 120, 122, 218, 219, 221
Hudson River school, 38, 53, 56, 65, 217, 218
Humanism, 3, 7, 218
Humboldt, Alexander von, 31, 109, 113
Hunt, William Morris, 150, 153, 154, 156, 220
Hussey, Christopher, 217
Huth, Hans, 220

Ideal landscape, 7, 22, 32
Illusionism, 11
Impressionism, 7, 19, 38, 117, 145, 156, 167, 175, 179, 184, 189, 193, 196, 199, 214, 220
India, 91
Indians, 60, 120, 139, 172
Industrialization, 56, 59, 69, 149, 159, 172, 215
Ingres, Jean-Dominique, 156
Inman, Henry, 50
Innes, George, 156, 159, 220
Irving, Washington, 31, 32, 38, 42, 218
Isaak Delgado Museum (New Orleans), 103
Isaiah, 120
Isham, Samuel, 218
Italy, 46, 100, 159

Jackson, Andrew, 80
Jamaica, 189
Jarves, James Jackson, 149, 153, 220
Jefferson, Thomas, 204
Jerusalem, 78, 86
Johnson, Allen, 219
Johnson, David, 59, 65, 100, 218
Johnson, Eastman, 175, 220
Jones (scene painter), 219

Kallir, Otto, 220
Kansas City, Mo., 65
Karr, Louise, 218
Keats, John, 31
Keefe, W. Ranford, 122
Kellner, Sidney, 218
Kensett, John Frederick, 59, 100, 218
Kentucky, 120
King, Edward S., 217
Kingston Senate House Museum, 219
Kirchner, Ludwig, 202
Koch, Joseph Anton, 12, 50
Kokoschka, Oskar, 19
Koninck, Philip de, 7
Kopisch, August, 12

Labrador, 113
Lackawanna Valley, Pa., 156
LaFarge, John, 154, 156, 220

Lancaster, Pa., 46
Lander, Frederick West, 106
Landscape of mood, 7, 36, 65, 175
Lane, James M., 221
Langhans, Carl Ferdinand, 12
Lanman, Charles, 218
Lawson, Ernest, 179, 184, 220
Lee, Joseph, 139, 220, 224
Lee, Sherman E., 221
Leicester Square (London), 11, 81
Leonardo da Vinci, 3, 4
Leroy, Amable Philibert, 217
Lesley, Parker, 218
Leslie (scene painter), 219
Lewis, Henry, 91, 219
Lewis, Meriwether, 80
Lima, Peru, 76
Lipman, Jean, 219, 220
Little masters, 56, 118, 119, 214
Little, Nina Fletcher, 217
Liverpool, 46
London, 10, 30, 40, 50, 78, 80, 81, 90, 109, 162
Long Island, 65
Louisiana, 69, 96
Louisville, Ky., 91
Loutherbourg, Philip, 11, 75
Louvre (Paris), 40, 207
Low Countries, 3, 4, 122

McCausland, Elizabeth, 218, 220
McDermott, John Francis, 219
McDowell, Tremaine, 36, 218
McEntee, Jervis, 100
MacFarlane, Janet R., 220
Maine, 162, 179
Manet, Édouard, 19, 156, 167, 179
Manhattan, 179, 202
Manwaring, Elizabeth Wheeler, 217
Marblehead, Mass., 75
Marin, John, 199, 202, 204, 221
Mark Twain, 89
Marseilles, 46
Martin, Elizabeth Gilbert, 220
Martin, Homer D., 167, 196, 220
Maryland, 189
Masaccio, 3
Mason, J. Alden, 219
Massachusetts, 75, 126, 156
Mather, Frank Jewett, Jr., 218, 220
Matisse, Henri, 19, 199
Mechanization, 56
Mechlin, Leila, 221
Medici, 103
Mediterranean, 113
Meeker, Joseph Rusling, 69
Meier-Graefe, Julius, 220
Mellquist, Jerome, 220, 221
Memling, Hans, 86, 219
Merrett, Susan, 126
Meryon, Charles, 59
Metcalf, Willard C., 179, 184
Metropolitan Museum (New York City), 31, 46, 80, 81, 175

Mexico, 78, 113, 219
Michelangelo, 30, 31
Middle ages, 3, 119, 120, 122
Middle West, 69
Millard, Everett L., 220
Miller, Alfred J., 53, 56, 218
Miller, Dorothy C., 217
Millet, Jean-François, 150
Milton, John, 81, 86
Mississippi, 38, 65, 87, 89, 90, 91, 96, 97, 126, 139
Missouri, 65, 120, 218
Missouri Botanical Garden, 53
Mohawk Valley, 42, 97
Monet, Claude, 19, 179, 184, 189
Monticelli, Adolphe, 167, 172
Montparnasse, 179
Moore, Charles Herbert, 150, 196, 220
Moran, Thomas, 109, 117, 118, 159, 219
Morse, Samuel Finley, 32, 42, 75, 220
Moses, Grandma. *See* Robertson, Anna Mary
Mount, William Sidney, 65, 69, 218
Mt. Holyoke, Mass., 219
Mumford, Lewis, 218
Munch, Edvard, 19, 202
Munich, 175
Murell, William, 221
Murillo, Estéban, 40
Museum of Fine Arts (Boston), 31, 32
Museum of Modern Art, 219, 220
Mysticism, 32, 159

Napa, Cal., 144
Napoleon, 11, 78
Nathan, Walter L., 218
National Academy of Design, 40, 42, 139, 172
National Collection of Art (Washington, D.C.), 189, 221
Naturalism, 19, 139, 149, 150, 172, 175, 214, 215
Nazarenes, 32
Neagle, John, 50
Near East, 3
New Bedford, Mass., 78, 106
New England, 31, 69, 150, 184
New Jersey, 59, 69
New objectivity, 19
New Orleans, 89, 90, 103
Newport, R.I., 154
New York City, 26, 40, 42, 53, 65, 78, 86, 90, 144, 150, 153, 167, 179, 184, 189, 199, 207, 219
New York Historical Society, 16, 26, 75, 78
New York Public Library, 218
Niagara Falls, 31, 46, 59, 75, 78, 90
Nile, 89
Normandy, 167
Norton, Charles Eliot, 150
Norway, 19

Odell, George C. D., 219
Ohio, 46, 119
Ohio River, 126
Oldenbourg, Rudolf, 217
Olmsted, Frederick, 53, 153, 193
Oregon, 53, 218
Orient, 113, 119, 120

Pacific, 80
Padua, 3
Palmer (Bond), Frances, 88
Panorama, 10, 11, 12, 75, 78, 80, 81, 88, 89, 90, 91, 96, 97, 113, 119, 149, 204, 214, 217, 219
Panoramic school, 117, 120, 149, 153, 167, 196, 214
Panoramic style, 75, 80, 86, 88, 100, 106, 109, 117, 159, 214, 217, 219
Pantheism, 36, 56
Paris, 10, 30, 31, 40, 53, 59, 75, 78, 86, 90, 143, 144, 150, 154, 156, 159, 162, 175, 199, 206, 217
Parker, Barbara N., 220
Patinir, Joachim, 4, 122
Paul (Richter), Jean, 32
Paysage intime, 12, 69, 100
Peale, Charles Wilson, 75, 218
Pechstein, Max, 202
Peep show, 11
Peinture à valeurs, 154, 167
Pène du Bois, Guy, 220
Penn, William, 120
Pennsylvania, 69, 118, 120, 206, 211
Pennsylvania Academy of Fine Arts, 65, 97
Perspective, 2, 3, 88, 119, 122, 126, 144
Peterkin, L. Denis, 221
Peters, Harry T., 219
Peters, J., Sr., 126
Philadelphia, 26, 38, 40, 75, 78, 91, 97, 135, 211, 220
Philipps, Duncan, 220
Photography, 97, 131, 162, 204, 206, 211
Picasso, Pablo, 19, 206
Picket, Joseph, 144
Picturesque, the, 10, 12, 24, 50, 53, 211, 215, 217
Pike's Peak, Col., 109
Pleasants, Jacob Hall, 217
Plein-air, 19, 59, 162, 179, 189
Pleorama, 12, 90
Poestenkill, N.Y., 126
Pointillism, 19
Pomarede, Leon, 19, 91, 97
Pope, Arthur, 220
Porter, Mrs. Clyde, 218
Postimpressionism, 199, 204
Postromanticism, 53, 56
Poussin, Gaspard. *See* Dughet
Poussin, Nicolas, 7, 40, 120, 126, 196
Precisionism, 206, 211, 214, 215
Prendergast, Maurice, 199, 221
Pre-Raphaelism, 149, 150
Pre-Raphaelites, 119, 150, 190, 196, 211, 220
Primitives, 1, 119, 120, 122, 126, 131, 135, 144, 189, 202, 214
Primitivism, 135, 144, 202, 204
Prouts Neck, 162
Providence, R.I., 78, 219
Pyrenees, 207

Quebec, 207
Quidor, John, 38

Ranger, Henry Ward, 167, 193, 220
Raphael, 30
Rathbone, Perry T., 219

Read, Georgia Willis, 219
Realism, 53, 69, 117, 150, 162
Reed, Luman, 40, 81
Reinagle, Hugh, 219
Rembrandt, 4, 7, 40
Renaissance, 3, 4, 11, 30, 86, 119, 122, 150
Renoir, Auguste, 184
Repoussoir, 2, 40, 88, 120
Reynolds, Sir Joshua, 81
Rhineland, 4
Rhine Valley, 40
Rhone Valley, 46
Richardson, Edgar Preston, 217, 219, 220
Risley, John, 90
Robert, Hubert, 12, 30
Robertson, Anna Mary (Grandma Moses), 144, 214
Robinson, Theodore, 179, 220
Rocky Mountains, 96, 103, 106, 149, 218
Rococo, 53
Romanticism, 12, 24, 26, 30, 31, 36, 42, 46, 53, 75, 113, 135, 159, 175, 215, 218
Romantic realism, 50, 69
Rome, 4, 7, 30, 31, 40, 46, 50, 175, 217
Rosa, Salvator, 7, 31, 32, 40, 46
Rourke, Constance, 221
Rousseau Henri ("Douanier"), 19, 119, 202, 204
Rousseau, Jean-Jacques, 30, 31
Rousseau, Theodore, 12, 153
Rubens, Peter Paul, 4, 40
Rugard (Germany), 217
Ruge, Clara, 220
Rügen (Germany), 42, 217, 218
Ruisdael, Jacob van, 7, 10, 32, 40, 46, 218
Runge, Philipp Otto, 12, 218
Ruskin, John, 150
Rust, Fern Helen, 218
Ryder, Albert Pinkham, 172, 220

St. Anthony (Falls), 91
St. Louis, 65, 69, 89, 90, 91, 97, 131, 218, 219
St. Thomas Aquinas, 3
Salem, Mass., 75, 218
Salzburg, 217
San Francisco, 139, 220
Sargent, John Singer, 162, 167
Sattler, Johann Michael, 217
Savery, Roeland, 4
Schack, William, 221
Schiller, Friedrich von, 31
Schinkel, Friedrich, 12
Schmidt-Rottluff, Karl, 202
Schuylkill River, 135
Schwarz, Heinrich, 219
Scotland, 56
Seghers, Hercules, 7
Seine, 135
Setauket, L.I., 65
Seurat, Georges, 19
Shakers, 211
Shannon, Martha A. S., 220
Sheeler, Charles, 207, 211, 214, 220, 221
Shelley, Donald A., 218
Shelley, Percy Bysshe, 31

Sherman, Frederick Fairchild, 220
Sisley, Alfred, 156
Sloan, Junius R., 221
Slous, Henry Courtney, 81
Smith, John Rowson, 90, 91, 219
Smith, Thomas ("Derby"), 90
Snelling, Fort, 139
Soby, James Thrall, 217
Society of American Artists, 175
Sonntag, William Louis, 59
Space feeling, 88, 109, 117, 220
Spain, 207
Spieler, Gerhard G., 56
Staël, Germaine de, 31
Stanton, Theodore, 217
Stewart, William Drummond, 36
Stieglitz, Alfred, 204, 206, 221
Stockton, Cal., 139, 143, 144
Stockwell, Sam, 91
Stony Brook, L.I., 65
Stratigraphic method, 1
Stuart, Gilbert, 31
Sturges, Jonathan, 40
Subiaco (Italy), 32
Sully, Thomas, 53, 159
Sumter, Fort, 106
Surrealism, 19
Susquehanna River, 32, 97
Swan, Mabel M., 218
Sweet, Frederick A., 217, 218, 219, 220
Swedenborg, Emanuel, 159
Switzerland, 46
Symbolism, 3, 12, 42, 122, 196, 199

Tableau mouvant, 11, 12
Tarrytown, N.Y., 139
Taylor, William N., 24
Technocratic landscape, 196, 211
Telbin, William, 217
Ten, the, 184
Terlinden, Charles, Vicomte, 217
Thames, 156
Thieme-Becker, 218
Thompson, Jerome, 65
Thoreau, Henry David, 50, 53
Thorwaldsen, Bertel, 31
Tiber, 103
Tieck, Ludwig, 32
Tiffany, Louis Comfort, 196
Titcombe, W. H., 131, 221
Toepffer, Rodolphe, 204
Tonalists, 172
Tripoli, 69, 75
Trompe l'œil, 11, 69, 117, 219
Troyon, Constant, 153
Trumbull, John, 59, 75, 78
Tschudi, Hugo von, 217, 218
Tucker, Allen, 220
Tuckerman, Henry T., 103
Turner, William, 12, 19, 26, 30, 80, 86, 109, 159, 219
Twachtman, John H., 179, 184, 220

Union Pacific Railway, 88
United States, 2, 69, 75, 109, 149
University Museum (Philadelphia), 91

Valori plastici, 19
Valparaiso, 156
Valvo, Ninfa, 220
Vanderlyn, John, 31, 46, 59, 78, 219
Velasco, José María, 133, 219
Venice, 7, 11, 135, 199
Venturi, Lionello, 221
Vermeer van Delft, Jan, 7
Vernet, Joseph, 26
Versailles, 78
Victoria, Queen, 90, 91
Voll, Karl, 219

Wade, William, 219
Wadsworth Atheneum (Hartford, Conn.), 78, 218
Wagner, Richard, 109
Walden (Pond), 50
Waldmüller, Ferdinand, 12, 59, 65
Waldo, Frank, 221
Wall, William G., 38, 218
Walters Collection, 218
Washington, D.C., 189, 221
Washington Heights (New York), 184
Watteau, François, 53
Webster, J. Carson, 221
Weir, John Ferguson, 100
Weir, Julian Alden, 179, 220
Weitenkampf, Frank, 217
West, the, 3, 56, 80, 88, 97, 106, 109, 139
West, Benjamin, 31
West Point, 77, 156
Wheeler, Monroe, 221
Whistler, James McNeill, 31, 154, 156, 214
White (scene painter), 219
White Mountains, 46
Whittier, John Greenleaf, 56, 219
Whittredge, Worthington, 175, 220
Wide-angle view, 86, 117, 135
Wilde, S., 220
Williams, Hermann Warner, Jr., 218
Willis, Nathaniel Parker, 219, 220
Wilson, Richard, 10, 16, 26
Wimar, Charles, 97, 219
Windsor Castle, 91
Winstanley, William, 217
Worringer, Wilhelm, 207
Worroll, John, 219
Wyant, Alexander, 167, 196, 220

Yale School of Fine Arts, 100
Yellowstone Park, Wyo., 109
Yosemite Valley, Cal., 109
Young, M. H. de, Memorial Museum (San Francisco), 220